THE MOST INFLUENTIAL PEOPLE OF OUR TIME

WHITE STAR PUBLISHERS

Project Editor
VALERIA MANFERTO DE FABIANIS
LAURA ACCOMAZZO

Graphic Design
MARIA CUCCHI

Editorial Staff
ICEIGEO, Milan

Collaborators: CLAUDIO AGOSTONI, CARLO BATÀ, CLAUDIA GALAL, GIULIA
GATTI, ENZO GENTILE, MARGHERITA GIACOSA, FEDERICA GUARNIERI, LORENZO
MARSILI, PAOLO PACI, PAOLA PAUDICE, CHIARA SCHIAVANO, ALFREDO SOMOZA.

THE MOST INFLUENTIAL PEOPLE OF OUR TIME

Edited by

ROBERTO MOTTADELLI
GIANNI MORELLI

Contents

Introduction	6	James Watson and Francis Crick	114
Thomas Alva Edison	10	John Fitzgerald Kennedy	116
Sigmund Freud	14	Nelson Mandela	124
Emmeline Pankhurst	16	Eva Perón	130
Auguste and Louis Lumière	20	John Paul II	134
Henry Ford	24	Elizabeth II	140
Wilbur and Orville Wright	28	Fidel Castro	146
Frank Lloyd Wright	32	Andy Warhol	152
Marie Curie	34	Martin Luther King	158
Gandhi	36	Yasser Arafat	164
Vladimir Lenin	40	Neil Armstrong	170
Guglielmo Marconi	44	Mikhail Gorbachev	174
Winston Churchill	46	Yuri Gagarin	176
Joseph Stalin	52	Elvis Presley	180
Albert Einstein	56	Tenzin Gyatso	182
Pablo Picasso	58	Saddam Hussein	188
Franklin Delano Roosevelt	64	Bob Dylan	192
Coco Chanel	70	Stephen Hawking	196
David Ben-Gurion	74	Muhammad Ali	198
Le Corbusier	80	Lech Wałęsa	204
Adolf Hitler	84	Steve Jobs	206
Charles de Gaulle	90	Bill Gates	208
Mao Zedong	96	Osama bin Laden	210
Walt Disney	102	The Beatles	214
Frida Kahlo	104	Mark Zuckerberg	220
Saint Teresa of Calcutta	108	The Authors	222

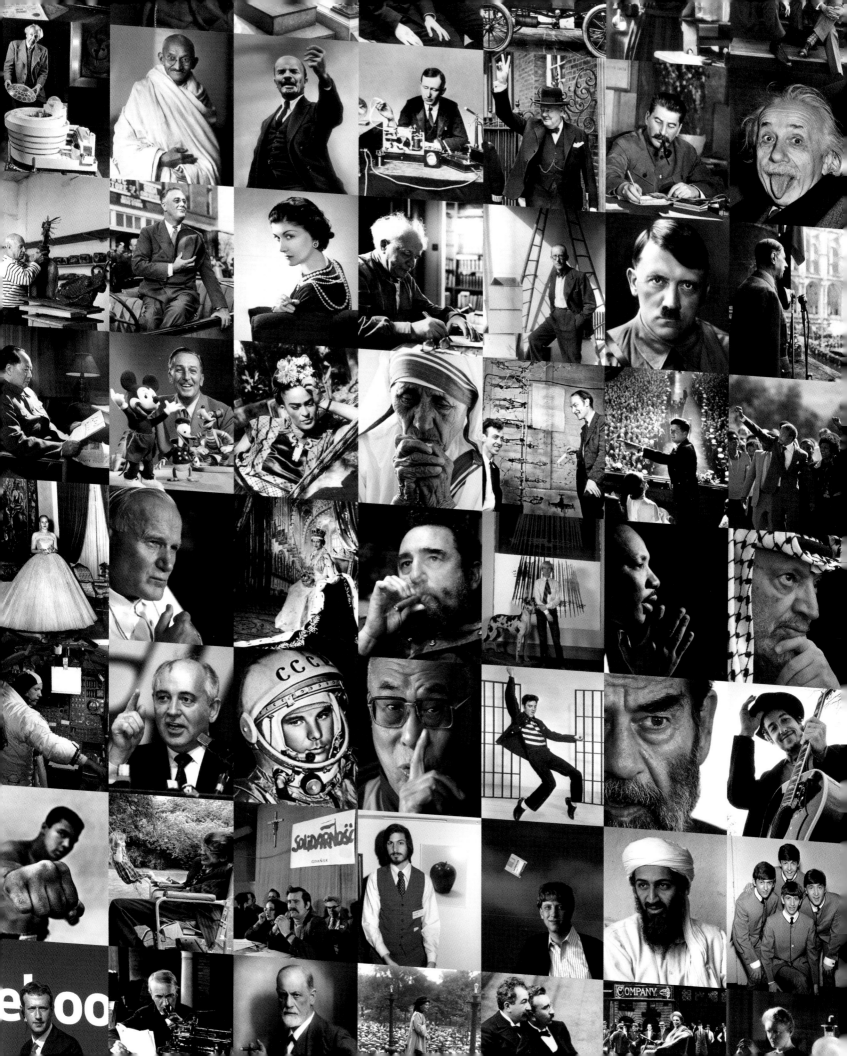

Introduction

by Gianni Morelli

"All men are equal, but some are more equal than others." George Orwell offers us a good picture of human society, of its dreams and its nightmares.

Accepting this thesis, we can ride it to burn an enemy, a man of different color, a witch, or a believer in another god. These are the nightmares. While in this book we have not forgotten them, we wanted the dreamers to be more numerous.

Intuition, weakness, strength, willpower, genius, madness, cruelty, perversion, unscrupulousness, creativity, good fortune, power, *sangfroid*, arrogance, violence, courage, culture, intelligence. They are so unevenly distributed, and still these qualities bring forth the figures we need for our history books. Since we had to choose from thousands, we preferred to look straight into the eyes of these men and women from the late 19th century to the present. It is a century – give or take a decade – that has molded our life in the third millennium, and it is also a different century from those that preceded it: for many reasons, but above all for the rapid expansion of global demographics and the corresponding speed with which societies have transformed.

It has been written that "History walks on the legs of men," but in the 20th century the pace of history changed. From horses and carriages to trains, steamships, cars, airplanes and spaceships (making a mockery of gravity), more recently the world communicates in real time and virtual reality. And thus the great figures of this century emerged from a turbulent stream, jostling their way upward through billions of individuals.

It all began with the development of modern industry in the second half of the 19th century. The curve of scientific discoveries and technical progress rose in parallel with the rising population curve. Since then, progress has been unstoppable. The adoption of steam engines (from looms to railroads) disrupted the tempo of agricultural societies that had been prevalent throughout the world for millennia. But it was the period from the last three decades of the 19th century to the

First World War that constituted the real watershed. The widespread use of the Morse telegraph revolutionized communication: up to that time, for example, in a country like France, it took from weeks to months to send and receive news. The telegraph put an end to this problem by making long-distance communication almost instantaneous. In the same years, phonographs and gramophones became popular: to have one meant being able to listen to the voice of someone not present, or even someone deceased. Or one could enjoy the music of an orchestra that had played on the other side of the world. And from the same Thomas Edison research laboratory that produced ever more evolved gramophones sprang a hundred other wonders, above all long-lasting light bulbs, the means to light the nights, roads, and rooms of the world. As amazing as the telegraph was at the time, the light bulb was positively magical.

Meanwhile, the rich *bourgeois*, drunk on champagne in the *café-concert*, envisioned their glorious future to the rhythm of the can-can, the dancers' bloomers roiling overhead. The Belle Époque blossomed, but the workers were left out: they organized themselves into parties and labor unions to fight exploitative capitalism. In the streets of London, Emmeline Pankhurst staged protests and led the suffragettes in the march to obtain voting rights for women. The 20th century was announced, and it was extraordinary. It opened, like a Georges Méliès spectacle, with a radio broadcast: thanks to Marconi's invention, the telegraph no longer needed wires. Huge steamliners, like the *Titanic*, were launched. (Not even the tragedy stopped the race to build ships.) Flying machines were built: enormous airships and the shaky propeller aircraft of the Wright brothers. And the Lumières' cinematograph was born.

There seemed to be no limits to the young 20th century. In Mexico, the first of the first modern revolutions broke out. In the meantime, in Paris, Marie Curie studied radioactivity: she would win two Nobel prizes, important steps on the road toward equal rights for women. Also noteworthy of

Introduction

these first years of the century was the appearance on city streets of cars: immediately popular, their number would go on multiplying. However, in the always-troubled Balkans, the first global war would begin. Among the most significant and horrifying developments of the First World War were the use of toxic gases and aerial bombardments: from 1914 to 1918, 9 million soldiers died and there were more than 5 million civilian casualties. But the 20th century would hardly pause to reflect. After the Treaty of Versailles was signed, the Charleston swept away the bad memories and trimmed inches from hemlines. Coco named her perfume Chanel N. 5 and Le Corbusier published *Vers une architecture*. In the East, the Soviet Union was formed, a consequence of Lenin's vision and the Communist Revolution of 1917.

In 1926, in Berlin, Einstein and Freud met and had "a very pleasant talk." On a much more serious note, in the United States the Roaring Twenties came to a sudden end with the Wall Street Crash of 1929. In Europe, the dramas of the 1930s took the stage: the Spanish Civil War began, and dictatorships – of Franco, Hitler, Mussolini and Stalin, among which we must recognize differences, and which still cast shadows on our lives today – became the norm. Despite the horror, artists persevered: Picasso would paint the *Guernica*, and on the other side of the Atlantic Walt Disney would receive an honorary Oscar for his beloved cartoon character, Mickey Mouse.

Swing music and military parades accompanied the great powers toward a new catastrophe: this time there were 60 million deaths, and hundreds of cities, large and small, were destroyed by bombs, culminating in Hiroshima. From the Second World War emerged penicillin, the nuclear arms race, decolonization, and a planet divided into two: allies of the United States, and those of the Soviet Union. China turned red and Mao Zedong became its "Great Helmsman."

Europe was no longer the center of the world. On the contrary, it was itself divided and in turmoil, like so many places in the world in the nineteen-fifties. Thus, with the end of traditional war, the Cold War began. Ready to flare up from one moment to the next, as it did in Korea and the Middle East, where the State of Israel was established after the Holocaust. And then there would be Vietnam, Congo, and Yugoslavia.

In the countries west of the Iron Curtain, there was an attempt to unify Europe so that they would never fight again. In the Caribbean, in the same decade, Fidel Castro and Che Guevara drove Batista, Cosa Nostra, and the CIA out of Cuba. And Frank Lloyd Wright, ninety years old, presented a design for the highest skyscraper in the world (528 floors, a mile high, in the skies of Chicago).

The fifties concluded with the smiling face of Gagarin preparing to be hurled beyond the atmosphere, where no man had ever flown before. The sixties opened with the Nobel Prize awarded to Watson and Crick for the discovery of the double helix of DNA, and would conclude with Neil Armstrong's steps on the moon. In the United States, John and Robert Kennedy and Martin Luther King would be assassinated, Andy Warhol would miraculously survive an assassination attempt, and the world nearly lost the unparalleled boxing of Muhammad Ali: he was driven out of the ring for refusing to fight in Vietnam. From Elvis Presley's devastating sex appeal to Bob Dylan's nasally twang, everything was topsy-turvy and changing quickly. Even Nelson Mandela, exemplar of patience and commitment and fortitude, imprisoned by the state of South Africa for twenty-seven years, would live to see the abolition of *apartheid* and his ascent to the presidency. The Soviet Union disintegrated, while Pope John Paul II, a tireless traveler, and Queen Elizabeth II, an equally stalwart queen, marched on.

The new millennium opened with the destruction of the Twin Towers and the rash Second Gulf War, which undermined complex balances of power in the Middle East. In a parallel universe, we meet the cosmic mind of Stephen Hawking and the fathers of the era of the device, of software and social media: Steve Jobs, Bill Gates, and Mark Zuckerberg.

And all around, our planet is warming, the climate changing, geopolitics searching for new equilibria. Huge islands of plastic are blossoming in the midst of the oceans, medicine aims for miracles, and in a not too distant future smartphones will be simple microchips sewn beneath our skin.

This is the context: in the pages that follow, we relate the story of these men and women, for good or ill.

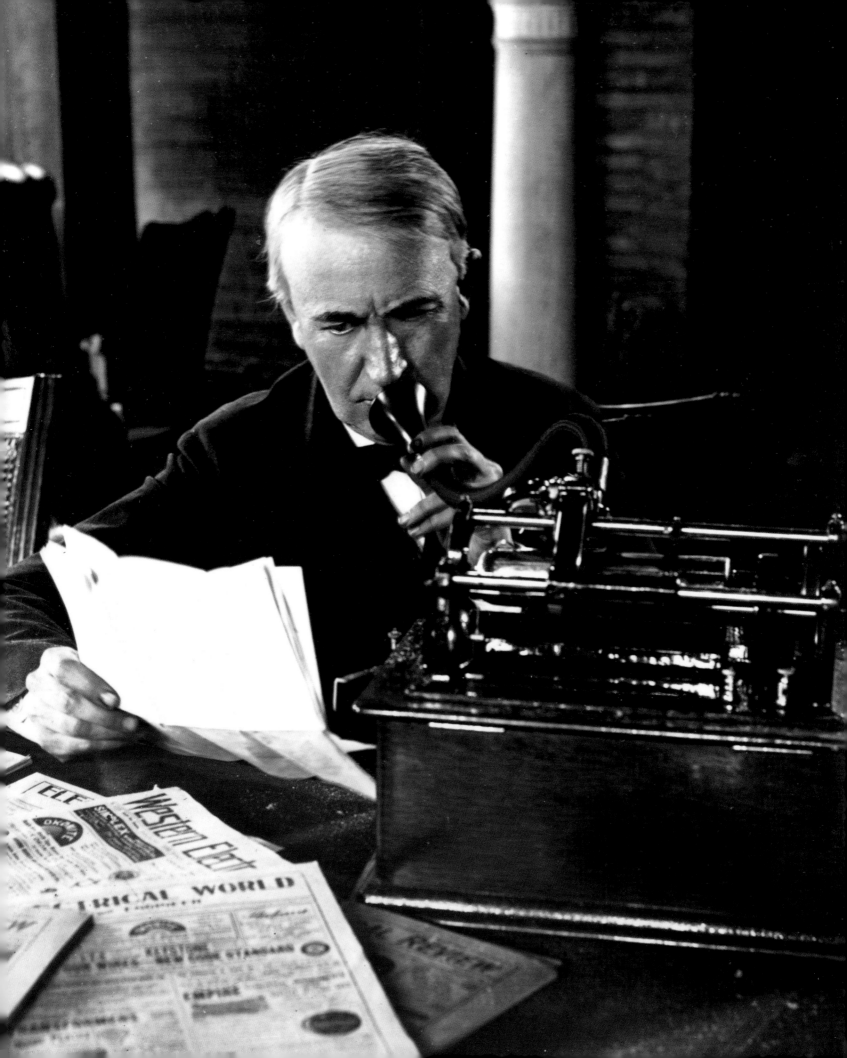

Thomas Alva Edison

He was a star of the Machine Age because of an extremely rare mixture of intuition, technology, marketing, and business acumen.

February 11th, 1847, Milan, Ohio, United States • October 18th, 1931, West Orange, New Jersey, United States

If we played the game of removing Thomas Alva Edison from history, the 20th century would be unrecognizable. His were the years – from the last quarter of the 19th century to the first decades of the 20th – in which scientific discoveries, combined with developments in technology and the rise of the entrepreneurial middle-class, revolutionized the world, daily life and culture. In that crucial period, very few of his fellow inventors and scientists, many of whom were also rich in talent, were capable of building an economic and technological complex like the one he created. A self-made man with very little formal education, he started as a paperboy on the trains of the Grand Trunk Western Railroad Company. After all, the word most associated with the name of Edison is "patent." Certainly he did not invent patents – the Greeks did that – but it was Edison who used them excessively and systematically, registering more than 1000 alone in the United States, plus hundreds in France, the United Kingdom, and Germany. We can say that in his career of more than 60 years, on average Edison filed more than one patent a month. And he initiated (and defended) thousands of lawsuits: at least 500 of these, to give an idea of the numbers, were in connection with early movie cameras and projectors, and brought against, above all, the Lumière brothers. When he could not win in court, Edison tried to create alliances with rivals, or to drive them out of the market by buying the rights to those discoveries and inventions that might eventually compete with his. Perhaps his greatest strategic innovation was the creation of a research laboratory (at Menlo Park, New Jersey), where he employed dozens of technicians whose work, often little publicized, contributed decisively to his success.

Thomas Edison demonstrates a sound-recording machine, the gramophone (derived from the phonograph) in the early 1890s. Edison explored the possibilities of recording sounds and voices on a cylinder (first of aluminum foil, then of wax) to develop a new office machine: the dictaphone. Fierce competition arose over this patent.

His greatest invention, on the other hand, is more difficult to identify. But by our hypothetical vote, one object wins hands down: the incandescent, long-lasting light bulb, and the equipment designed to transfer electricity. "We will make electricity so cheap," he once prophetically announced, "that only the rich will burn candles." He was proved absolutely right. Edison's most original invention was probably the phonograph: the machine capable of talking and playing music came out of nowhere. His most amusing was the kinetoscope, the precursor of all movie projectors. The most macabre was the electric chair. But among the many inventions he's credited for, it is impossible to forget the carbon microphone, which was used in telephones until the electronic era, and impossible to ignore the improvements he made in the telegraph, the X-ray machine, and mining equipment. For literally hundreds of mechanical problems, Edison provided ingenious technological solutions. In many cases, Edison's technologies were soon overtaken by developments he did not want to adapt to, as in the case of disks (gramophones) against cylinders (phonographs), or as in the endless legal battles that arose in the fight between direct current and Westinghouse's alternating current. But one thing remains indisputable: in those years, if there was talk of novelty and the next big thing, you could bet that in some way Thomas Alva Edison was involved.

Edison leaning on a bench in the laboratory in Menlo Park, New Jersey: his large house was transformed into a research center. Here, 30 miles from Manhattan, were most of Edison's inventions – from the phonograph to the incandescent light bulb – which he developed with a team of many technicians and scientists.

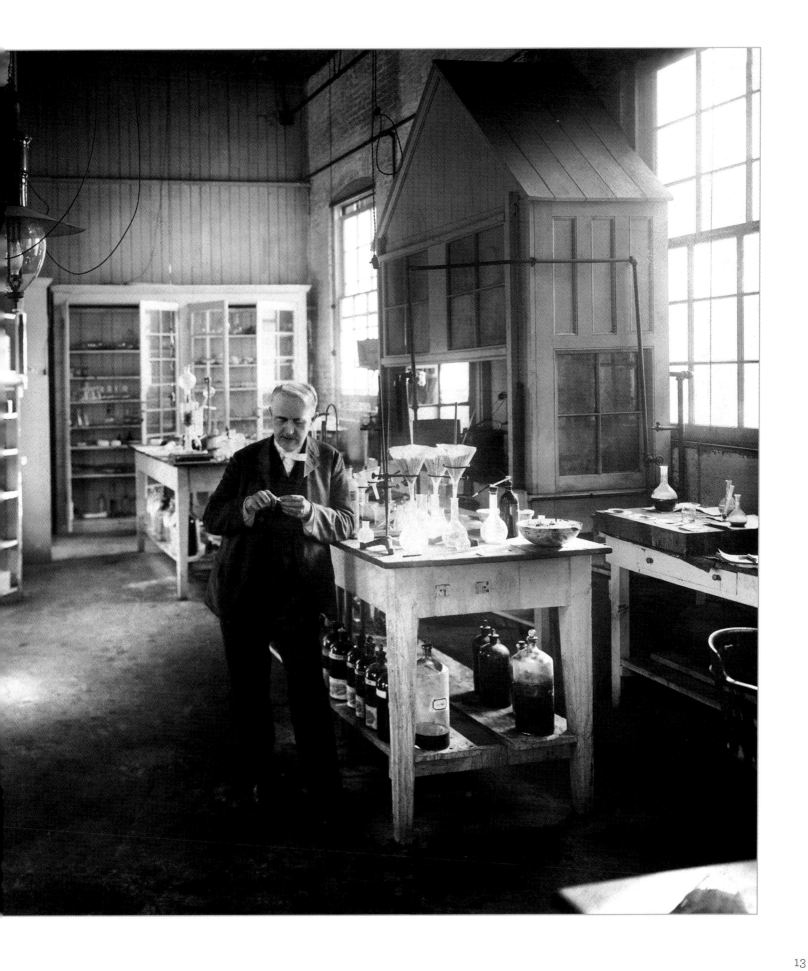

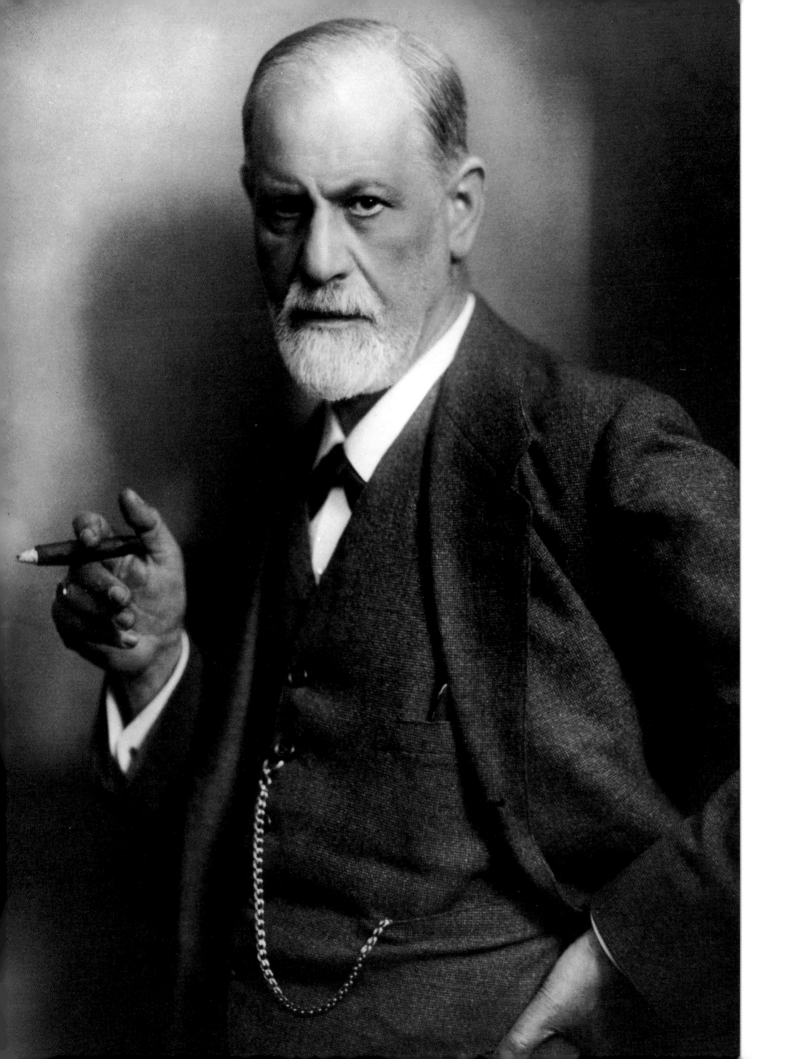

May 6th, 1856, Příbor, Austro-Hungarian Empire • September 23rd, 1939, London, United Kingdom

Sigmund Freud

He is one of the most quoted authors of the 20th century. He was provocative and innovative, and as the father of psychoanalysis Freud revolutionized how we see ourselves. His work left a permanent impression on contemporary culture.

Immoral. Perverted. Heretical. A sex maniac. After the publication of the book *The Interpretation of Dreams* (1899), insults of every kind rained down on the Austrian psychologist Sigmund Freud. Above all, people were scandalized by his concept of the unconscious. The cornerstone of his theory of psychoanalysis, the unconscious was conceived as a chaotic collection of instincts and urges affecting, without his or her awareness, an individual's everyday life. Freud, who did not mince words, summed it up like this: "The ego is not the master of its own house." And he piled it on: the urges that have the upper hand in humans are of a sexual nature, and they are active from the moment the baby sucks the mother's breast. If the parents do not respond to them properly, these urges can degenerate into mental illness. These assertions were unacceptable for the puritanical Viennese society of the early 20th century, which began to gossip about Freud's private life. When he published *Fragments of an Analysis of a Case of Hysteria* (1905), in which he quoted from the sexually-themed conversations he had had with the young Ida Bauer in therapy, some readers accused him of having an affair with the patient. But at the same time, the success of his therapy began to draw the attention of scholars, which limited the effect of the controversy. There was only one "accusation" that Freud could not fight: that of being Jewish. At the end of the 1930s, the Nazis began to closely observe the elderly doctor. So in 1938, Freud took refuge in London, where he was received with every honor. Psychoanalysis is still attacked today: some consider it *passé*, while others accuse Freud of misogyny and even – how times change! – of moralizing. But his concept of the unconscious was an irreversible trailblazer in the description of the human being, which had until then been described in terms of rationality or the conscience. Nowadays the couch, repression, neurosis, and the *lapsus* have entered ordinary discourse. And for more than a century, the mysteries of the human psyche have enriched literature, cinema, music and pop culture.

Sigmund Freud in 1922, photographed with his ever-present cigar: he smoked as many as twenty a day. But smoking was not the only vice of the father of psychoanalysis: he also took cocaine and compulsively collected art and Persian carpets. He carefully examined his own weaknesses, using himself as the first subject for the construction of his theories.

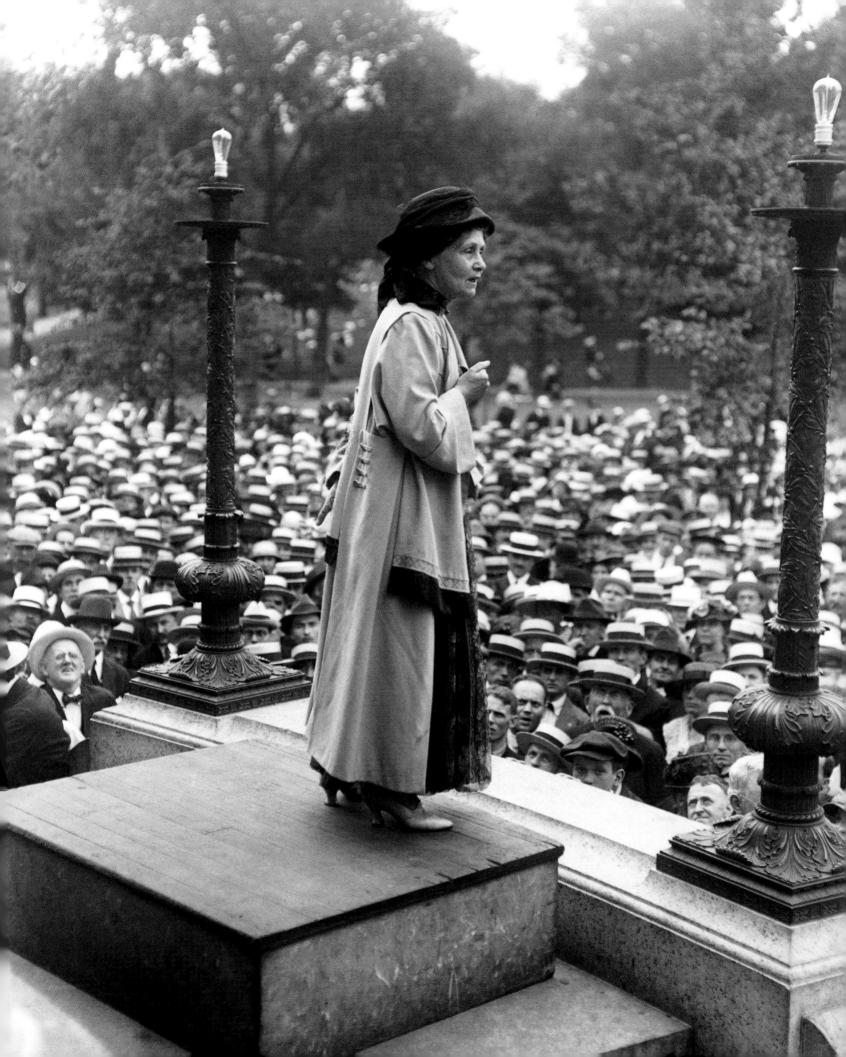

Emmeline Pankhurst

At the beginning of the 20th century, London was shaken by a group of rebellious women demonstrating in the streets. Breaking store windows and starting fires, these women, the suffragettes, were fighting for the right to vote. Emmeline Pankhurst was their leader.

Emmeline Goulden's eyes of ice hid a heart that had burned since she heard, as a girl, her father sigh: "What a pity she wasn't born a lad." At 14, she snuck into a meeting for female suffrage, and getting women the right to vote became her life mission. In 1894, with her husband Richard Pankhurst, who was also an activist, she obtained the right to vote for women in local elections. When Richard died in 1898, Emmeline took command of operations, coining effective slogans ("I would rather be a rebel than a slave") that won hundreds of women to the cause. She created a newspaper and even an anthem and a flag to communicate the grievances of British women: they felt they were a separate nation in a country that did not want them as citizens. Emmeline encouraged her comrades to protest – there were violent demonstrations, even fires started in tearooms and at cricket pavilions – and to get themselves arrested, so that photographs in the press would rouse public opinion. She herself was arrested seven times. The government responded with derision and brutality: force-feeding hunger strikers or setting mice free in the demonstrations. The name "suffragettes" itself, given to the women by journalists, was a pejorative. But the men in power miscalculated: the suffragettes received public support, so much that in 1908 the jeweler Mappin & Webb launched a line of jewels in purple, green and white, the colors of the movement. In 1914 the First World War broke out, and while suffragette activism slowed down, Emmeline did not stop: she went to America to further the cause. In 1918, the government granted – with some limitations – women over 30 the right to vote, to reward them for their contribution in the war. In July, 1928, the age was lowered to 21, as it was for men: but it was too late for Emmeline to see. She died only a few days before, leaving three daughters, all activists, and millions of new, empowered British citizens.

The outbreak of the First World War created division within the suffragettes. While some of them decided to postpone their protests, Emmeline Pankhurst took advantage of the historic moment to broaden the scope of the movement outside Europe, in the United States and in Canada.

Emmeline Pankhurst leads a procession of suffragettes. Her Women's Social and Political Union included both women of the working class and numerous representatives of London high society. This diversity was fundamental to the success of the movement, which benefited from contacts with, and financing from, the higher echelons of politics.

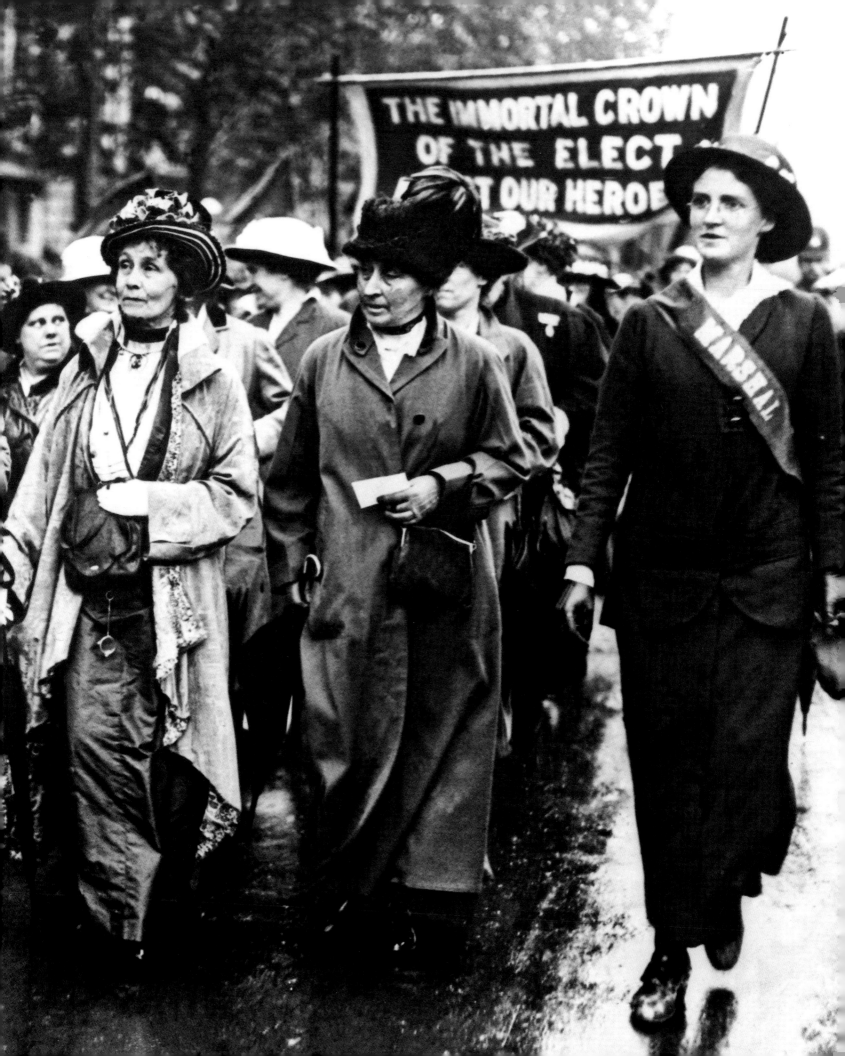

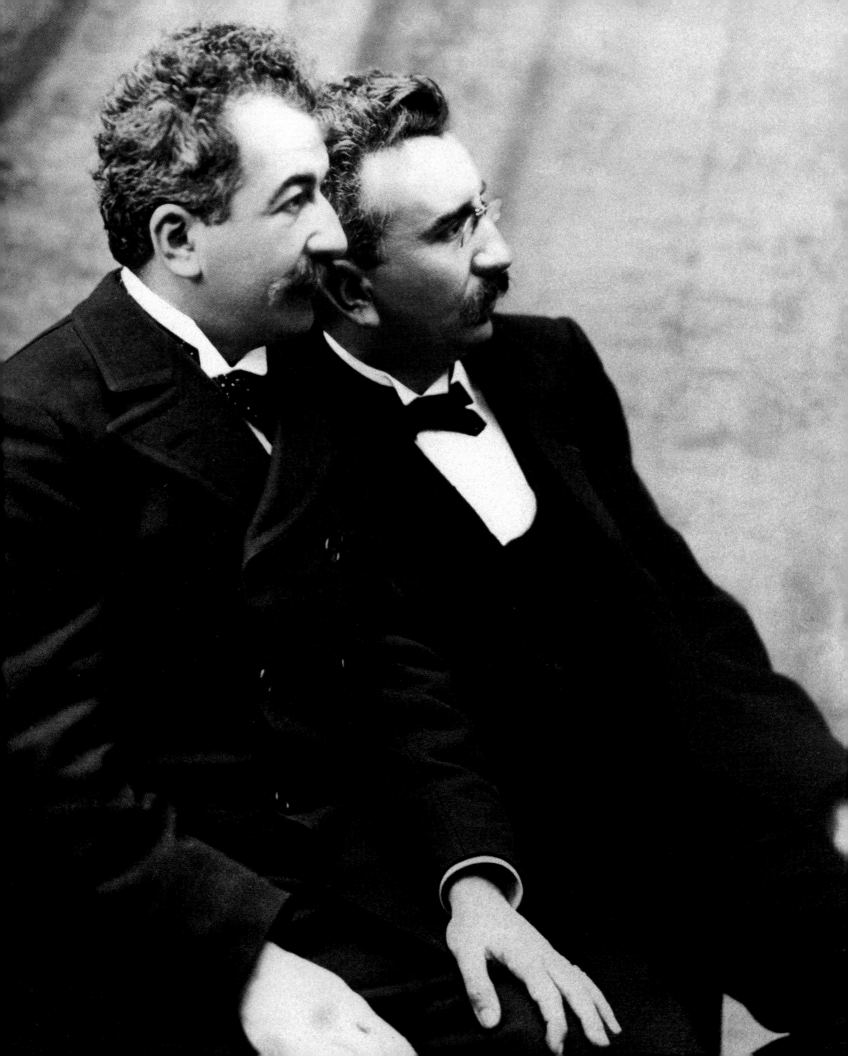

Auguste and Louis Lumière

Between 1892 and 1896 as many as 126 patents were registered at patent offices throughout the world for devices that would "make images move." For one that prevailed, its destiny was in its name: Lumière, like film exposed to light, would become an essential element for the seventh art.

Antoine Lumière, the father of Auguste and Louis, was already a successful photographer in Lyon, France, when, in 1894, he saw the presentation of the kinetoscope, an invention which sprang from the genius of Thomas Alva Edison. It looked like a wooden chest of drawers. On its top, there was an eyepiece: by looking inside, from a rather uncomfortable position, the observer could watch a moving film. Lumière Père returned home and proclaimed: "Get the image out of the box."

Auguste and Louis took him seriously and in a year had *le cinématographe* ready. With a white sheet for a screen, about half an hour of projections, and having sold about thirty tickets, on December 28th, 1895, in the Salon Indien of the Grand Café in Paris – the *Ville Lumière, ça va sans dire* – Auguste and Louis presented their invention. It was a triumph. Public projections won over the audience: together they laughed, cried in joy, and gasped in fear. Now legendary for how their audience reacted is the sequence of the train at the La Ciotat station: shot from a position nearly on the tracks, the train appears to run into the audience. (More than a few spectators left the room running.) The cinematograph also opened perspectives on distant, almost unreachable worlds: in the Lumière films one saw the sea, Naples, *a corrida*, King Edward VII of the United Kingdom, and even Japan and China. But there work wasn't limited to proto-docu-

Auguste: October 19th, 1862, Besançon, France • April 10th, 1954, Lyon, France
Louis: October 5th, 1864, Besançon, France • June 6th, 1948, Bandol, France

Auguste (left) and Louis Lumière. They obtained diplomas from the prestigious Écoles La Martinière in Lyon, the former in chemistry and the latter in physics. As teenagers, they began to work with their father, Antoine, a photographer and entrepreneur, immediately developing important innovations in the production of photographic plates.

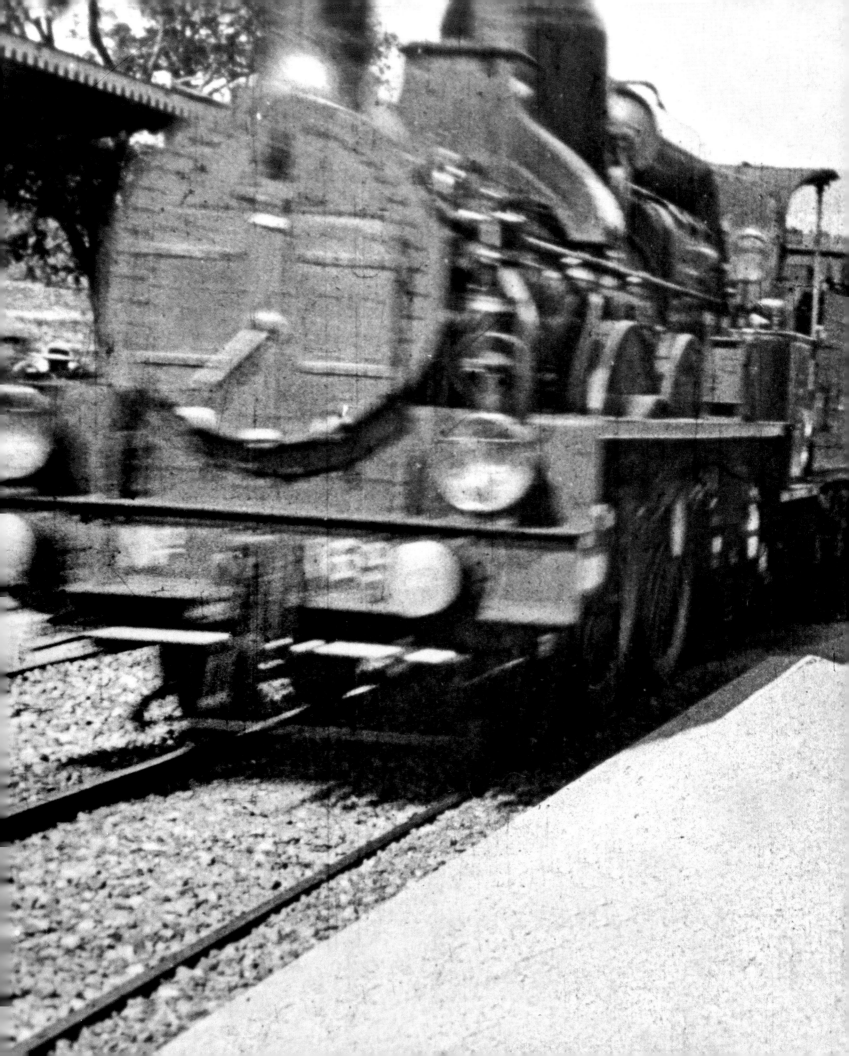

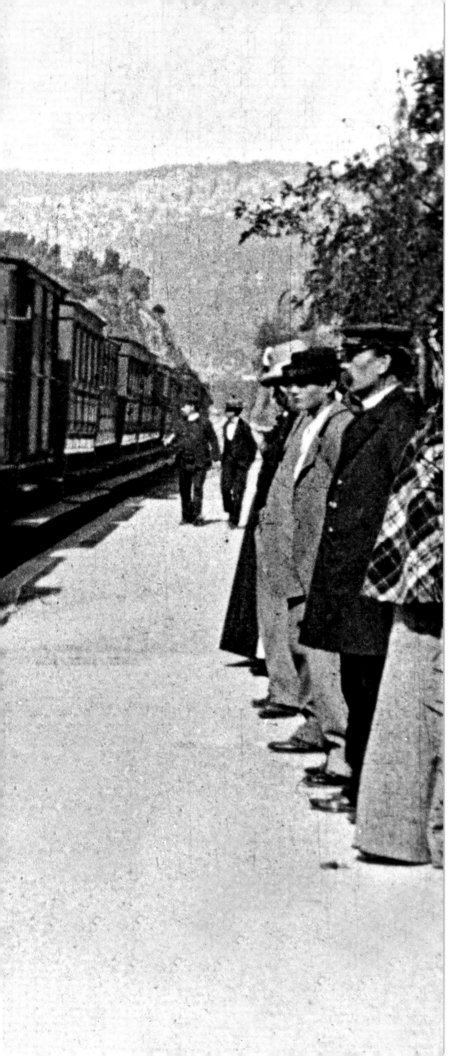

mentaries: the Lumières also laid the foundations for fictional films with *L'arroseur arrosé*, a brief sketch in which a gardener is the victim of a boy's practical joke.

In only a few years, the Société Lumière opened movie theaters throughout the world – even in Cuba and Mexico. But eager for new conquests, Auguste and Louis in 1902 ceded the use of their patent to other brothers (the Pathés, who would lay the foundation for French cinema) to devote themselves to color photography, an invention they considered more promising. It's said that the Lumières concluded, "The cinema is an invention without any future." But this is probably just a malicious rumor that's become legend.

A frame from *L'Arrivée d'un train en gare de La Ciotat*, one of the most famous short films by the Lumière brothers. It was projected for the first time in January, 1896. The moving train and the almost frontal camera angle, to frame a long perspective, demonstrate the potential of the cinema and show that besides being prolific inventors, the Lumières were also capable directors.

Henry Ford

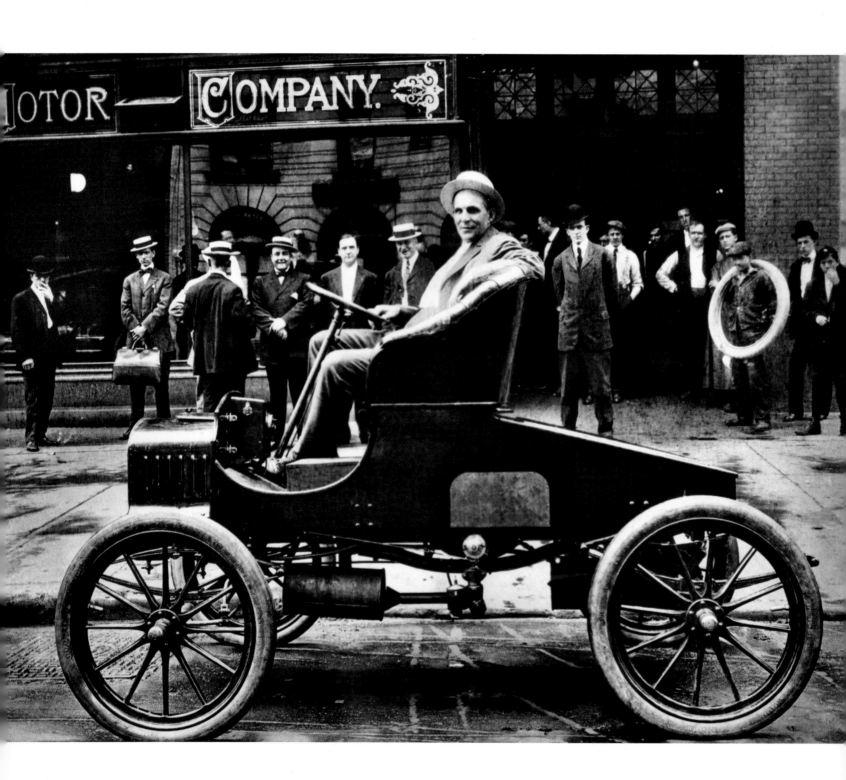

July 30th, 1863, Greenfield Township, Michigan, United States • April 7th, 1947, Dearborn, Michigan, United States

An organizational genius and an innovator of industrial production methods, Henry Ford, the founder of the Ford Motor Company, was the first to sense that the 20th century would be the century of mass car ownership: "Any customer can have a car painted any color that he wants so long as it is black."

Although he invented neither the car nor the assembly line, it was Henry Ford who, at the beginning of the 20th century, introduced these mainstays of modern life to American society. In 1908 the Model T Ford first became available to the growing middle class. Millions of these cars were turned out by factories designed according to Ford's industrial vision, what would soon be called "Fordism": this profitable form of mass production guaranteed, above all, high wages and job security for his employees. So, in addition to spearheading a revolution in industrial production, Ford was in the vanguard of a social revolution that would profoundly affect the way of life and method of transportation in the 20th century. In only a few years, he became one of the wealthiest and most famous people in the world; he studied and implemented various innovations, both technical and entrepreneurial, to lower production costs. These included the development of franchising and the opening of dealerships in every corner of the world. It was a kind of globalization before its time. To achieve this extraordinary result, Ford took advantage of his experience in a mechanic's workshop in Detroit (after work, he amused himself by building cars in his garage at home). His training continued with a brief period of work as an engineer for nothing less than Thomas Edison's energy company. In 1903 he founded the Ford Motor Company. In a few years, the company became the largest auto manufacturer in the world. This success was due to the simplicity of the models Ford offered, to their moderate prices, and to the fact that the cars were built with materials of the highest quality. Ford sensed that the masses were ready for car ownership: between 1908 and 1927 his company produced and sold 15 million Model Ts. They were, without exception, black. The steering wheel was on the left side, and the engine and transmission unit were completely protected: these and other brilliant touches made the first car reliable, safe, easy to drive and, an aspect not to be ignored, economical to repair.

Henry Ford sits smiling in the car – known at the time as the first "horseless carriage" – in front the Ford Motor Company in 1907. Before the Model T, the company produced Models A, B, C, F, K, N, R and S. In particular, about 7000 Model Ns were sold: production was interrupted in 1908, the year production of the Model T began.

Henry Ford

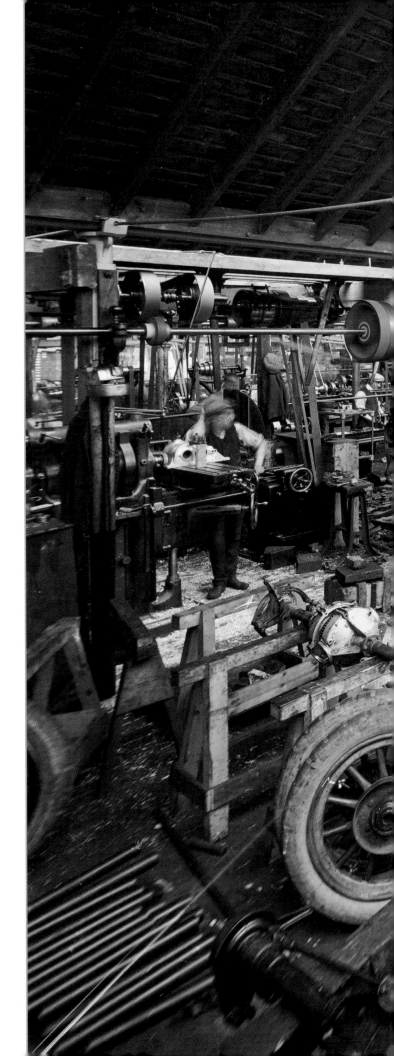

Before the advent of the assembly line, cars were produced on a small scale and put together by hand, as we see in this 1907 photograph of a British car factory. Less than two years later, the system introduced by Ford to build the Model T would reduce the assembly time for a vehicle from over 12 hours to 93 minutes, creating a considerable price reduction.

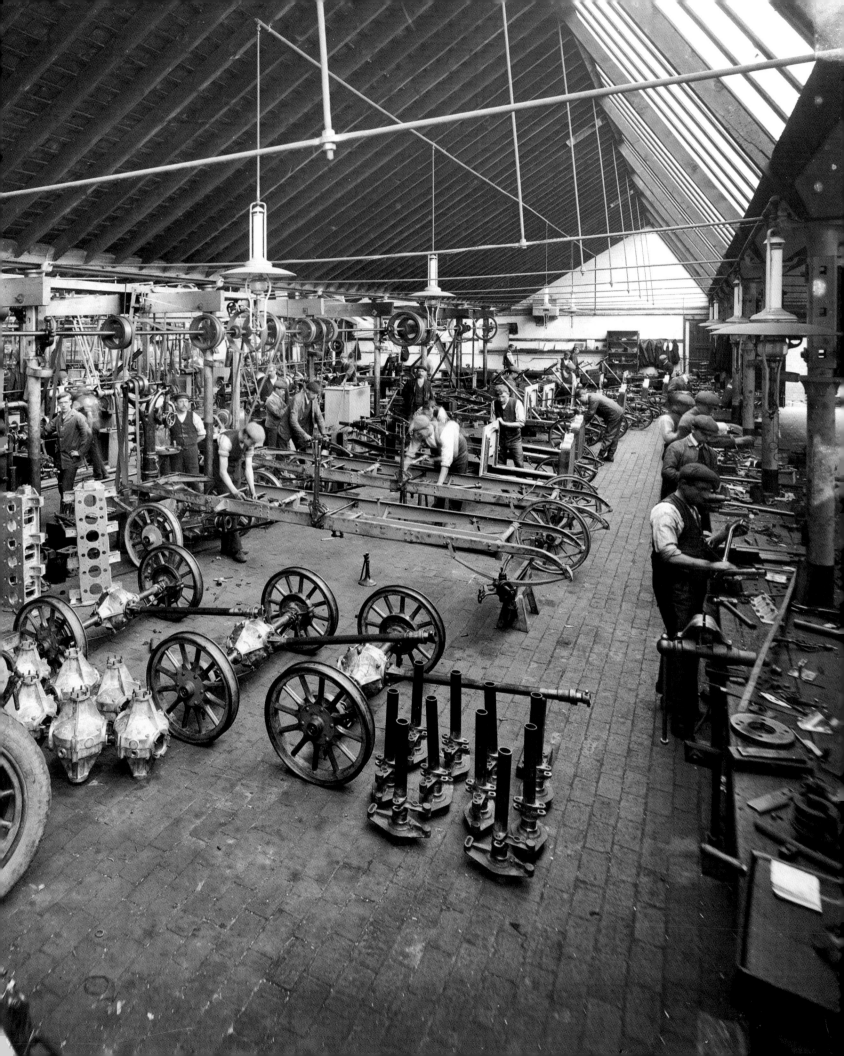

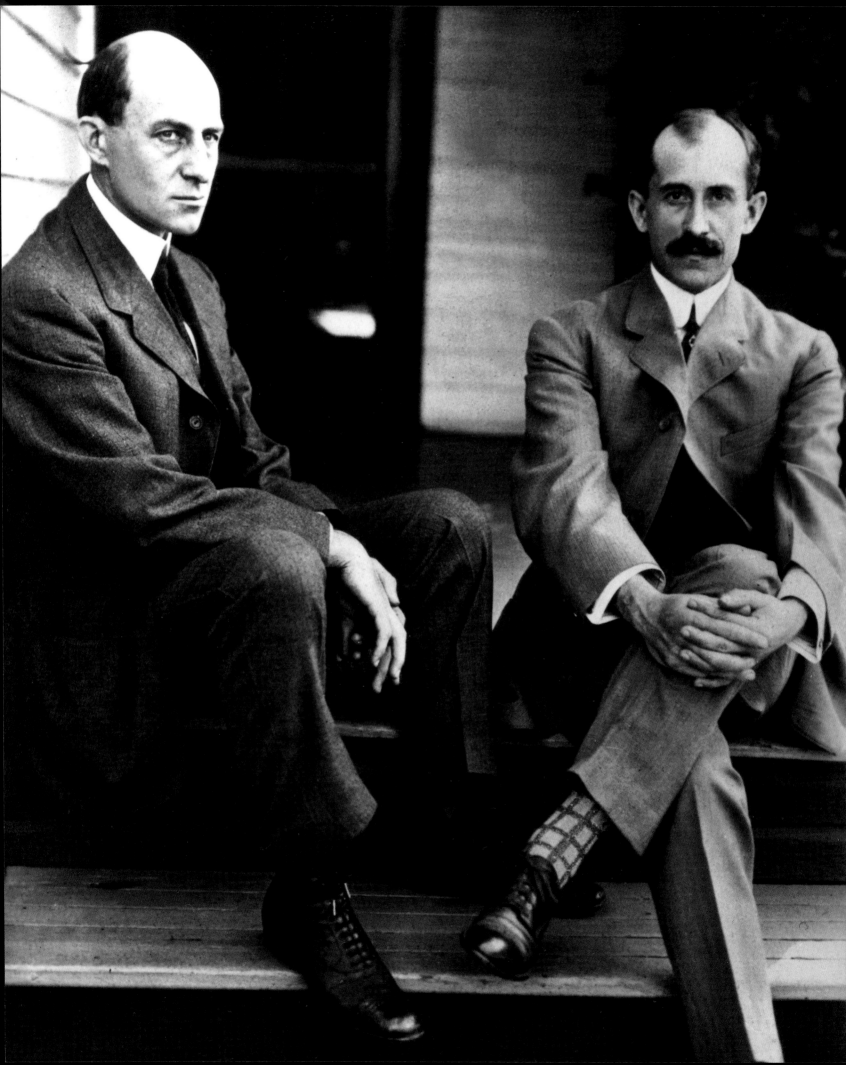

Wilbur and Orville Wright

On December 17th, 1903, Wilbur and Orville Wright, two brothers with a passion for mechanics, succeeded in flying the first man-powered aircraft.

A strong wind was blowing on the beach of Kitty Hawk, North Carolina, on December 17th, 1903. Perhaps too strong. But the brothers Wilbur and Orville Wright were not discouraged. They were there to fly and, if their plan worked, they would be the first to fly a man-powered aircraft. They were stubborn and competitive; for years they had been working on their prototype, the *Flyer*, assembling it piece by piece at their bicycle workshop. Orville and Wilbur were neither scientists nor engineers. They made a living by building and repairing bicycles. But they had dreamed of conquering the skies since they were children, when their father, a Protestant pastor, gave them a model helicopter which could fly: the toy broke and they repaired it.

On that December 17th, Orville was the first to take command, controlling the *Flyer* from a position on his stomach. He was holding his breath when the aircraft took off and perhaps did not even have time to realize that he was flying; after about 100 feet the plane landed softly on the sand. Wilbur was the last: he was on board when the *Flyer* – after 59 seconds in the air – decided to crash, fortunately without too much damage.

Wilbur: April 16th, 1867, Millville, Indiana, United States • May 30th, 1912, Dayton, Ohio, United States
Orville: August 19th, 1871, Dayton, Ohio, United States • January 30th, 1948, Dayton, Ohio, United States

Wilbur (left) and Orville Wright pose in front of their house on Hawthorn Street in Dayton, Ohio, in 1909. A year before Orville sustained serious injuries in a flying accident, but the brothers were not discouraged. In September of 1909 Wilbur performed in New York City, flying around the Statue of Liberty during the tercentenary celebrations for the discovery of Manhattan.

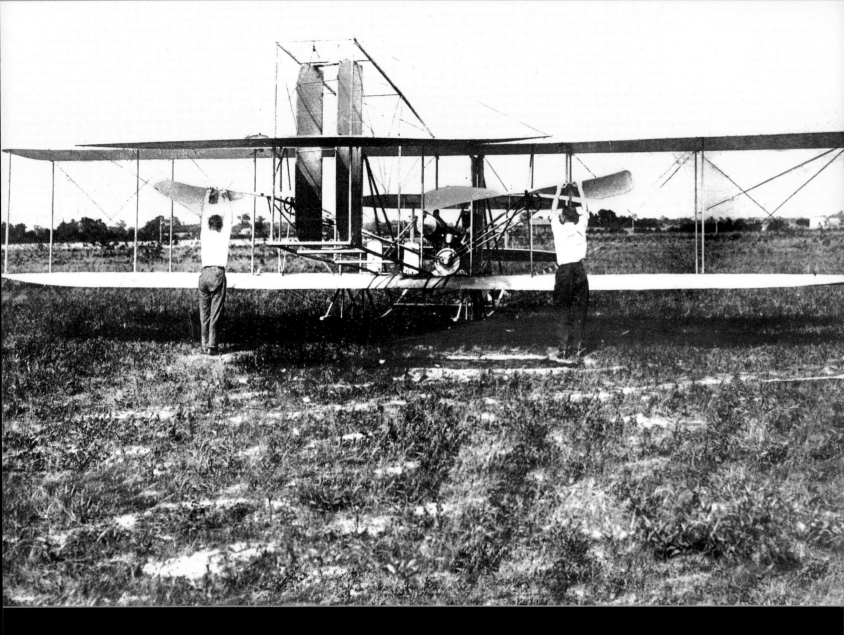

Five men were present at the scene: two workers from the marine station at Kitty Hawk, and three passersby. They certainly did not realize that they were witnessing a key moment in the history of humanity: it was the opening of the era of the airplane, a machine destined to revolutionize transport and make the world a smaller place. The only newspaper to report the event was the *Virginia Pilot*, thanks to an aspiring reporter who was a friend of one of the eye witnesses. The Wright brothers, sensing the importance of their invention, then faced a new challenge: building and selling aircraft. They even decided not to pilot planes in order to make their business take off. But at that endeavor they were less successful. Wilbur Wright died in 1912. With disputes over patents, and conflicts with more powerful companies, for Orville the world of business would turn out to be more insidious than the wind and more difficult to conquer than the skies over Kitty Hawk.

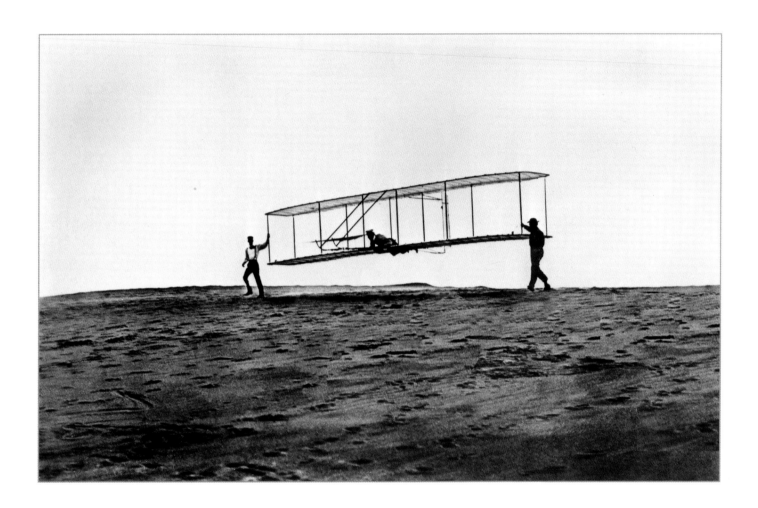

30 The Wright brothers start the engines on one of their airplanes by turning the propellers by hand. Ever since 1903, the two inventors have clearly understood the importance of taking photographs of all these operations, both to silence possible doubts and to publicize their activity. In fact, they intend to produce planes and sell them to the U.S. Army.

31 Before perfecting the *Flyer*, Wilbur and Orville Wright try with gliders: it is no accident that the structure of the first plane follows that of the biplane without an engine, or that the pilot has to lie down horizontally. Between 1900 and 1902, to launch the gliders, the two brothers chose the same beach at Kitty Hawk, North Carolina, where in 1903 they would also fly with an engine.

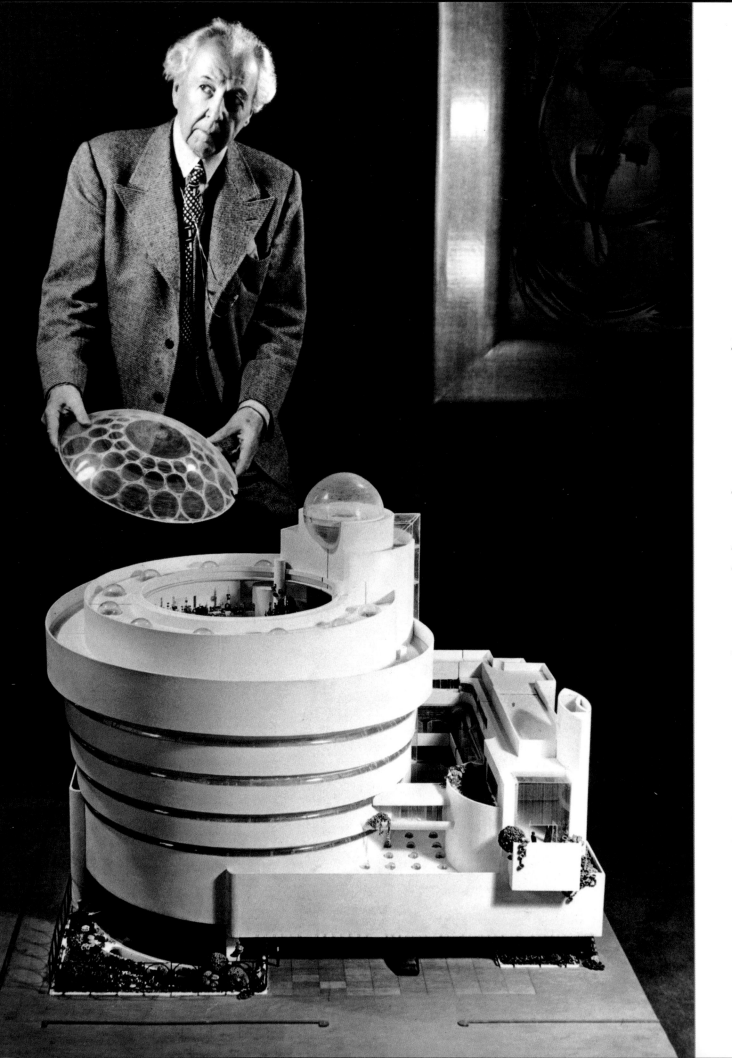

June 9th, 1867, Richland Center, Wisconsin, United States • April 9th, 1959, Phoenix, Arizona, United States

Frank Lloyd Wright

For more than 70 years, architect Frank Lloyd Wright composed of air and light, in harmony with the environment. Organic architecture, which he first promoted, was not only a revolutionary way of designing buildings, but also a philosophy of life.

Before architecture there was nature, the human, and imagination. These were the priorities of Frank Lloyd Wright: we understand this when we look at the buildings that made him famous. Fallingwater, for example, which bestrides a stream, hides in a wood, like in a fairy tale. The hypnotic spiral of the Guggenheim Museum, in the heart of New York City, sets free the enveloping form of life. Or the "prairie houses," which at the end of the 19th century evoked the contours of the landscape and played at blending into it. These structures were entirely different from the neoclassical models fashionable at the time. After all, Lloyd Wright's first 20 years were mostly spent in the fields and forests around the village of Spring Green, where his mother raised him with the games of Friedrich Fröbel, the father of the education through enjoyment. When he began to study engineering, that environment was dear to Wright, together with the idea of a small modern family needing a welcoming house. This was an idea that formed after the divorce his parents, when he was left with his mother. Then he discovered Japanese culture, which enchanted him with its sober elegance and subtle lines. He was a restless spirit, and did not graduate. He designed and travelled, in Europe, Asia, and in America. He married, had six children, and then fell in love with another woman. After his new partner tragically died in a fire, he married another woman. Not long after that, following another divorce, he married a third time. He continued to work and to keep up-to-date until he was 90, never forgetting that the house was a place that must favor life. Or rather, the house itself is a living organism, internally consistent, and functional in relation to its environment. His "organic architecture" is just this: a meeting between cultures and disciplines, between East and West, between engineering and philosophy, the expression of a complete vision of the world. Here lies the secret of his modernity.

Frank Lloyd Wright presents the model of one of his last and most important works, the Solomon R. Guggenheim Museum in New York. In this photo from 1945, while he holds the dome of the central section, the architect seems to want to "lay the last stone" on the building. In reality, he will not live to see the completion of this work: he will die six months before the opening in October, 1959.

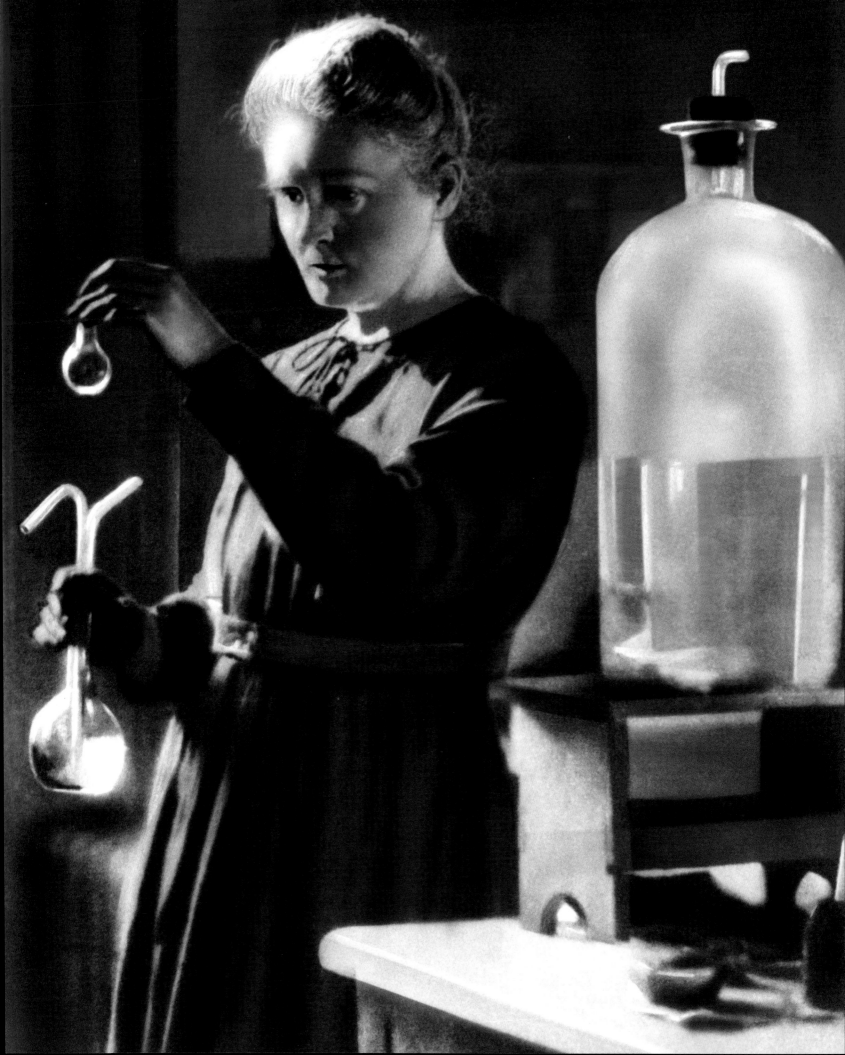

Marie Curie

Marie Curie was the first woman to attain a university degree in physics, and the first to receive the Nobel Prize; she received the Nobel twice, in different scientific fields. A genius who worked for the good of humanity, Curie has been a model for generations of women.

Little Maria was only four years old when she saw her elder sister stumbling in her reading: she tore the book from her sister's hands and began to read aloud, astonishing everyone. She was already a scientist, with a mind that, in Poland under Tsarist Russia, seemed too curious and brilliant to belong to a woman. She was also fiercely independent in manner and thought. Maria could not accept the idea that a girl's highest aspiration must be to find a good match; she rejected the idea of submitting to a husband. She replaced faith in God with trust in knowledge and the scientific method. In her adolescence, Maria grew impatient with Poland of the late 19th century: she was not even allowed to attend university, which was reserved for men. Thus in 1891, at 24, she enrolled at the Sorbonne, in Paris, and became Marie. After two years of school, she became the first woman to graduate in physics. She then completed a degree in mathematics, and soon after became the first woman to teach at the prestigious university. Her relationship with Pierre Curie, her future husband, was above all a partnership based on a passion for research. Their union resulted in the discovery of two new elements, radium and polonium, and fundamental insights into radioactive phenomena; with Henri Becquerel, they received the Nobel Prize in Physics in 1903; and they had two daughters, one of whom, Irène, would in her turn win the Nobel Prize in 1935. The Curies did not patent the procedure for the isolation of radium, but made it available to all, to advance human progress. And yet, after Pierre's death (1906), Marie was the target of malicious gossip because not only did she pursue other relationships, but she also continued her research and philanthropic activities: thus, in 1911 she received the Nobel Prize in Chemistry, and during the First World War she worked as a radiologist with wounded soldiers. It was precisely the radioactivity to which she was exposed that caused Marie Curie's death. But by then her discoveries, and her exemplary life, had set off a revolution – for medicine and for women.

Marie Curie in her laboratory around 1912. For a long time, the Polish scientist did her research with inadequate equipment. Nonetheless, in 1909 she organized at the Sorbonne the Institut du Radium – known today as the Institut Curie – a research center on radioactivity and its medical applications. In 1911 she won her second Nobel Prize but, as a woman, she was not admitted to the French Academy of Sciences.

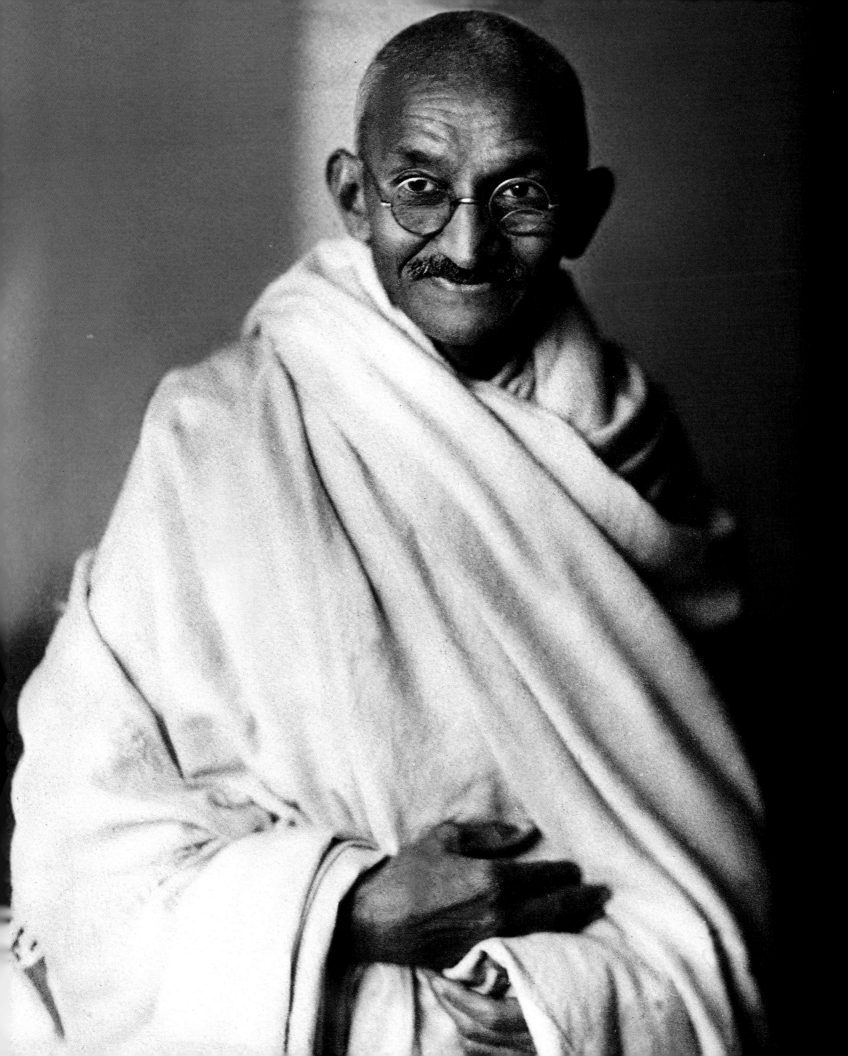

Gandhi

A hero of Indian independence and a model for the entire world, Mahatma Gandhi exemplified a new way of fighting for rights: through civil disobedience and non-violence. "It is the first article of my faith," he said, "and the last article of my creed."

In the life of Mohandas Karamchand Gandhi, his humble response to extreme adversity often revealed the extraordinary character of this frail man.

It was 1922 and Gandhi, the leader of the anti-colonialist movement, organized throughout India a boycott of British products. But in the city of Chauri Chaura, the mechanism of civil disobedience broke down: demonstrators and police fought, and more than 20 police officers were burned alive. The Mahatma – or "great soul," as his people already called him – stopped the protest, undertook a fast of penitence, and at the trial asked for the strongest sentence. He would spend two years in prison, to which he was no stranger: he had served sentences in South Africa, and still others in India, fighting for independence. In all, he'd spent more than six years in prison. But with every conviction he took the opportunity to spread the message of *satyagraha*, non-violent revolution. It is precisely this method of fighting for rights that make him a central figure in the 20th century: the day of his birth, October 2nd, a public holiday in India, has also been proclaimed the "International Day of Non-Violence" by the UN.

The son of merchants, with a law degree from University College of London, Gandhi was destined for a middle-class position and lifestyle. Then, in 1893, he was sent to South Africa on a legal case: in Durban, where there was a very large Indian community, he faced the reality of racial discrimination for the first time. He thus began his struggle for civil

Gandhi, 1940. One of the Mahatma's most controversial positions dates from this period. Faced with the outbreak of the Second World War, in a letter he urged the British people to respond to Nazi aggression with non-violence: "You will invite Herr Hitler and Signor Mussolini to take what they want of [. . .] your beautiful island, with your many beautiful buildings. You will give all these but neither your souls, nor your minds."

rights: he founded a party, the Natal Indian Congress, and a newspaper. He also started his first *ashram*, where he and others lived monastically, their days organized by agricultural work and prayer. It was in South Africa, as well, that Gandhi began successfully to put methods of "civil disobedience" into practice.

He returned to India in 1915. As President of the Congress Party, Gandhi became the reference point for the anti-colonial struggle. Their practice of *satyagraha* culminated, in 1930, with the Salt March: a walk of 240 miles, with thousands of participants protesting against the salt tax. For Indians, Gandhi was by then the Bapu – the father of the country. His main objective became the full independence of India. The *Quit India* movement was founded in 1942. Its demand to the colonial government was simple: the British had to leave the country. In spite of brutal repression, the movement achieved total success five years later: on August 15th, 1947, independence was proclaimed. But the ex-colony was divided, separating Hindu India from Muslim Pakistan. Thus began an enormous movement and transformation of the population, accompanied by bloody conflicts and disputes over the unresolved borders. Gandhi continued to personify the aspiration to justice of all Indians of every caste and religion; he fasted for peace, and mediated between conflicting groups. Meanwhile, more and more people in the world adopted his model of life: ascesis in the *ashrams*, the practice of chastity, poverty, silence, manual work, religious ecumenism, and above all non-violence, the way modeled by Gandhi for humanity. The utopia he might have imagined, however, was never achieved: the Mahatma died in 1948, assassinated by a fanatical nationalist.

Gandhi sits by his traditional spinning wheel in this famous photo from 1946 by Margaret Bourke-White. Before agreeing to pose for the American photographer, Gandhi apparently asked her to spin on the spinning wheel: it was a practice to which the Mahatma dedicated himself daily for at least an hour, even when he was abroad.

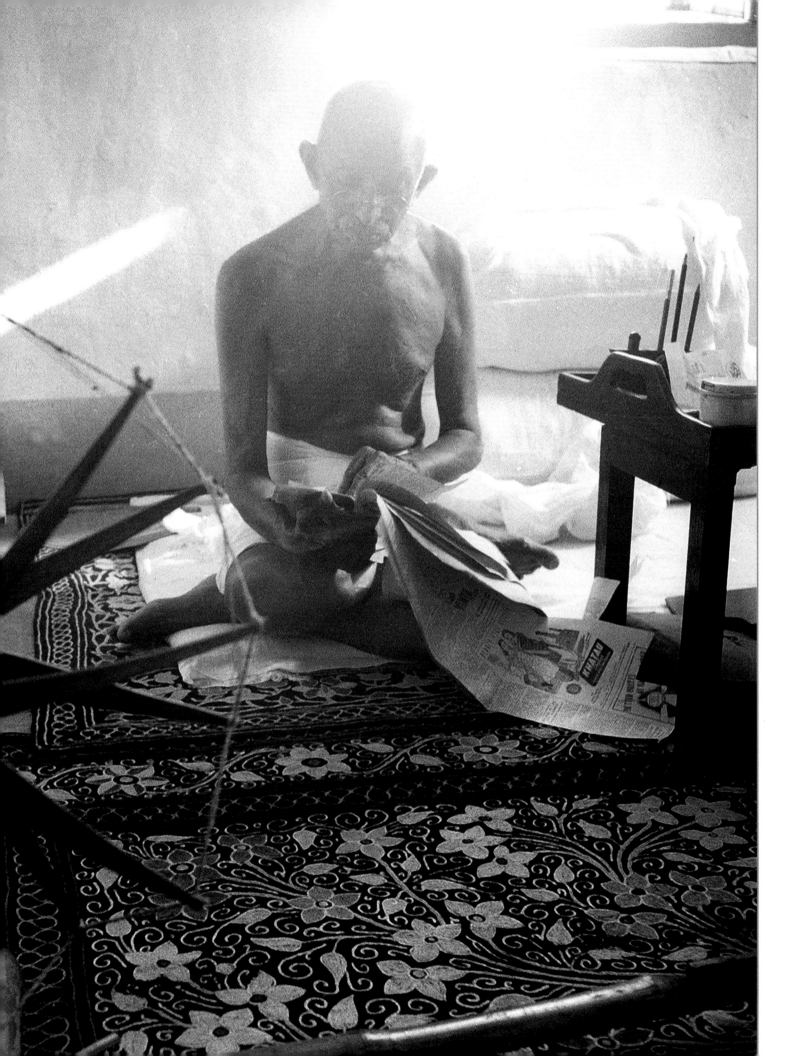

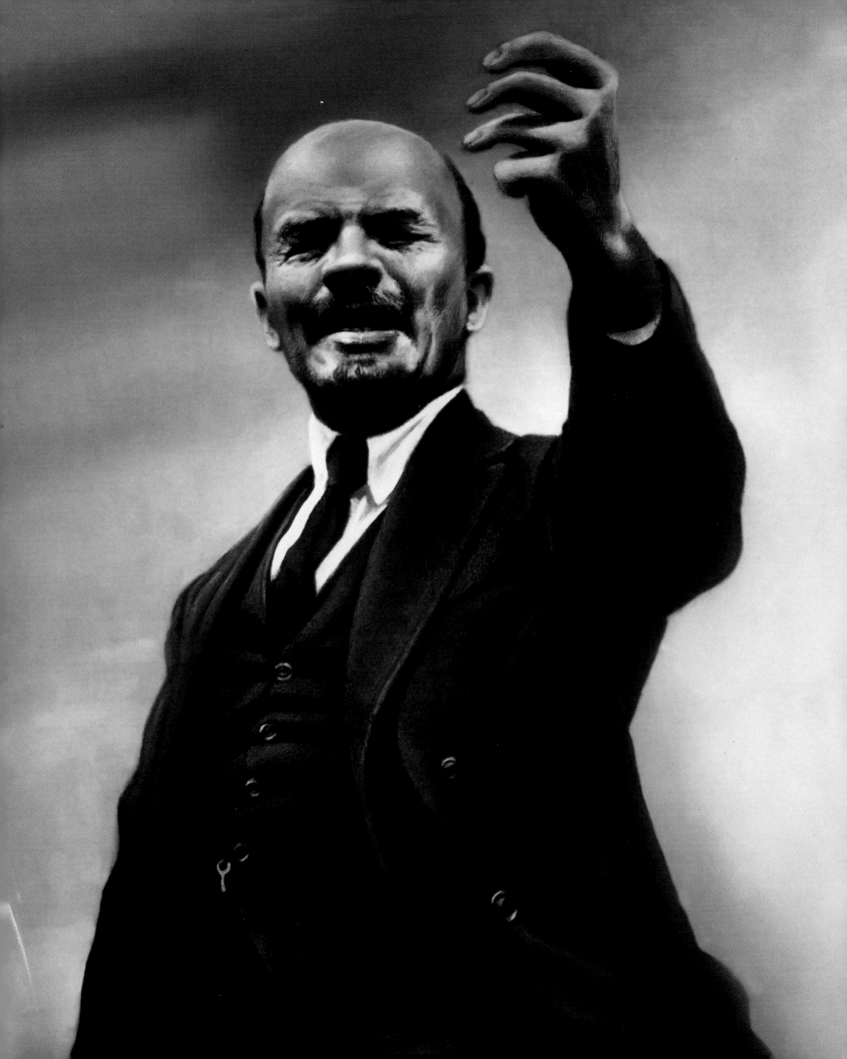

Vladimir Lenin

April 22nd, 1870, Simbirsk (later Ulyanovsk), Russian Empire • January 21st, 1924, Gorki (later Gorki Leninskiye), USSR

Vladimir Ilyich Ulyanov, known by all as Lenin, overthrew an apparently eternal monarchy and, strictly adhering to Marxist principles, modernized the economy of the largest country in the world.

In 1917, it was not a proletarian who led Russian peasants and workers in the October Revolution, but an intellectual, the lawyer Vladimir Ilyich Ulyanov, a man better known as Lenin. He was a committed Marxist, an extraordinary propagandist and a charismatic orator, a professional revolutionary whose political career, 30 years earlier, took a very precise turn. In 1887, in fact, his elder brother, Alexander, a socialist and libertarian, was executed for having taken part in an assassination attempt against Tsar Alexander III. Lenin was later expelled from the University of Kazan for his political activities, and, in 1893, he moved to Saint Petersburg. There, his involvement with the Russian Social Democratic Labour Party (RSDLP) drew the attention of the Tsarist police. He was undeterred by their threats, even following a sentence of 14 months in prison and three years' exile in Siberia. After his sentence, Lenin married Nadezhda Krupskaya, another banned revolutionary, and they took refuge in the West, in Germany and Switzerland, where he continued to write propagandistic essays and to be active in politics. In 1903, at the Congress of London, his revolutionary faction – the "Bolsheviks," that is in the majority – gained the leadership of the RSDLP. Lenin recognized the First World War as the event that would open the way to the revolution. He managed to return to Russia with the complicity of Germany, which in April, 1917, permitted the passage of an eastbound train. Hidden on this train were numerous anti-Tsarist intellectuals and political figures. Lenin's political program, in fact, envisaged Russia's leaving the war, and this was enough for the German government to allow him to return from exile.

Here Lenin is seen during a speech at the Third Congress of the Comintern (Communist International), held in Moscow in June and July of 1921. In Russia the Red Army is about to defeat the counterrevolutionary "Whites," consolidating the October Revolution. Lenin's aim is to incite revolution in other countries, coordinating the actions of various national Communist parties.

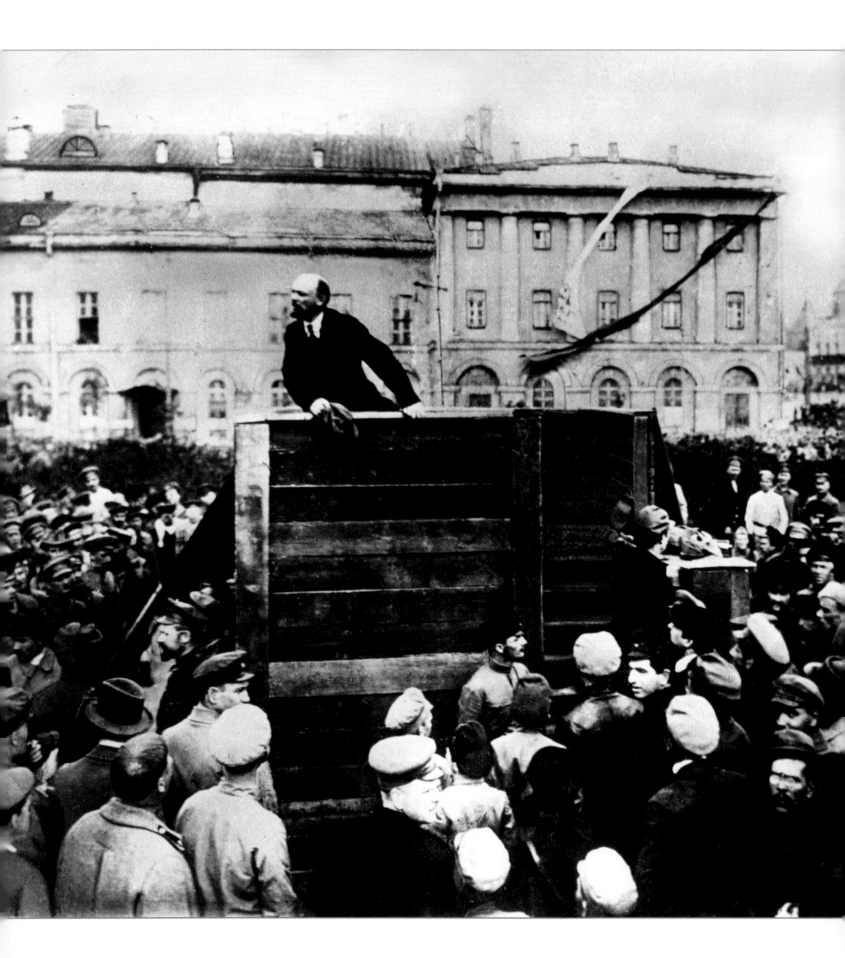

A few months before, the February Revolution had forced Nicholas II to abdicate. Lenin intended to overthrow the provisional government led by Alexander Kerensky, and to expel from the institutions the non-socialist parties – and the Mensheviks, the minority reformist faction of the RSDLP – in order to give power to the soviets, councils representing the workers and the peasants.

A disturbing chain of events followed. In the October Revolution, the Bolsheviks and Lenin took power. The Bolshevik RSDLP then transformed into the Communist Party and, in so doing, created a one-party socialist state. Land was redistributed to the peasants. The short-lived peace established by the treaty of Brest-Litovsk was followed by a death sentence for Nicholas II and his family, civil war, the rise of a political police force, and the Red Terror. The propagation of the revolution to the outlying territories of the ex-Russian Empire would result, in 1922, in the birth of the immense Soviet Union. Lenin presided over all of these events. However, quite ill for a long time, and as if the role that History had entrusted to him had been consumed, he died a little more than a year later, in 1924. We read in one of his last letters: "Comrade Stalin [. . .] has concentrated immense power and I am not sure that he always knows how to use it with sufficient prudence." Sadly, his words would be confirmed by what happened to the USSR – and even to Lenin's body, which was transformed into a relic in spite of Lenin's being against personality cults. With Stalin, the contradictions of the Revolution would assume tragic proportions.

On May 5th, 1920, Lenin encourages the Red Army with a passionate speech in the heart of Moscow. The makeshift stage emphasizes the closeness of the leader and soldiers, who are engaged both in a civil war and in a war against Poland (1919-21). In the original shot, on Lenin's left stood Trotsky and Kamenev too. They were erased from all later prints of this photograph after being disgraced under Stalin.

Guglielmo Marconi

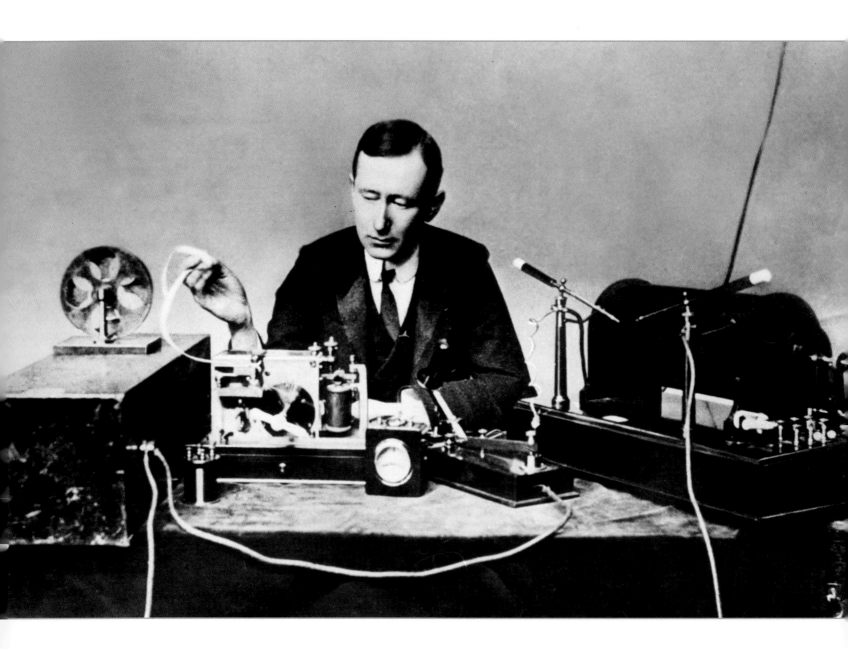

In the first months of 1903, Marconi was in South Wellfleet (Cape Cod, Massachusetts), where he had just opened a wireless-telegraph station by sending a message from President Theodore Roosevelt to King Edward VII. Here the inventor shows the journalist Lawrence Perry how the wireless telegraph is able to receive and send messages across the ocean.

"The efforts of my life have laid a solid foundation on which future generations will continue to build." Thus spoke the man who patented the wireless telegraph. His invention, it was immediately recognized, marked the beginning of an era: that of wireless telecommunications, from the S.O.S. to the text message.

It was like one of those now famous garages in Silicon Valley in the early 1990s: he built it in his bedroom. It was 1894. Who could have imagined that the young man busy with batteries, bells and metal sheets would succeed in transmitting a message across the Atlantic by way of electromagnetic waves? Certainly not the Italian Ministry of Postal services, whom the young man, Guglielmo Marconi, had asked for finance. His letter was set aside, apparently with a note recommending he apply to the Rome lunatic asylum. And yet Marconi firmly believed that it was possible to use electromagnetic waves – a phenomenon already examined and described by Maxwell and Hertz – to communicate over great distances. He placed antennas as high up as he could, in order to avoid obstacles between the generator and the receiver of the waves. In 1895, he received a signal from a distance of about 1.5 miles. Success was within reach. Marconi's Irish mother suggested he transfer to England. In London, he registered his patent for the wireless telegraph.

On December 12th, 1901, five years after the registration of his invention, three dots, corresponding to the letter S in the Morse Code, traveled 2100 miles from Poldhu, in Cornwall, to Newfoundland: it was the crowning point of the work by the inventor and his Wireless Telegraph Trading Signal Company. It was the beginning of a new era for telecommunications, which up to that point had used networks of copper wire.

The first transmission of the human voice, however, would not happen for nearly another twenty years, in 1919. Meanwhile, Marconi was awarded the Nobel Prize in Physics (in 1909, together with Carl Ferdinand Braun) and the use of his invention in sea rescues made it possible to save thousands of lives, including those of 705 passengers from the Titanic. 1912, the year the Titanic sank, was an unlucky year for Marconi: he lost an eye in a car accident. But it took more than that to stop him. In the following decades he received many awards and honors, and achieved many successes, until, finally, he became an idol of fascist Italy, an exemplary citizen for the regime.

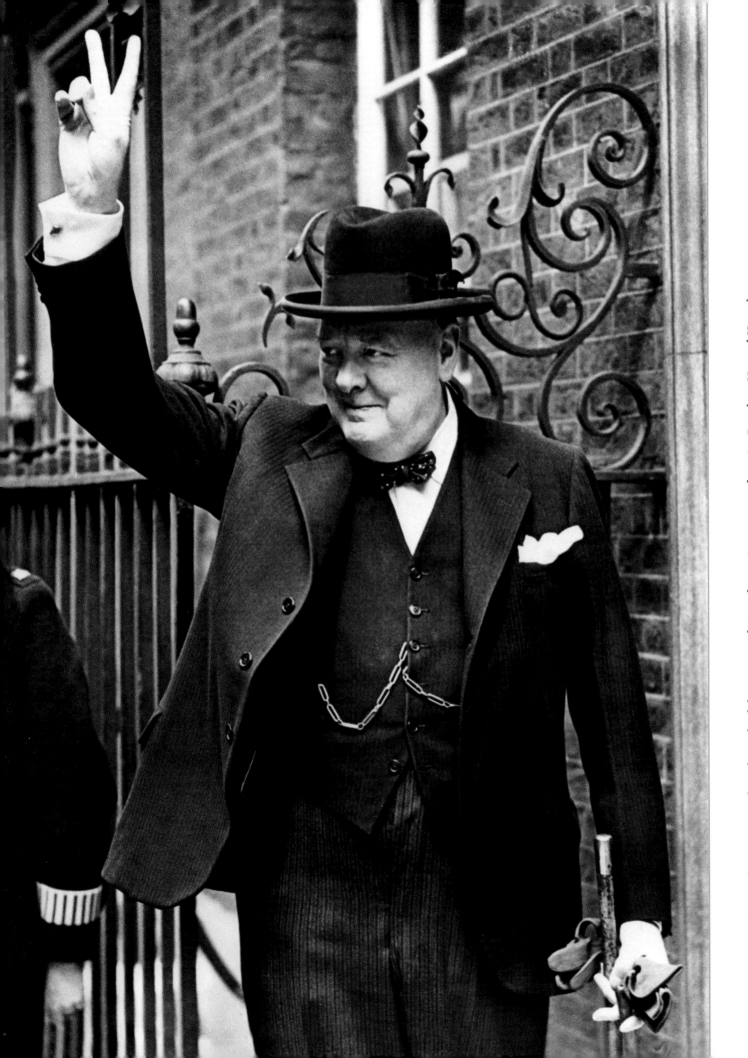

November, 30th, 1874, Woodstock, Oxfordshire, United Kingdom • January 24th, 1965, London, United Kingdom

Winston Churchill

He symbolized the resistance of democracy to the bloodthirsty designs of Adolf Hitler; he carried the United Kingdom on his shoulders and kept it standing, proudly, even as Luftwaffe bombs rained down on London.

The whole life of Sir Winston Leonard Spencer-Churchill is often seen through the frame of the five years in which he led the United Kingdom to victory over Nazi Germany: from May 10th, 1940, when he succeeded the hesitant Neville Chamberlain as Prime Minister, to July 26th, 1945, when he was replaced by Clement Attlee. In reality, before and after the Second World War, Churchill was the protagonist of events that alone would have been enough to make his an extraordinary life.

He was born into one of the most illustrious families of the British aristocracy and, in spite of a marked preference for writing, was launched by his father on an officer's career. While still very young, he obtained the role of military observer, allowing him to travel and collaborate with the British press: as a correspondent in Cuba for the *Daily Graphic*, he documented the events of the 1895 War of Independence. Then, as an officer – and also as a correspondent – he took part in the colonial wars fought by the British army in Pakistan and in Sudan. In South Africa, during the Second Boer War, he was captured and held in a concentration camp, but he managed an adventurous escape.

At only 26, he had enough knowledge of men and of the world to allow him to face the snares of politics. As a "public man" he wasted no time: Member of Parliament (for the Conservatives, for the Liberals, and then again for the Conservatives), Secretary of State for the Colonies, President of the Board of Trade, and then, in 1910, Home Secretary.

Leaving 10, Downing Street, in June, 1943, Churchill makes the "V for Victory." The Prime Minister adopted the gesture from 1941 to the end of the war to encourage both the British and the people across the Channel attacked by the Nazis. In fact, in French the noun "victory" begins with a "v," while in the Netherlands the letter was understood as the symbol for *vrijheid,* i.e. "freedom."

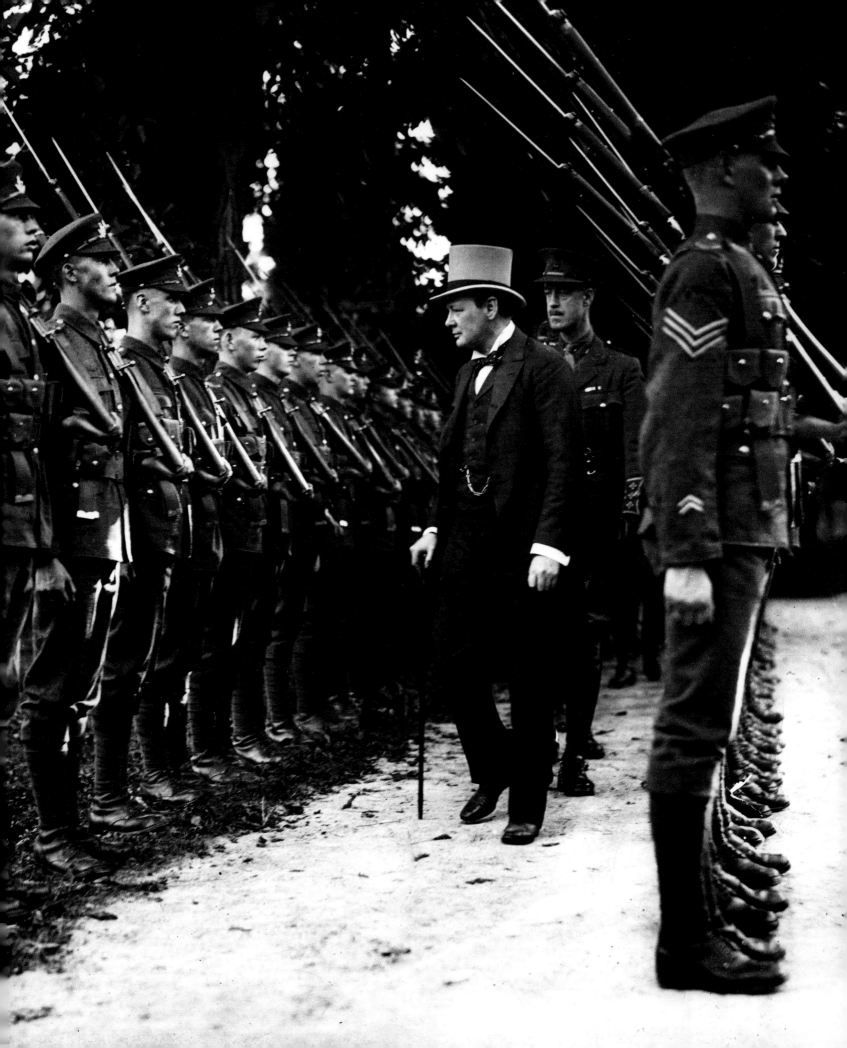

As First Lord of the Admiralty and Minister of Munitions, he was among the first to sense the importance of the adaptation of the army and navy to the new technologies, making an important contribution to the victory of the United Kingdom in the First World War. Then, with Europe in flames once again, came the role of premier.

Not even searing defeat, in the elections of 1945, could stop him. Churchill could read international politics better than anyone else: in March, 1946, it was he who coined the phrase "Iron Curtain" to portray the condition of Europe divided between two blocs.

48 June, 1919. Churchill had been Secretary of State for War since January, after being Minister of Munitions. Here he is reviewing a unit of the British occupying forces in Germany, defeated in the First World War. Around this time, the Treaty of Versailles is signed in France.

49 Between October, 1899, and mid-1900, Churchill was in South Africa as a war correspondent: *The Morning Post* had hired him to report on the Second Boer War. Here he is in the Bloemfontein camp. After being taken prisoner by the Boer army, Churchill managed to escape. He fled in secret to what is today Mozambique, about 300 miles away.

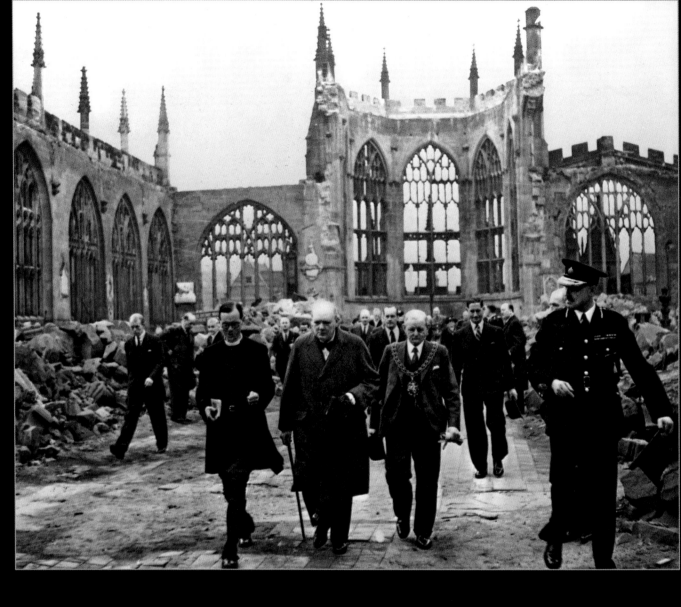

Before he died, he managed again to head the government, from 1951 to 1955. And he even succeeded in winning the Nobel Prize for Literature in 1953, for his historical writings.

These successes show us how capable, courageous and determined Churchill was. But they do not tell us of his private difficulties – he suffered from depression – or the contradictions of his inflexibility. In a position of power, Churchill responded harshly to strikes and public protests; more infamously, when Germany was already defeated, he ordered the devastating bombardment of Dresden in response to the destruction of British cities by the Luftwaffe. The bombing of Dresden was an attack against harmless civilians, and though he was a gentleman trained at war, in this decision Churchill's desire for revenge prevailed over the code of honor.

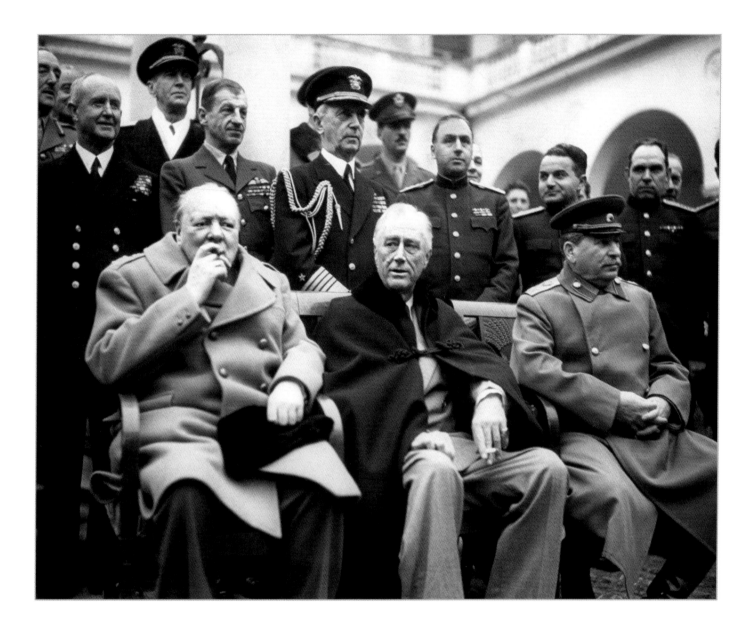

50 On September 28th, 1941, Winston Churchill visits the ruins of Coventry Cathedral, which was destroyed with much of the city by the terrible German bombardments. The destruction of Coventry was the origin of the German verb *koventrisieren*, i.e. to carpet-bomb a city in order to raze it to the ground. In February, 1945, to avenge the attack on Coventry, the Royal Air Force and the U.S. Air Force destroyed Dresden. Today the two cities are twinned.

51 February, 1945. Churchill, Roosevelt, and Stalin meet at the Yalta Conference. Victory over the Axis powers is near. The tired but satisfied British Prime Minister has agreed with the leaders of the USA and USSR on how to conclude the war. They have also drafted guidelines for the international order that will be established in the coming years. This includes the founding of the United Nations.

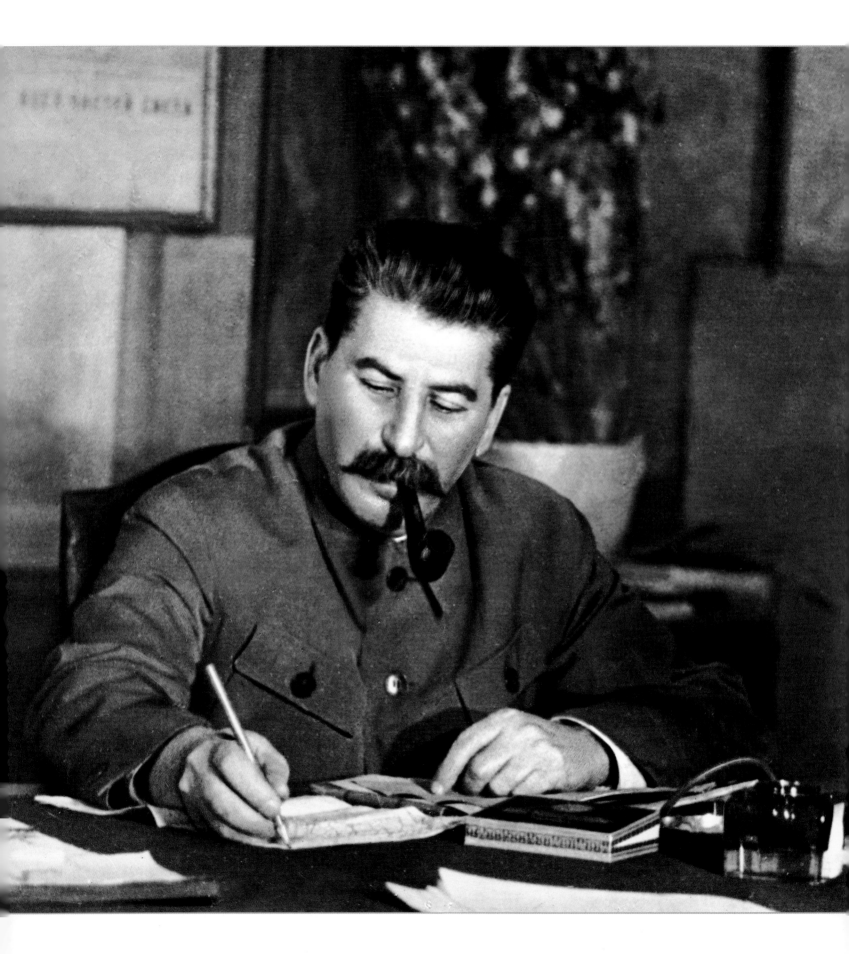

Joseph Stalin

For thirty years, Stalin was the controlling father figure of the Soviet Union, a ruthless dictator nonetheless loved by his people. Capable of defeating Hitler, Stalin also sent many old comrades to their death.

From Gori, an obscure town in Georgia, which at the time was part of the Russian Empire, Stalin rose to the highest position in the Kremlin. There he remained, practically omnipotent, for more than thirty years. He was venerated by the people but feared by anyone who had to deal with him. Because behind his thick moustache and good-natured mask, Iosif Dzhugashvili hid a heart harder than steel: in fact, they called him "the man of steel," or *Stalin*, in Russian. It was a nickname that gradually replaced his *nom de guerre*, Koba, which he used in his youth as a member of the political underground. After deserting an Orthodox seminary, Joseph realized that he was a restless socialist and enrolled in the RSDLP (Russian Social Democratic Labour Party), later joining Lenin's Bolsheviks. In spite of some physical problems (a semi-paralyzed left arm and a slight limp, which were caused by two childhood accidents), he repeatedly challenged the Tsarist police, planning insurrections and taking part in bank robberies to finance political activity. Imprisoned and exiled to Siberia several times, Stalin not only escaped, he remained so committed to Lenin's political vision that he was elected a member of the Central Committee of the Party as early as 1912.

Stalin's rise began precisely in the shadow of the Bolshevik leader, who had come back to Russia after the 1917 February Revolution. He remained in the background during the October Revolution, but in the Civil War he came into outright conflict with Leon Trotsky. He was a skilled organizer who was hard and unscrupulous, and he succeeded in acquiring more power by favoring the bureaucratization of the Party: in 1922 he was appointed General Secretary, a position that two years later was his springboard to receive the legacy of Lenin, who, however, preferred Trotsky.

The pipe and the pen are two recurring motifs in official photos of Stalin: in this way, the Soviet leader appears calm and reflective, always diligently at work for the good of the USSR. Today, his pipe and pen, with other memorabilia, are on display in the Joseph Stalin Museum in Gori, Georgia.

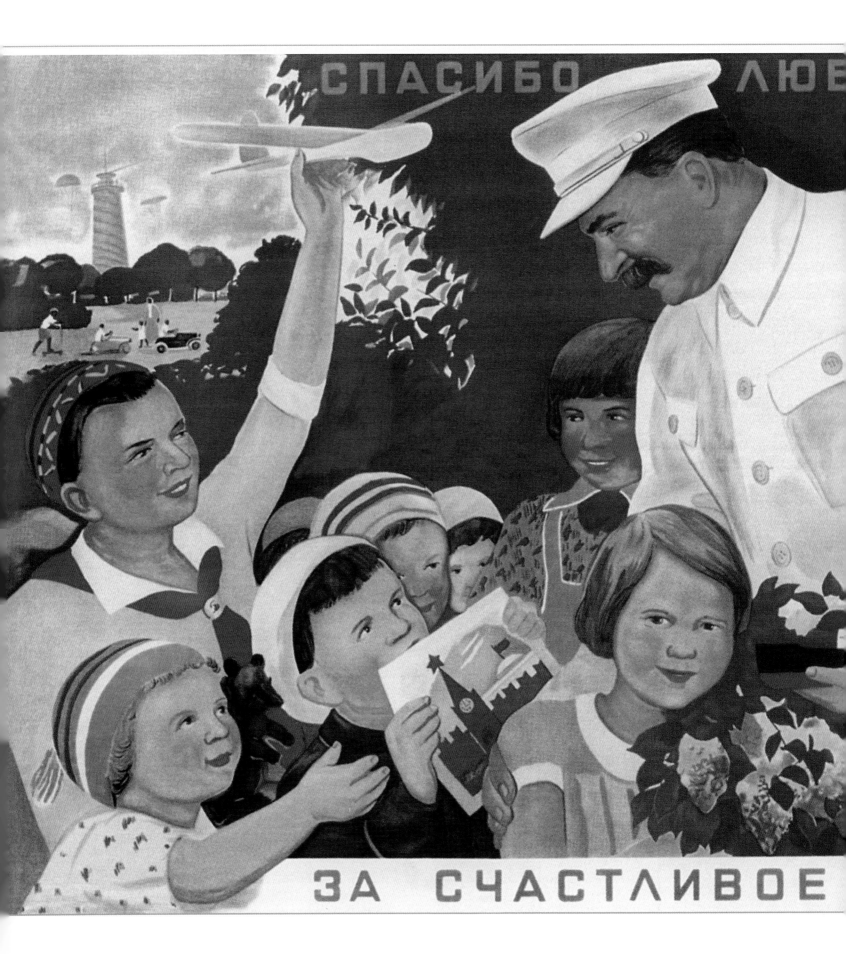

СПАСИБО ЛЮ

ЗА СЧАСТЛИВОЕ

Stalin immediately eliminated anyone who might put him in the shade: there began an endless series of show trials of the Bolshevik old guard and of real or presumed political opponents. These ended in notorious "purges" – executions and sentences to long periods of "re-education" in Siberia. Under what was soon revealed to be a dictatorship, there was no room for those who did not agree to his plans for industrialization and land collectivization, or for those who opposed the gigantic internal migration directed by Moscow in order to create new cities and populate uncultivated lands. The people who endured famine, brought about by strategic decisions of Stalin himself, had no right to speak. It is estimated that between 1930 and 1953, 700,000 death sentences were carried out, an incredibly high, unbearable price to pay, even while recognizing the enormous strides made by the USSR, which transformed in that period from a fragile, illiterate country into a superpower. It is high even when it is set against the victory of the Red Army over Nazi Germany, which was mainly the consequence of Stalin's charisma, and which changed the Second World War, in Russian eyes, into the epic "Great Patriotic War." More than any other achievement, this victory made the face of the dictator a timeless icon, the embodiment of the pride of Mother Russia. So unimpeachable was Stalin's reputation that veneration of the man survived even the 1956 denunciation of Stalinist crimes by his successor, Nikita Khrushchev.

For Soviet propaganda, Stalin was the "little father of the peoples," generous and smiling. On this poster, he appears surrounded by children wishing to thank him (as the words in Cyrillic characters say) for the happy childhood his leadership has granted them. While they embrace Stalin, the children hold up to him a picture of the Kremlin and two symbols of modernization in the USSR, a ship and an airplane.

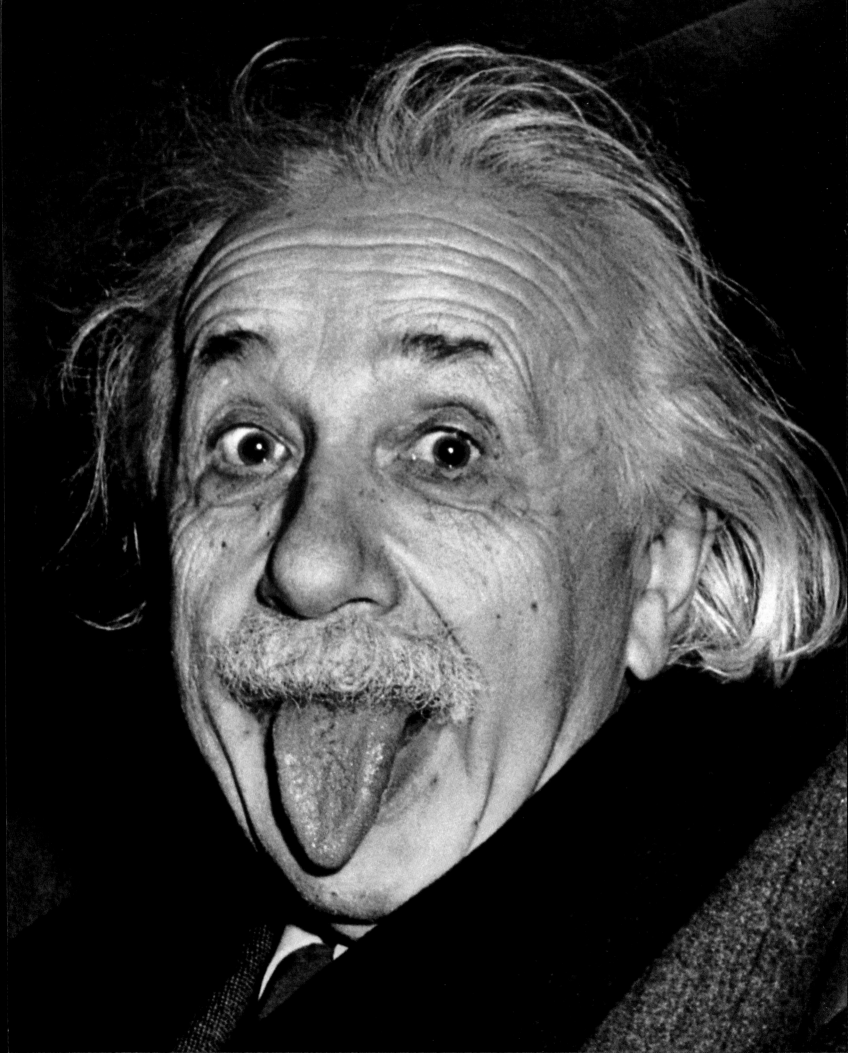

Albert Einstein

The genius *par excellence*: Einstein was not only one of the greatest and most important scientists ever, he was also an extraordinarily popular figure. He was authoritative, eccentric, committed, and provocative.

If you happened to be strolling about Princeton University in the early 1950s, you might have bumped into a rather eccentric individual. He had uncombed hair, an unkempt moustache, and shabby clothes, and he'd show up at the oddest times. But the man, Albert Einstein, was a genius, and by then he was famous not only at Princeton, but throughout the world. In 1921 he was awarded the Nobel Prize in physics for work he did, in 1905, on the photoelectric effect, even if he was already famous for the theory of relativity. He came up with a little formula that explains the universe: $E=mc^2$, or, energy is equal to mass multiplied by the square of the speed of light. Einstein, however, was not only an immensely important scientist. He was a beacon of culture, and active in philosophy and politics. Being a Jew who fled Nazi Germany, he was committed to civil rights and peace, against nuclear arms (which, however, he had more or less directly contributed to creating). In 1952 he refused the presidency of the state of Israel: he preferred to play the violin, and apparently he did it extremely well. He enjoyed a fame that went beyond borders, and his name and face were familiar even to those who had never heard of Physics. This was partly due to his ironic, extremely human, attitude about life, which led him to give answers which floored interviewers or to put his tongue out in photographs. Indeed, Einstein always resisted impositions and constrictions, right from his earliest years in school. Free in the spirit – and also in the heart, as his numerous extramarital affairs can testify – he probably enjoyed the idea that his appearance became the stereotype of the "mad scientist." No one knew better than Einstein that one needs a little madness to think outside the box, and that intelligence is alive, indefinable, and mysterious, and may assume unpredictable forms. This is not to offend the pathologist who, during the autopsy, took out Einstein's brain to analyze it, deluding himself that he could discover the secret of genius under the microscope.

In 1951 Albert Einstein turned 72 years old. After receiving many requests from the press for a birthday photo, Einstein finally faced the photographers and sarcastically stuck out his tongue. This photo, by Arthur Sasse, would become the most famous portrait of the scientist. Apparently Einstein himself liked it so much that he sent it as a greeting card to his friends.

March 14th, 1879, Ulm, Germany • April 18th, 1955, Princeton, New Jersey, United States

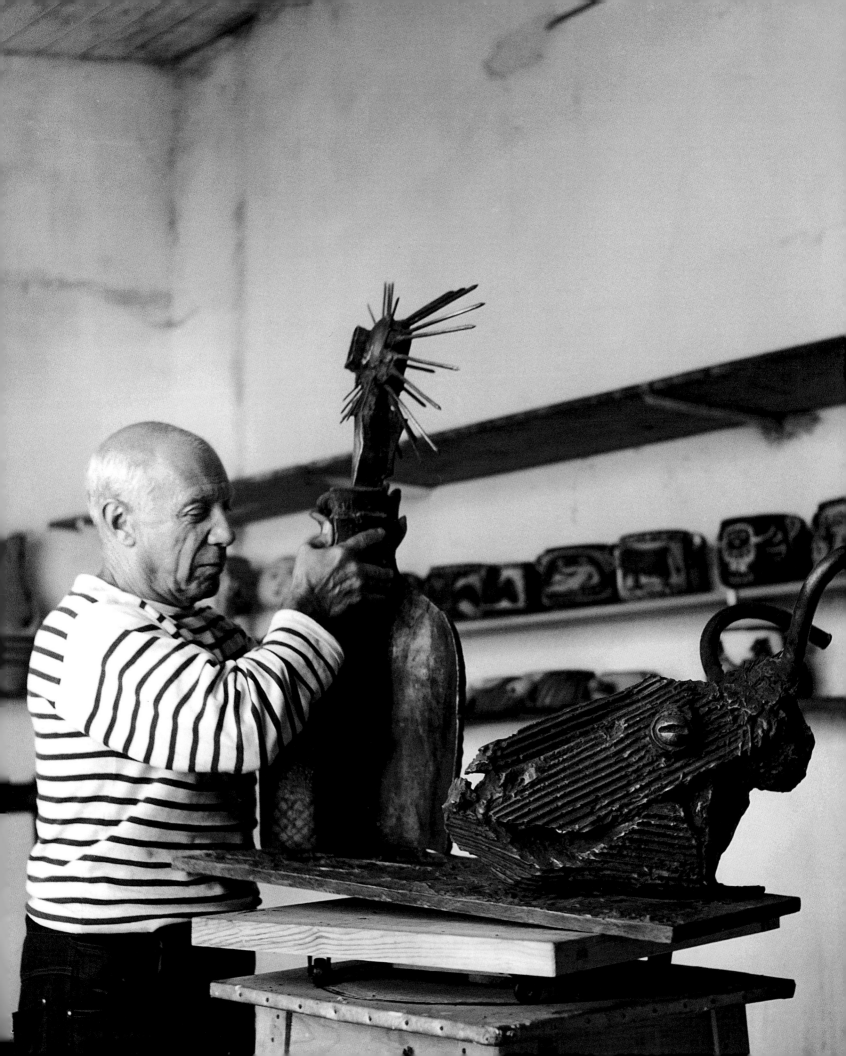

Pablo Picasso

If we think of revolutionaries in art in the 20th century, the first name that comes to mind is his: Pablo Picasso, the father of Cubism, exemplar for all of the avant-garde.

When Pablo Ruiz y Picasso arrived in Paris for first time, he found it festively decorated: the vertical marvel of the Eiffel Tower, the horizontal elegance of the metro, and the Gare d'Orsay, the Gare de Lyon and the Grand Palais, all freshly opened. It was a special occasion: the 1900 World's Fair. A little of that dazzling light was reflected onto Picasso, who had arrived from Barcelona to exhibit a painting in the Spanish pavilion. At 19, he had already gone beyond his father, José Ruiz, an art master, and was fairly well known in Spain. But Pablo immediately realized that the prestige of a painter could only be measured there, in Paris, among the cabarets and museums of the *Ville Lumière*, and that it was the moment to grow up: from *enfant prodige* to true artist. His metamorphosis was marked by mourning. It was in Paris, in fact, that his dearest friend, Carlos Casagemas, committed suicide in 1901. And Picasso – who decided to drop his paternal surname Ruiz – reacted by transforming his anguish into the paintings of the Blue Period: beggars, blind people, musicians, and sad Harlequins. This was followed by the acrobats and naive boys of the Rose Period. For others painters, these masterpieces would have been the culmination. But in 1906 Pablo Picasso was only 25, and he had no intention of stopping.

Here there began another story, one in which Picasso showed he was much more than a painter. He was a visionary genius, capable of taking Western art upon his shoulders and carrying it into the 20th century. A magnetic man, he could also be devastating. (Two of his women, Marie-Thérèse Walter and Jacqueline Roque, committed suicide; his partner, Dora Maar ended up in a psychiatric clinic.)

Picasso beside his sculpture, *Goat Skull, Bottle, and Candle* in 1952. The sculpture was created from a host of found materials: Picasso used the handlebars of a bicycle to represent the goat's horns, and the heads of large bolts form its eyes. Nails are used for the tufts between its ears and for the rays of light emanating from the candle.

October 25th, 1881, Malaga, Spain • April 8th, 1973, Mougins, France

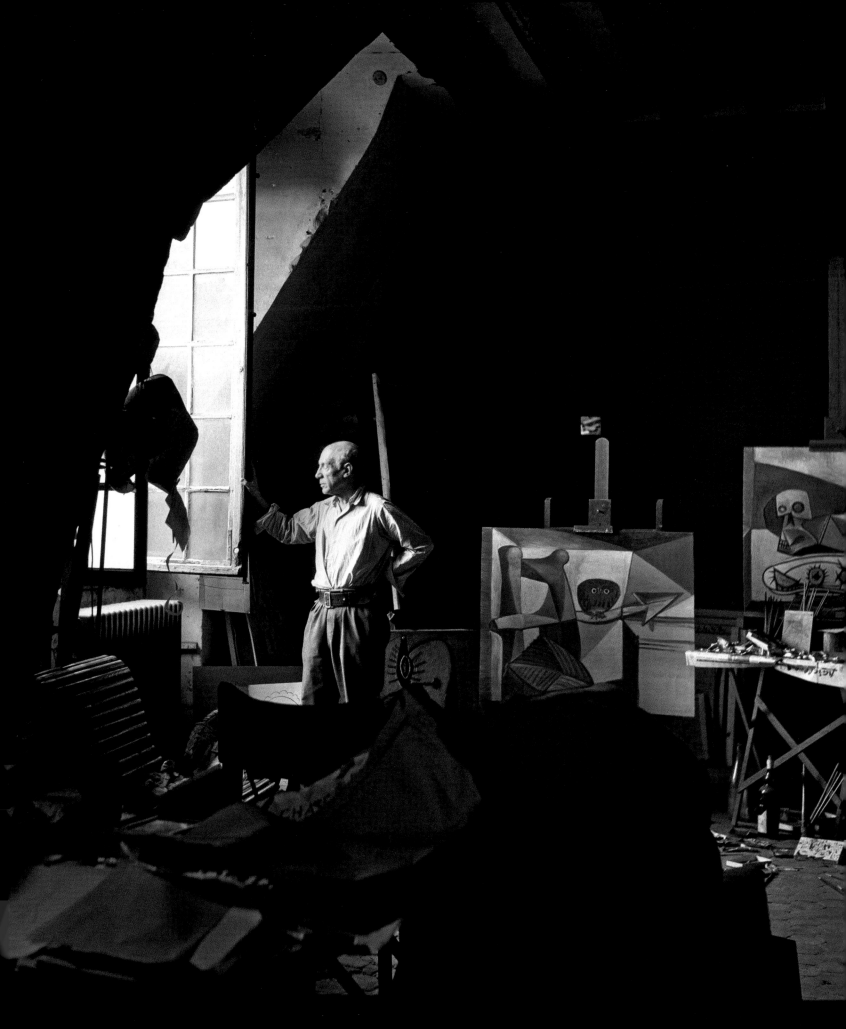

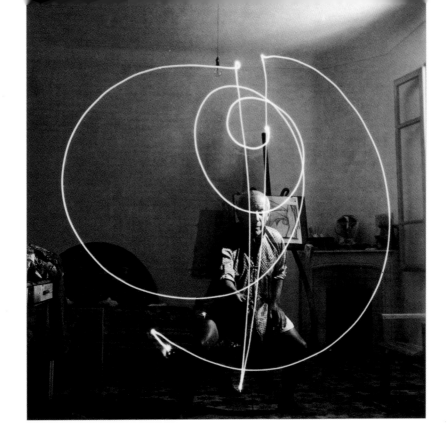

The key year was 1907, when he painted *Les demoiselles d'Avignon*, which incorporated extra-European influences and African accents. Depth and volumes disappeared, and the painting rebelled against the rules of perspective and, above all, against the "obligation" to copy reality. Faces and objects, expressed in the bi-dimensionality of the canvas, seemed to explode. This was Cubism. Together with Georges Braque, Picasso was its father and highest interpreter. He'd go on to present it in a thousand ways, gaining fame that went beyond the limits of the art world. Because Picasso was an excellent self-manager, and capable of ending the careers of potential competitors, he was destined to achieve an unrivalled success: "My mother said to me, 'If you are a soldier, you will become a general. If you are a monk, you will become the Pope.' Instead, I was a painter, and became Picasso."

60 The painter in his Paris studio, at 7 Rue des Grands-Augustins, where he painted *Guernica* in 1937. A century before, Balzac used the same address in *Le Chef-d'œuvre inconnu* for the *atelier* of his protagonist. The photo is from 1948, the year in which Paul Haesaerts made the documentary *Van Renoir tot Picasso*, which portrayed Picasso's ascent to the summit of the art world.

61 In 1949, the photographer-engineer Gjon Mili, who worked for *LIFE*, showed Picasso some photos taken with an electronic flash and stroboscopic technique. Picasso immediately understood its potential: holding a small electric light (perhaps a simple flashlight) he began to "paint" in the air for the camera. The result was magical, a series of illuminated drawings that seemed to float in the air.

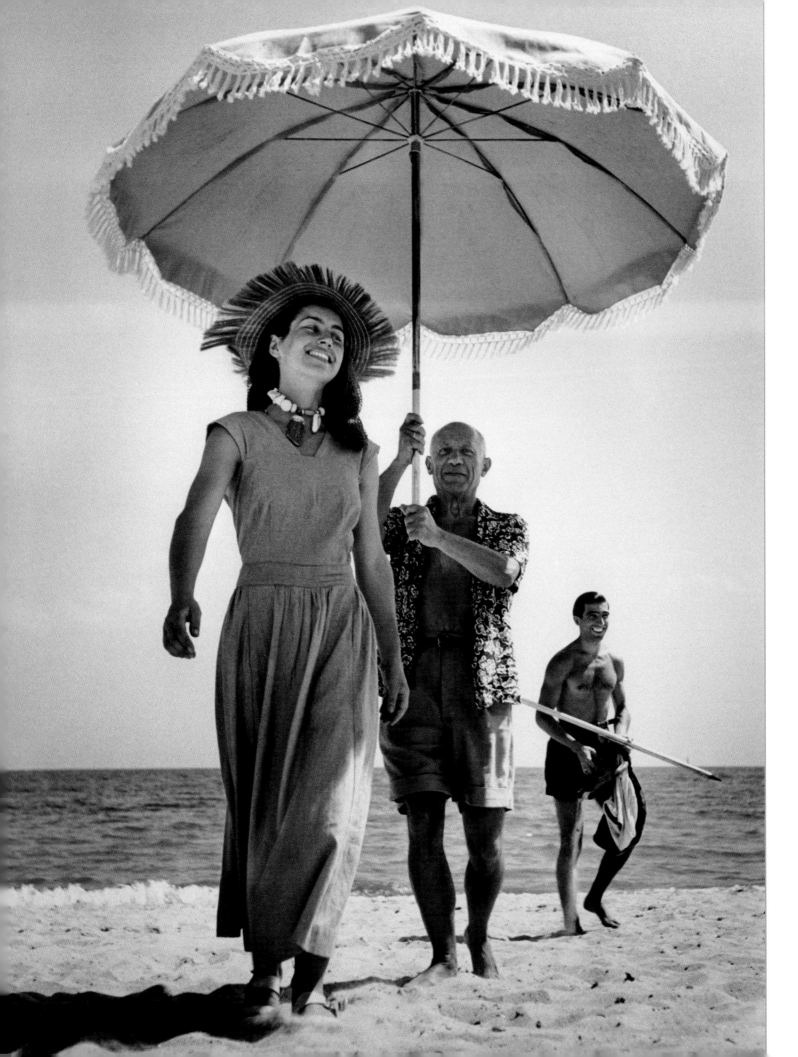

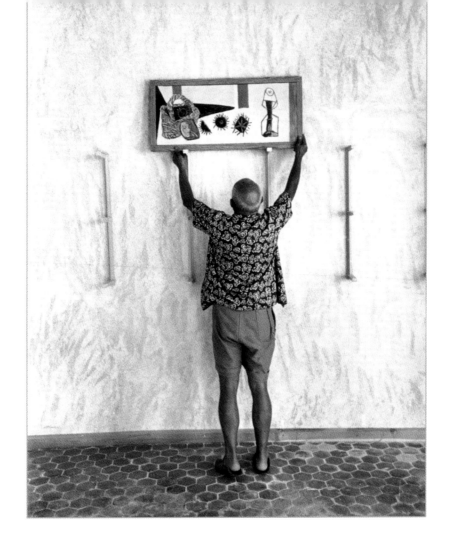

In the meantime, he also revolutionized sculpture, assembling objects found more or less by chance. He reinvigorated society's understanding of the artist, presenting himself as an aware, modern, committed intellectual. It is enough to mention *Guernica*, the painting that denounces the atrocities of the German-Italian bombing during the Spanish Civil War, or the *Dove of peace* of 1949. Even at an advanced age, in his *buen retiro* on the Côte d'Azur, he continued to work with the enthusiasm of a young man. This longevity should not surprise us, considering one of his most famous sayings: "It took me four years to paint like Raphael, but a lifetime to paint like a child."

62 August, 1948. Robert Capa joined Picasso and his family on the beach of Golfe-Juan, Côte d'Azur, and took a photo which would become very famous: the artist holds an umbrella over his partner, Françoise Gilot, while Javier Vilato Ruiz, his nephew, smiles in amusement.

63 In this Robert Capa photograph from 1948, Picasso puts up one of his works in the Château Grimaldi, in Antibes. Two years earlier, the artist had set up his *atelier* for a few months in the same building. In gratitude, he left the castle many drawings and paintings. Since 1956, the Grimaldi Museum has been the Musée Pablo Picasso: the first in the world dedicated to the Spanish master.

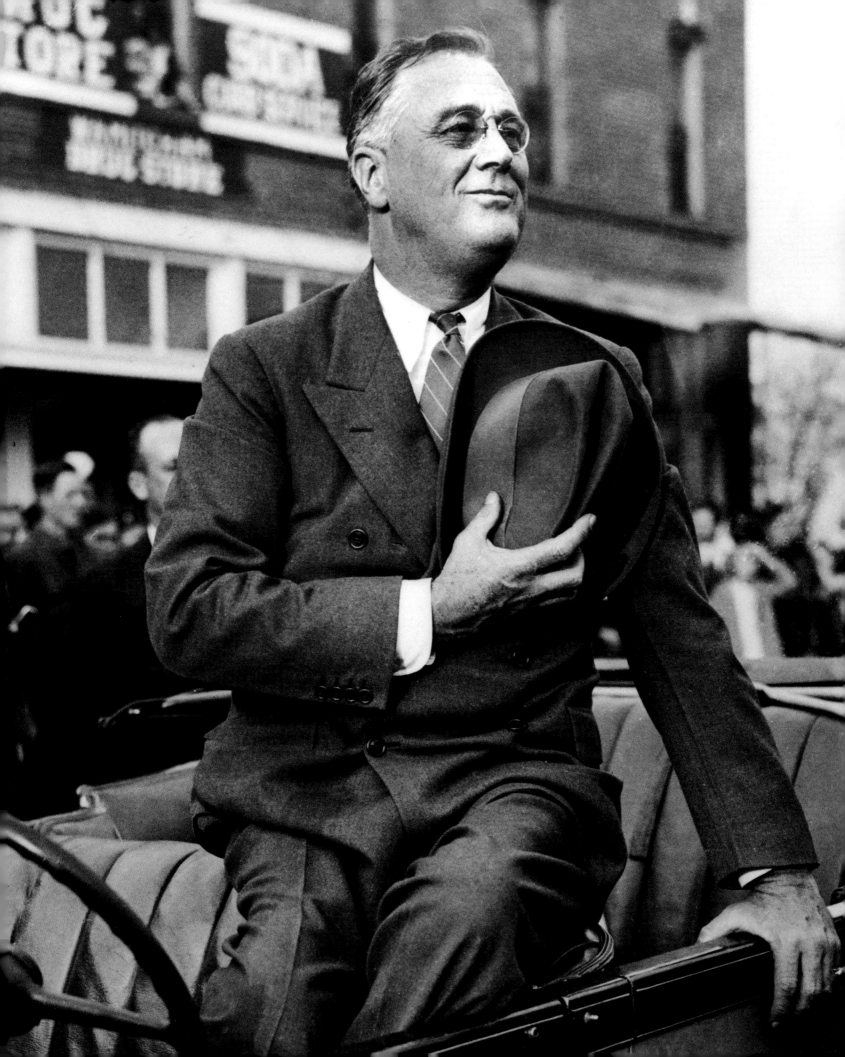

Franklin Delano Roosevelt

January 30th, 1882, Hyde Park, New York, United States • April 12th, 1945, Warm Springs, Georgia, United States

He was a man convinced that without work there could be no democracy. This president, confined to a wheelchair, led the United States out of the worst economic crisis in history, and led the country to victory in the Second World War.

His political longevity was incredible. He won four presidential elections, and served 12 consecutive years in the White House during the most difficult period of the 20th century. He did all of this while surviving an assassination attempt, in 1933, and despite his illness – perhaps poliomyelitis, perhaps Guillain-Barré syndrome – which he contracted at 39, disabling him in his legs but making him all the more determined.

He was a born fighter: while in private he used a wheelchair, in public Roosevelt tried to play down his handicap by using crutches, leg braces, even an orthopedic corset. And he drove his own Ford, which was equipped with modified controls.

He grew up in a family of the upper middle class, and chose a political rather than a legal career, registering with the Democratic Party in 1910. His baptism of fire was the Wall Street Crash in 1929, which he faced as Governor of the State of New York, with his wife Eleanor at his side: she was an extraordinary figure, his first advisor, a feminist, and committed to civil rights. While the United States was entering the most dramatic economic crisis in its history, Roosevelt gained popularity by measures to help the unemployed, reducing the costs of public services and giving aid to families with problems. These policies earned him the Democratic candidacy and then victory in the presidential election of 1932.

Franklin Delano Roosevelt takes off his hat to the Stars and Stripes during a parade. The photograph is from around 1938, during the prosecution of the so-called "second New Deal," undertaken during Roosevelt's first term. In fact, many of the hardships of the 1930s Great Depression were overcome by means of the President's innovative economic policies.

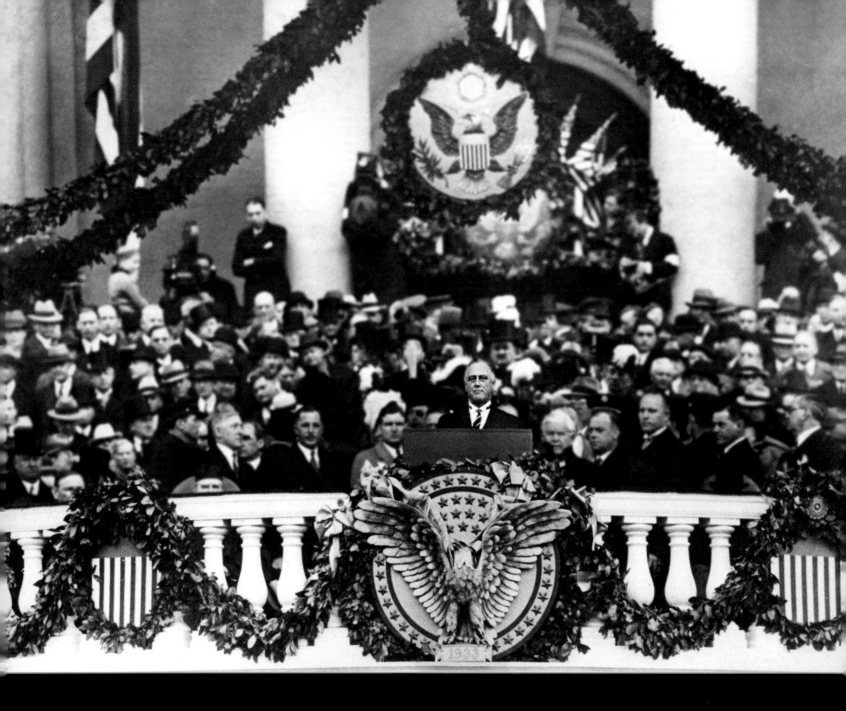

On March 4th, 1933, Roosevelt made his inauguration speech as 32nd President of the United States, while the country was experiencing a dramatic economic crisis. On that occasion, he declared: "This great nation will endure as it has endured, will revive and will prosper. So, first

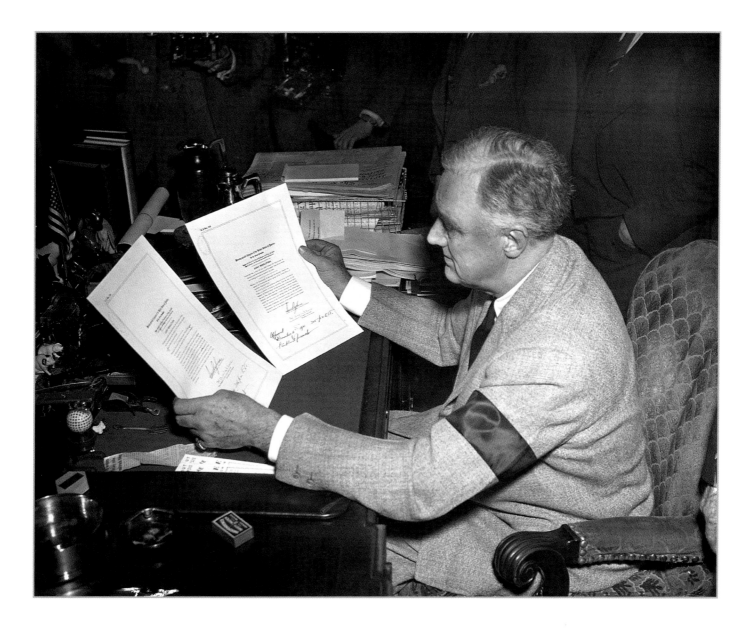

President Roosevelt, in his study, examines the declarations of war of December 11th, 1941, against Germany and Italy. After receiving unanimous consent from both houses of Congress, the resolutions await the President's signature. During the war, almost 300,000 US soldiers will die and about 670,000 will be wounded.

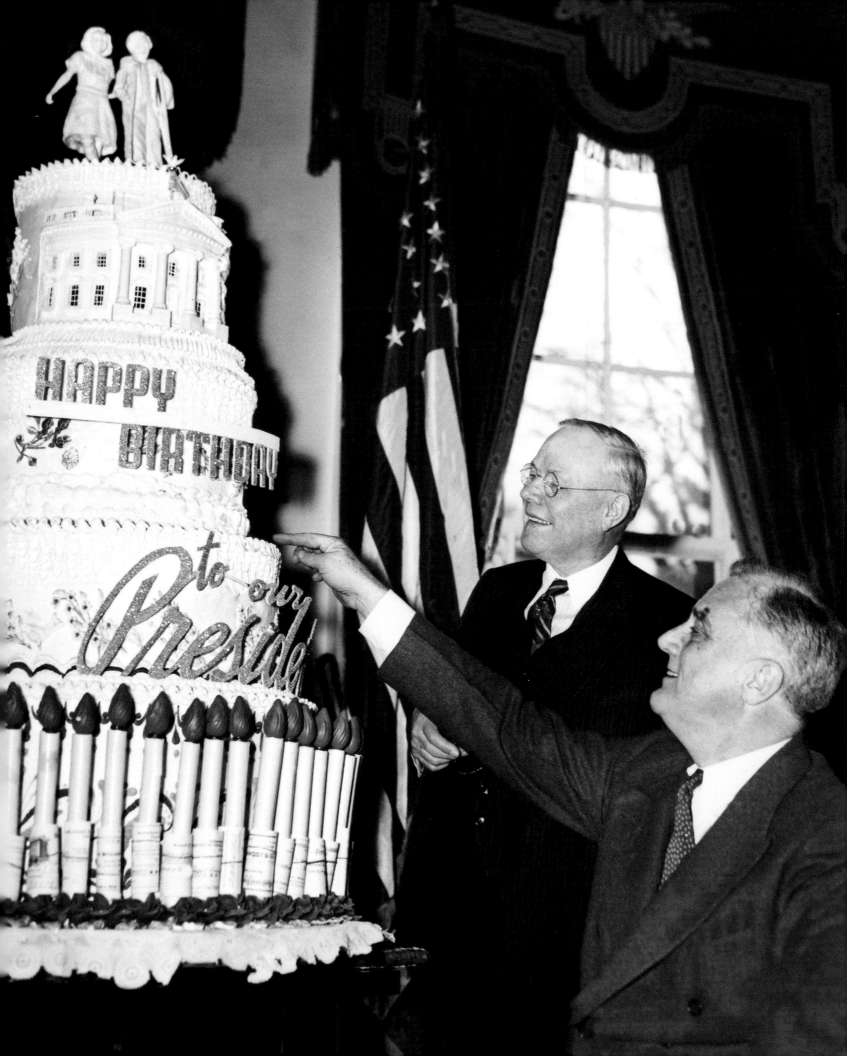

Meanwhile, the Great Depression continued to claim more victims. In the cities, millions of unemployed wandered in search of non-existent jobs, while in the countryside the crops could not be sold. Banks failed one after another, destroying the savings and hopes of millions of people. Roosevelt managed to realize what he had promised in the election campaign by implementing what he called the New Deal. It was a legislative and cultural revolution: the New Deal increased taxes on the wealthy, provided new controls on the banks and on public offices, and offered a vast program of jobs for the unemployed, supported by public finance. Liberals criticized him. The President replied: "True individual freedom cannot exist without economic security. [...] People who are hungry and out of a job are the stuff of which dictatorships are made."

Re-elected in 1936 in spite of hostility from high finance, and again in 1940 and 1944, he had to confront the Second World War. And he did it decisively, faithful to ideals of justice and democracy. He broke with the traditional isolationism of the United States, overcame the resistance of most of the ruling class, and persuaded Congress to vote for concrete support for the United Kingdom. Following the attack on Pearl Harbor, on December 7th, 1941, he declared war on Japan, entering the Second World War and making a vital contribution to the defeat of the Axis powers. It was a choice that enabled him, in February of 1945, to join Churchill and Stalin in the Yalta conference, laying the foundation for that role of leader of the West that the United States would soon assume. Only his death – from a cerebral hemorrhage – prevented him from seeing the victory of the democracies and the birth of the United Nations, the project to which he was committed even in his final days.

A birthday cake for President Roosevelt prepared in Washington by the union of bakers and pastry cooks. The labor unionists, and more generally the workers, together with the middle class, many intellectuals, and representatives of various religious minorities were an integral part of the "New Deal Coalition" that supported Roosevelt and the Democratic Party.

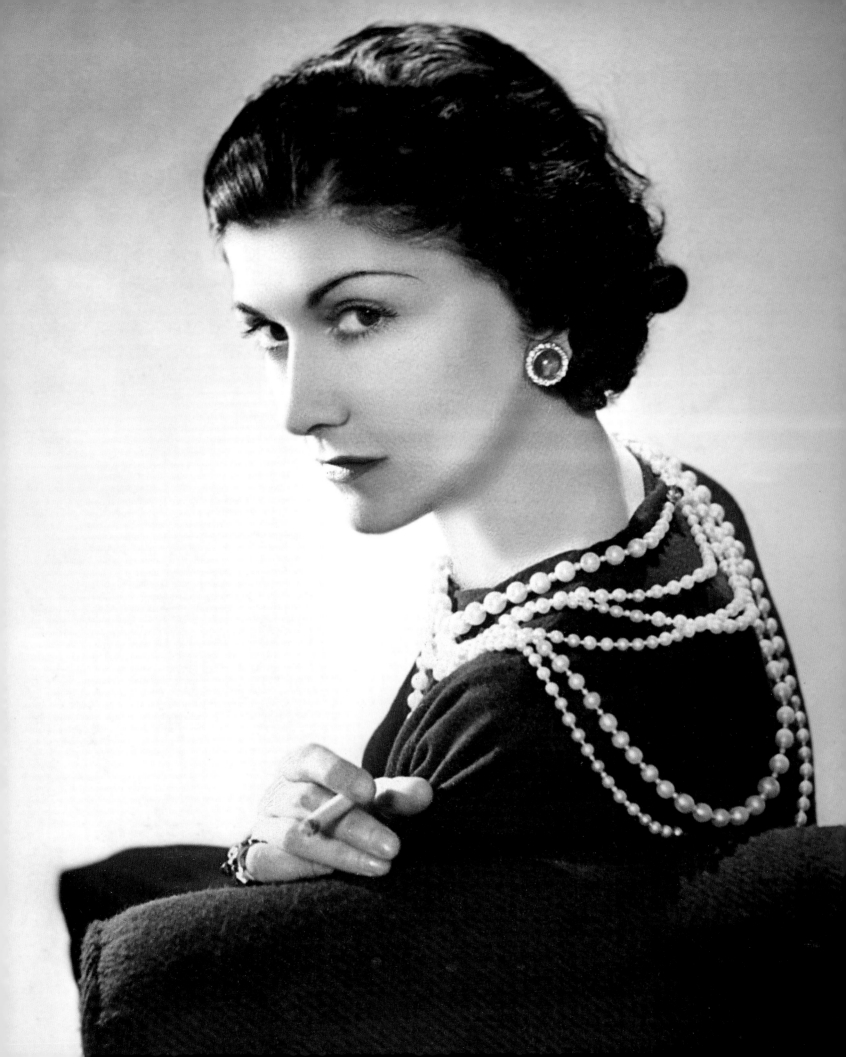

Coco Chanel

From extreme poverty to myth, Mademoiselle Chanel made her name the most recognizable in *haute couture*. She was the creator of a style that was both simple and timeless, and although it has been said that she created the modern woman, she never declared herself to be a feminist.

In order to work, "You need to roll up your sleeves." Gabrielle Bonheur Chanel knew this very well: she got down to work the moment she left the orphanage. First she sang in a *café-concert* where someone began to call her Coco because of her favorite song, *Qui qu'a vu Coco*. From 1909 on, she made hats: simple, comfortable, sober in shape and color. These qualities broke from the style of the first years of the 20th century, and they would come to characterize every creation of hers. She was beautiful, and realistic enough to gain the support of wealthy men – like the Briton Arthur "Boy" Capel (1881-1919), the true love of her life. In 1910 Coco opened a milliner's shop on Rue Cambon in Paris, where she also began to sell items of clothing. She was so successful that, in 1913, she opened a boutique in Deauville, a sophisticated coastal resort, and then soon opened a third shop in the equally sophisticated resort of Biarritz. However, her success was partly due to the First World War. In fact, thousands and thousands of Frenchwomen were employed in factories and offices to replace the men who were sent to the front, to die like flies. They were workplaces where the elaborate clothing of the *Belle Époque* proved awkward and the very nineteenth-century idea of femininity seemed out of date; Coco's garments were perfectly suited for the moment in history. The *garçonne* was born: a new type of woman, dynamic, enterprising, independent, and with an uncomplicated look. A little androgynous, she was seductive in a new way. Coco in fact raised hemlines to below the knee, lowered the waistline, and encouraged women to wear jerseys and pants. She took male clothes and gave them a feminine touch. And she launched the fashion for short hair, it's said, after she burned hers on the stove.

Her "poor" style also attracted the rich: thus she gained entrée into the most exclusive circles, inevitably accompanied by gossip about presumed relationships with men and women, artists – among them,

August 19th, 1883, Saumur, France • January 10th, 1971, Paris, France

We owe the "invention" of costume jewelry to Coco Chanel. The stylist, in fact, liked to add to her sober garments jewels that were showy but not too expensive, suitable for wearing every day, made of crystal, semi-precious stones, gold-plated metals, and pearls which were often fake. Her great passion for jewels – more or less precious – is evident in this 1936 photo by Boris Lipnitzki.

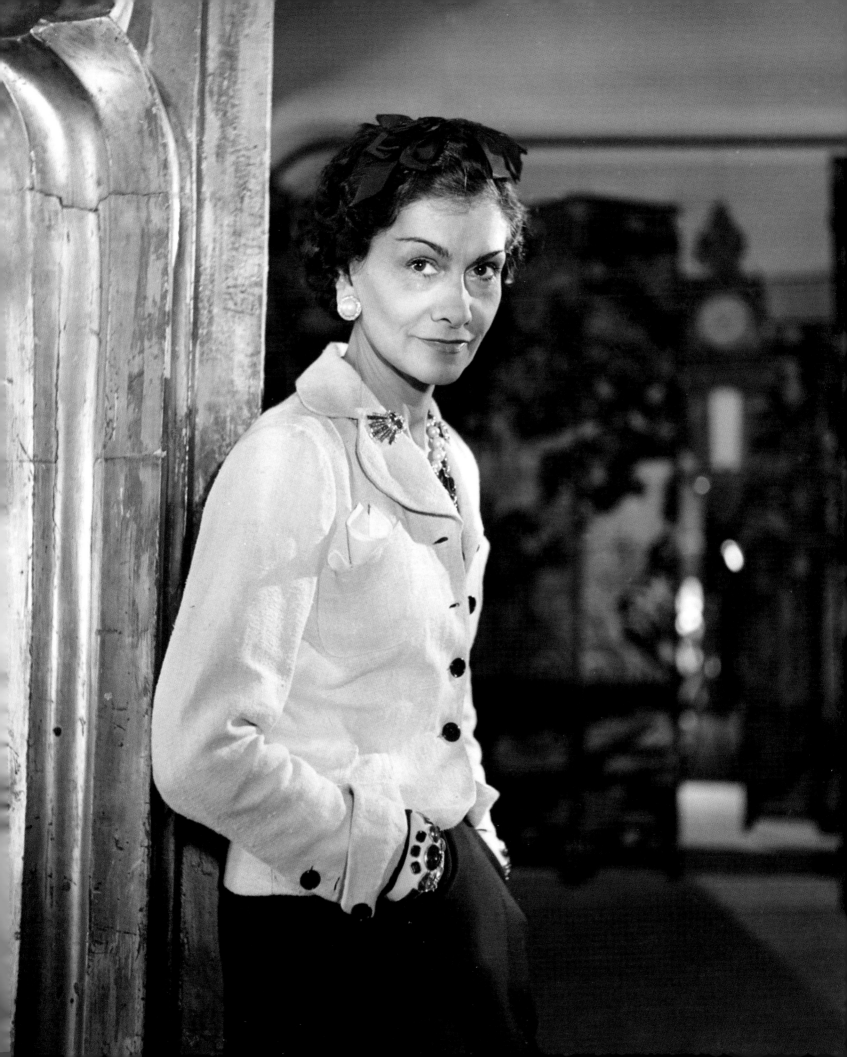

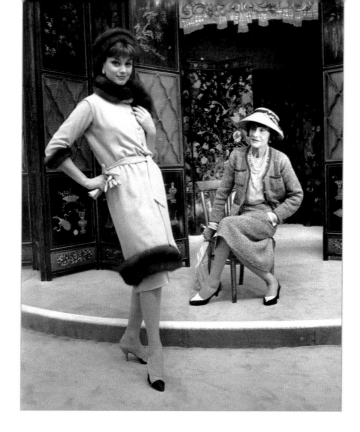

Igor Stravinsky – and aristocrats. There were also rumors about her morphine habit. But her first passion always remained work. The perfume *Chanel N° 5* was introduced in 1921. It entered the collective imagination through Marilyn Monroe: "What do I wear in bed? Chanel N° 5, of course." Five years later, Chanel came out with yet another icon: the *petite robe noire* (little black dress). The black sheath dress, which *Vogue* compared to the Model-T Ford, was something that from then on the world could not do without. The house was at the height of its fame when the Second World War forced Coco to flee Paris. She reopened in 1954, at seventy years old but still brilliant. In 1955, she released her umpteenth success, the *matelassé* bag. At the height of Christian Dior's new look, Coco launched her "slim" *tailleurs* (suits), which were immediately adopted by the stars. Jacqueline Kennedy, in an indelible image, wears one of these suits: it's stained with the blood of her assassinated husband. Coco Chanel was one of the first fashion houses to use a logo – two intertwined Cs – recognized throughout the world. Long after the death of *Mademoiselle Chanel*, who died at 87, the logo continues to signify clothing and accessories that are modern. Not "fashionable," it's been said, but "classic," because "La mode passe, le style reste": fashion passes, style remains.

72 In the 1930s Chanel was at the peak of her career. This 1937 portrait by Lipnitzki was taken at 31, Rue de Cambon, a boutique that after 1920 expanded to occupy five buildings (from No. 23 to No. 31). The building, where the heirs of the *maison* work today, also contained the stylist's private apartment. However, she always preferred to live in a suite at the Hôtel Ritz.

73 Boris Lipnitzki began again to immortalize Chanel in 1958. At 75, the stylist continued to work in her *atelier*. Here she is admiring one of her garments worn by Marie-Hélène Arnaud, a popular model who was the face of the 1950s Chanel collections. Arnaud wears beige and black two-tone slingbacks, an icon of the time, and the umpteenth success for Chanel.

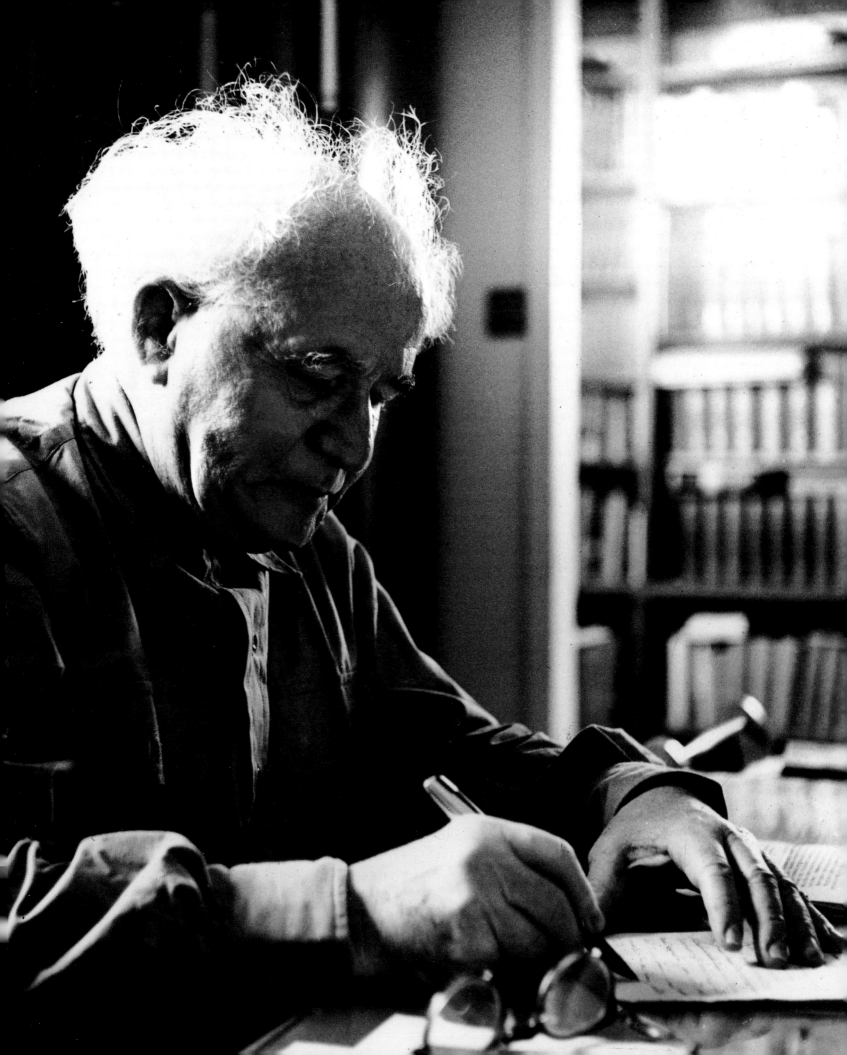

David Ben-Gurion

October 16th, 1886, Płońsk, Kingdom of Poland • December 1st, 1973, Ramat Gan, Israel

David Ben-Gurion, the "lion's son," challenged and defeated a thousand enemies: Tsarist police, German soldiers, British governors, Arab armies. In building a homeland for the Jewish people, nothing would get in his way.

To understand who David Ben-Gurion was, one needs to visit Sde Boker, the kibbutz where he spent his last years and where he is buried. There, in the north of the Negev Desert, a simple hut preserves the 5000 volumes of his private library; it is surrounded by flourishing vineyards, agricultural holdings, restaurants, museums, and art galleries. Sde Boker is the perfect representation of the State of Israel, the place where the father of the nation's most ambitious project was achieved. It began as a dream seventy years earlier, in 1904, in the heart of a Poland still under Tsarist Russia. David Grün, the son of a socialist lawyer, had been thinking carefully about the teachings of the philosopher Ber Borochov, whom he met while studying engineering in Warsaw, and thinking carefully about what was being called progressive Zionism. The idea was to create Eretz Israel, a modern, secular, and socialist state, which could become the homeland for the millions of Jews forced to leave Europe due to anti-Semitic pogroms. After being arrested during anti-Tsarist uprisings, David founded a movement for *Aliyah*, the return of the Jews to Palestine, where he himself emigrated in 1906. He farmed the land and changed his surname from Grün to Ben-Gurion (the "lion's son"). In 1912, he moved to Constantinople to study law. With the outbreak of the First World War, however, he was forced to leave the Ottoman Empire because he was a Russian citizen. This time he went to New York, where he met his future wife, Paula Munweis, and preached Zionism while waiting to permanently return to Palestine. He did so in 1918, and enlisted in the Jewish Legion to fight alongside the British. With the end of the war, his political and labor union career took off.

David Ben-Gurion at his desk in the 1950s. In 1948 he was elected Prime Minister and he would serve for 15 years, with a break between 1954 and 1955. He was implicated in an Israeli secret service operation (the Lavon affair), and forced to resign in 1963. He spent his last years on the kibbutz of Sde Boker, in the middle of the Negev Desert.

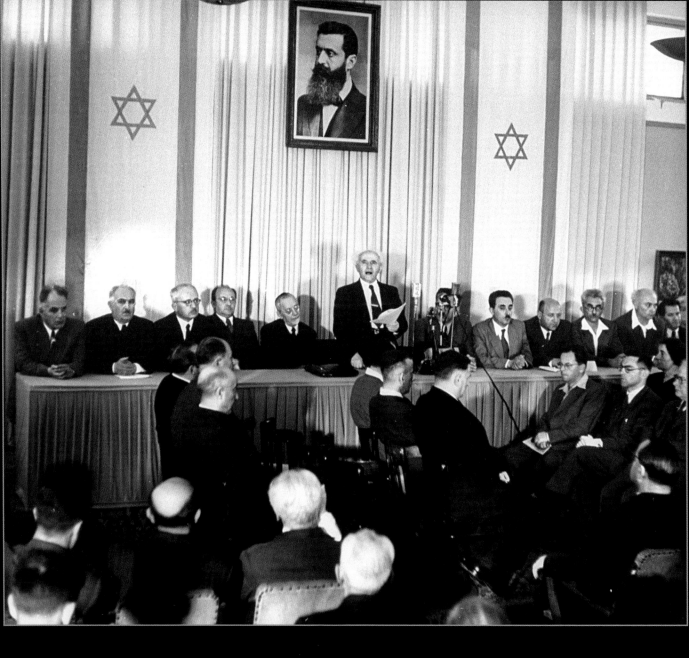

76 "The Land of Israel was the birthplace of the Jewish people. Here their spiritual, religious and political identity was shaped. Here they first attained to statehood. . ." Thus begins the Israeli Declaration of Independence, read by Ben-Gurion on May 14th, 1948. High above his head is a large portrait of Theodor Herzl, the founder of Zionism and "spiritual father" of the new state.

77 Ben-Gurion was one of the first civilians to visit the Wailing Wall after the Six Day War in June, 1967. This enabled Israel to occupy the West Bank and East Jerusalem. It was a conflict the ex-Prime Minister had opposed, even though he led two other military campaigns in the founding of the new state.

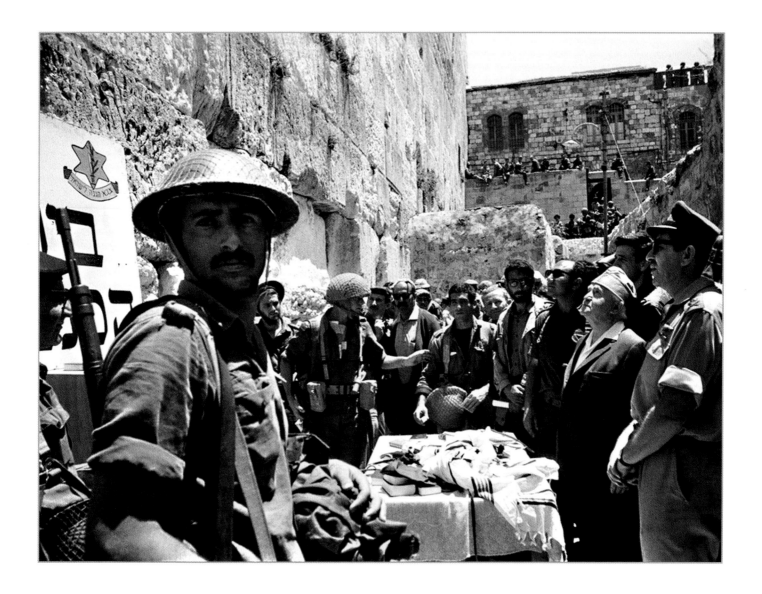

In 1930 he founded the Mapai, the party of the workers that would then become the Israeli Labor Party. In 1935 he became head of the Jewish Agency, the body that managed immigration into Palestine during the British Mandate. It was through the Agency that Ben-Gurion, in 1948, formed the first provisional government of the State of Israel. The "lion's son" stayed in power (with an interruption of two years) until 1963: in this period he won military victories in two wars, the Arab-Israeli War of 1948 and the Suez Crisis of 1956; he negotiated with the domestic opposition of Orthodox Jews; he made a cast-iron alliance with the United States; he promoted and managed the heavy immigration of Jews from Europe and the Middle East; and he became the man entrusted with the project of finding a place for the Jewish diaspora. The founding of Israel came at an extremely high price. Not only did it further complicate the already complex geopolitics of the Middle East, a region divided by ex-colonial powers, it displaced and marginalized the people of Palestine, who were forced to abandon their lands. But such political questions go beyond the figure and role of Ben-Gurion, who in any case succeeded at a titanic task. Even if his greatest and most poetic aspiration was to be a simple farmer, in a kibbutz in the desert, he is remembered as one of the greatest statesmen of the 20th century.

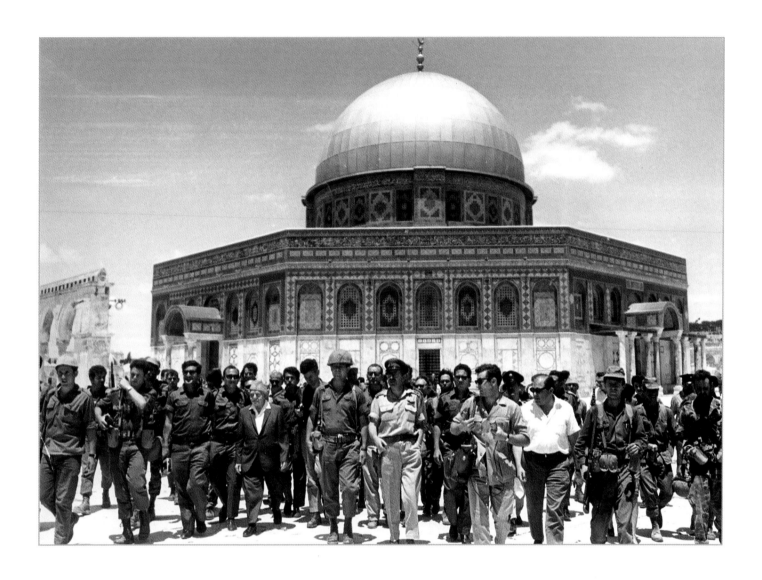

78 Ben-Gurion, photographed here by David Rubinger, gives a passionate speech on the opening of the University of the Negev, founded in 1969 at Beer-Sheva. The university, today the Ben-Gurion University of the Negev, specializes in biotechnologies and desert studies aimed at promoting development in the Negev desert area. It also houses a center dedicated to Zionist history and the life of the ex-Prime Minister.

79 In June, 1967, following the Six Day War, Ben-Gurion and the Israeli chief of staff, Yitzhak Rabin (future Prime Minister and Nobel Peace Prize winner) lead a group of soldiers in front of the Dome of the Rock. The Temple Mount, in the Old City of Jerusalem, has just been taken by the Israeli army.

David Ben-Gurion

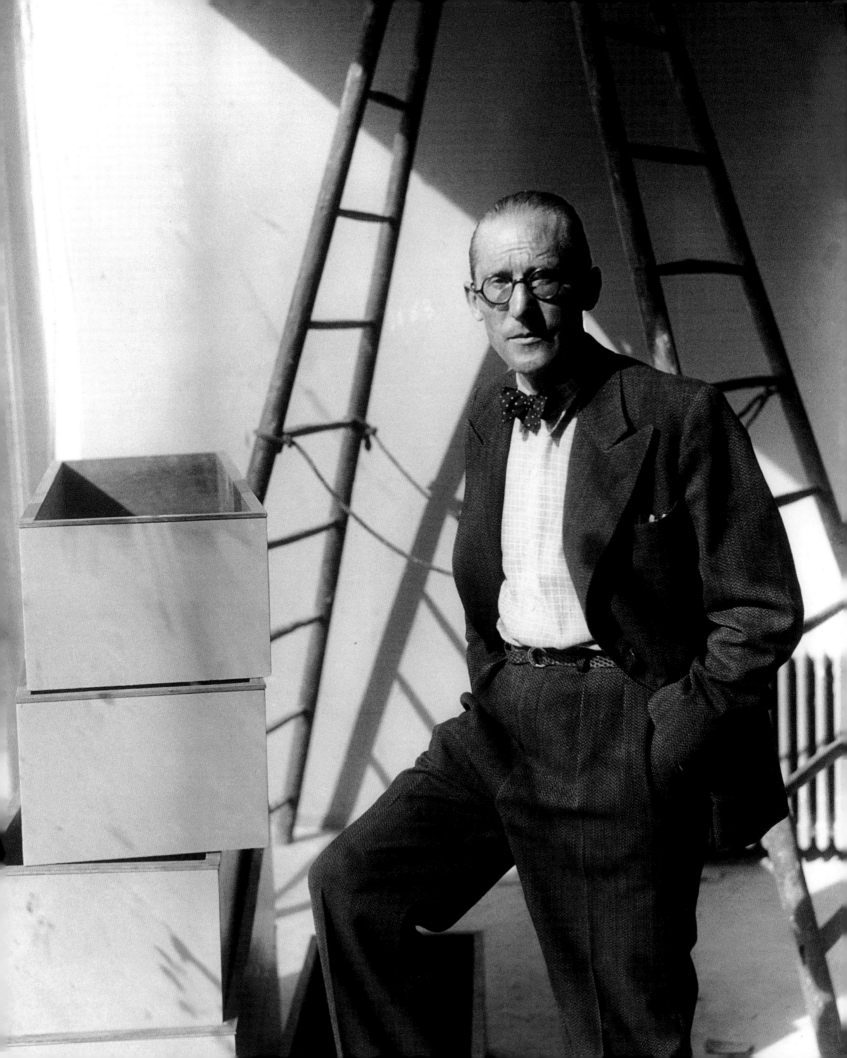

Le Corbusier

Le Corbusier, considered the "architect of the century" by many, was a symbol of the Modernist Movement. Although he without a doubt revolutionized architecture, he was also a designer, writer, and artist. His work contributed to the changing way of life in the first half of the 20th century.

There are many terms applied to Charles-Édouard Jeanneret-Gris, and not all of them are positive: egocentric, ruthless, arrogant. Vindictive. A megalomaniac: he once proposed demolishing the historic center of Paris. Racist and fascist. An impenitent philanderer, it was rumored that his lovers included Josephine Baker. Yet he was deeply loved by his wife, Yvonne Gallis, who did nothing more than forbid him from talking about architecture at the table. In his way, he loved her in return: after her death he kept with him a vertebra of hers that wasn't destroyed in the cremation. The popular evaluation of the architect Le Corbusier, the pseudonym Jeanneret-Gris used to sign books and projects, is an altogether different matter. Revolutionary, visionary, genius: in 1920, this young Swiss man in his early thirties, after only a few years in Paris, began to attract attention for his explosive ideas. He challenged conservative views, maintaining that the rapidly changing world needed a "new architecture" that was available to everyone. He chose to build in reinforced concrete and imagined rational and functional "machines for living," designed around the proportions of the human body. Thus he made buildings rising on *pilotis*, or stilts, with roof gardens and "ribbon windows" which cut the façade along its length. His *Unité d'habitation* are modern houses which can be endlessly reproduced but adapted to the needs of their inhabitants: to furnish them, he designed spare and elegant chairs, tables, and armchairs, like the famous LC4, the chaise-longue *par excellence*.

Eccentric but always elegant, Le Corbusier was also a style icon. Two details from this 1930s photo are enough to evoke the myth: the bow tie and the round glasses with heavy frames, as if to say that a man too must have certain reference points in his appearance. Le Corbusier was exemplary in his attention to how he presented himself, and his fashion would be imitated by many colleagues.

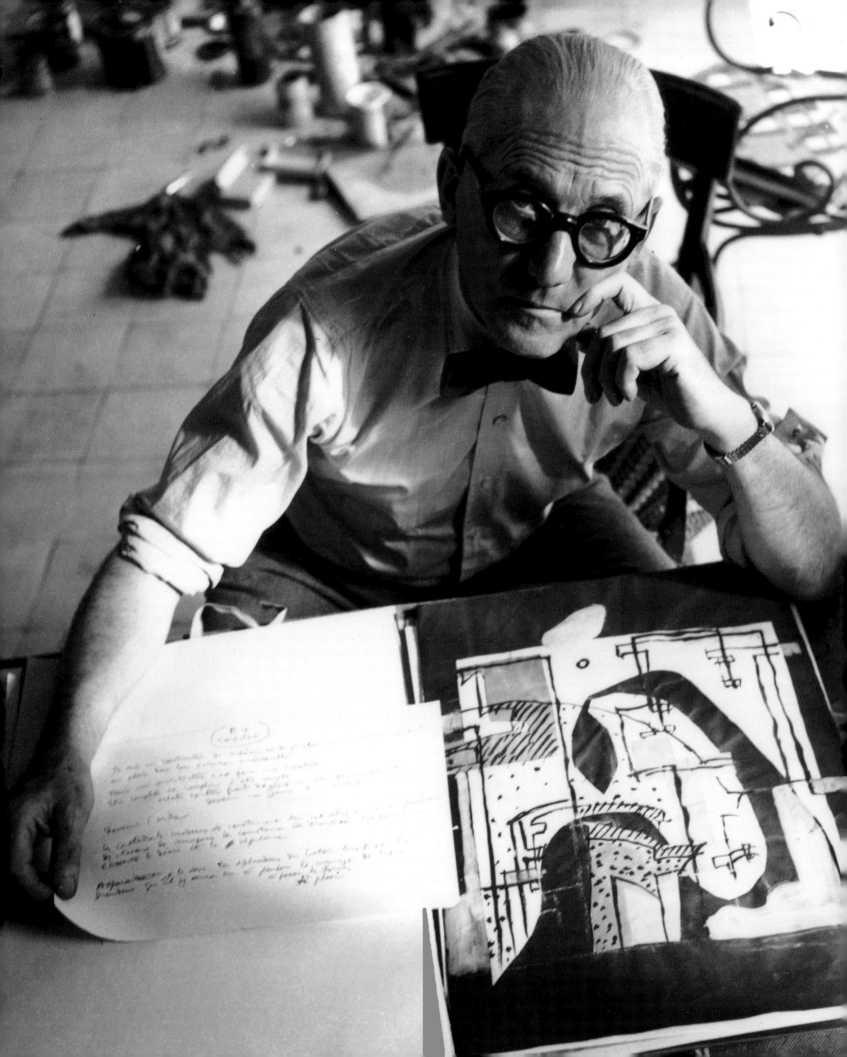

Le Corbusier even proposed the grandiose urbanistic vision of the *Ville Radieuse*, a utopia never achieved: it described the ideal of a world in which beauty and rationality coincide. "Architecture or revolution," he wrote. But the truth is that for him architecture was already revolution, a weapon that could change the world. Today 17 of his structures, milestones in the history of architecture, are UNESCO World Heritage Sites.

82 Le Corbusier in a portrait from around 1945 by the Polish photographer Michel Sima, who captured on film many characters from the Parisian cultural scene, including Picasso and Chagall. Sima often photographed artists at work: Le Corbusier is pictured with a sketch and a handwritten text, underscoring the importance of theoretical planning to the architect's designs.

83 The architect's desk, in the *Immeuble Molitor*, at 24 Rue Nungesser et Coli. The Swiss photographer René Burri took several shots of his famous compatriot and his works (particularly at the Ronchamp chapel), and so was able to encompass in this image Le Corbusier's world: the paper, projects, sketches, designs, and the indispensable glasses.

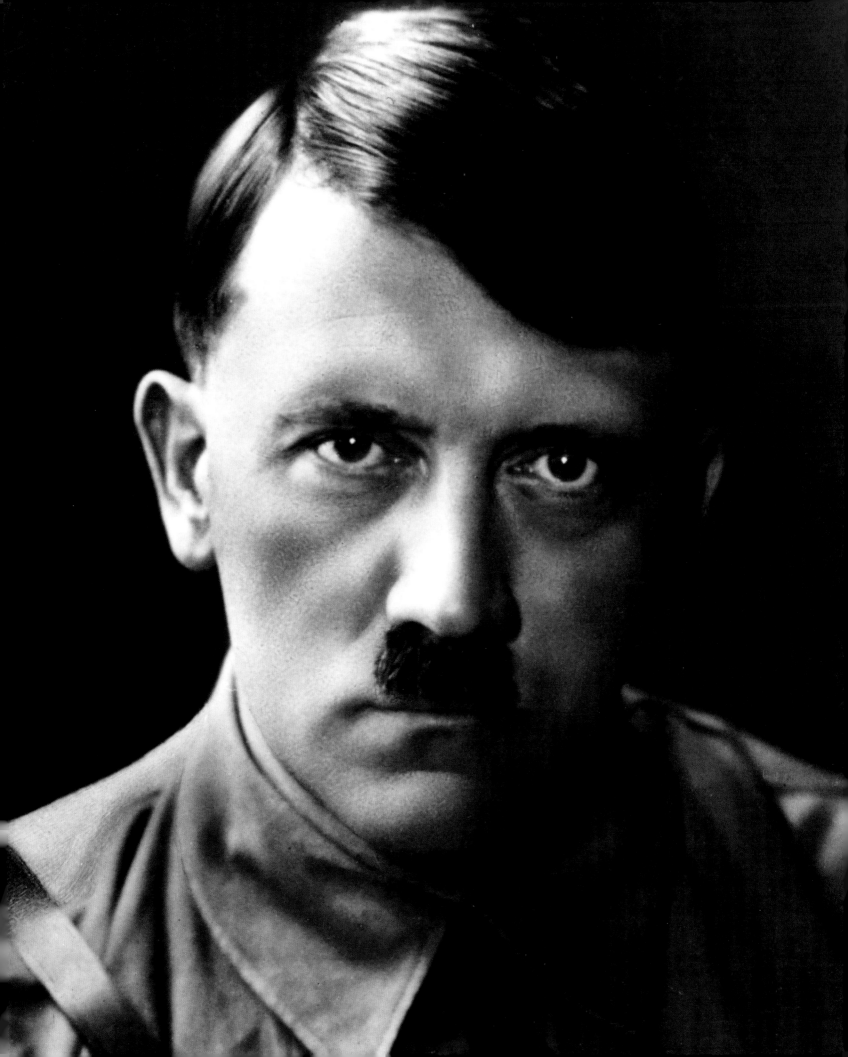

Adolf Hitler

The dictator *par excellence*, he was the embodiment of evil. From provincial corporal to the Führer of Germany, Adolf Hitler was directly responsible for the abomination of the concentration camps and for a war that resulted in more than 50 million deaths.

Perhaps the 20th century could have been spared its darkest moments if, in 1906, the Vienna Fine Arts Academy had admitted the young Adolf Hitler to its courses, rather than ending his ambitions as a painter; or if, following the First World War, the Treaty of Versailles had not imposed exorbitant reparations on Germany. This was the country for which Hitler had fought: homeless, a committed Pan-Germanist, he had enlisted as a volunteer in spite of being born in Austria and failing to pass the entry medical exam. After the war, it was from the extreme poverty and resentment the future dictator and the German people were forced to endure that the National Socialist party drew its strength. In the 1920s and early 1930s, Hitler succeeded in making himself the interpreter of widespread rage and exploiting it, directing it not only against the Western powers but also against all those who were "different": Jews, Communists, homosexuals, gypsies, and Jehovah's Witnesses.

From provincial megalomaniac, a beer-hall rabble-rouser, in 1933 he became Chancellor of Germany with the support of the Brownshirts, a paramilitary force that used violence to intimidate political opponents, and that reinforced his electoral success in the previous year. Thus the Third Reich began. The descent towards the Second World War was rapid. The stages are well-known: the Reichstag fire, the Night of the Long Knives, the Nuremberg Laws, the remilitarization of the Rhineland, *Kristallnacht*, the annexation of Austria and the Sudetenland. Then Germany invaded Poland. Then the concentration camps were built, and the Shoah began.

The ideological foundation of the regime was *Mein Kampf*, an autobiography that Hitler wrote in prison, after the failure of a *putsch* organized in 1923. From that time on, in spite of his arrest, Hitler was convinced that he enjoyed a sort of divine protection, that he was predestined.

In 1930 the National Socialist Party obtained a great election success, increasing from 2.6% to 18.3% of the votes. Hitler strategically obtained control of the movement, becoming head of the Brownshirts, and in the early 1930s had himself photographed in the uniform of the paramilitary group. His toothbrush mustache soon came to be known outside of Germany.

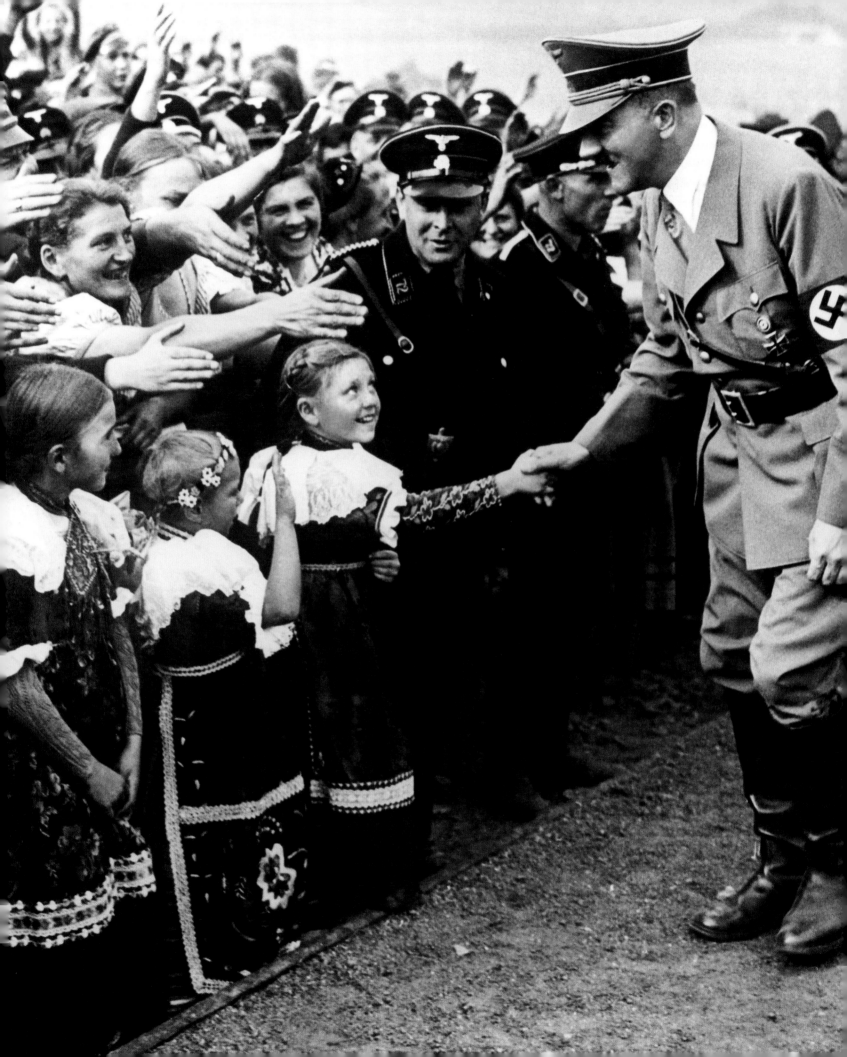

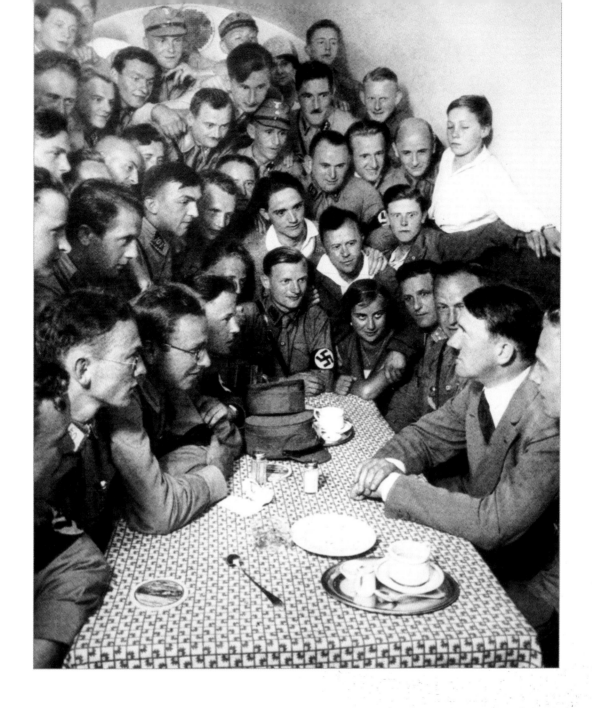

86 A throng of women and children in traditional costume welcome Hitler to the *Reichserntedankfest* (the Nazi "Harvest Thanksgiving Day") in October, 1937. The event, held near Hamelin, in Lower Saxony, was organized by Joseph Goebbels and Albert Speer. The regime wanted to celebrate agriculture and German traditions, reinforcing the unity of Führer and people.

87 January, 1933. National Socialist Party and Brownshirts members pose around Hitler after his appointment as Chancellor. Seated at the table, Hitler wears civilian clothes for the occasion: he aims to convey an image of normality and respectability. His real nature emerged after the Nazi Party's crushing victory in the March elections (43.9%), helped by widespread violence.

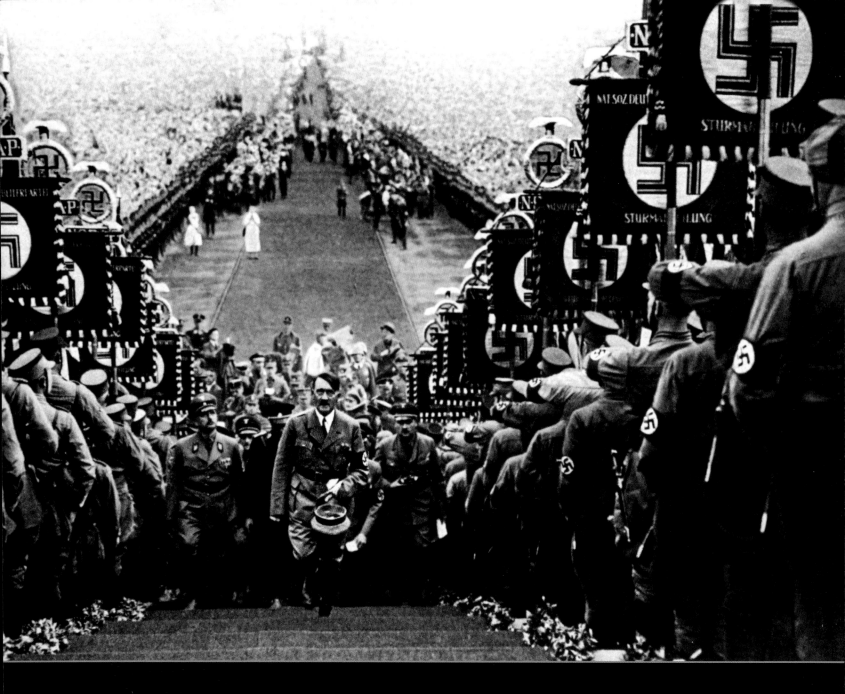

This gave him complete confidence in himself, which found expression in his magnetic personality and powerful oratory: his speeches – furious and captivating – were all the more effective because of the choreography orchestrated by Joseph Goebbels. In only a few years, Hitler succeeded in transforming a derelict Weimar Germany into an exceptional economic power. He achieved this by the consent of the people, with the support of industrial and financial elites, and because of an extremely efficient bureaucracy, which was able to interpret his peremptory orders and transform them into effective measures. Because Hitler certainly was not an expert in economics or a capable organizer.

Hitler participates in the *Reichserntedankfest* of September-October, 1934 at Bückeberg. It is the second occasion of the event, which started in 1933: about 700,000 Germans take part. On October 4th, after walking the 2000 feet (600 meters) of the *Führerweg* ("Führer's route"), the dictator goes up to the podium, greeted by Nazi standards.

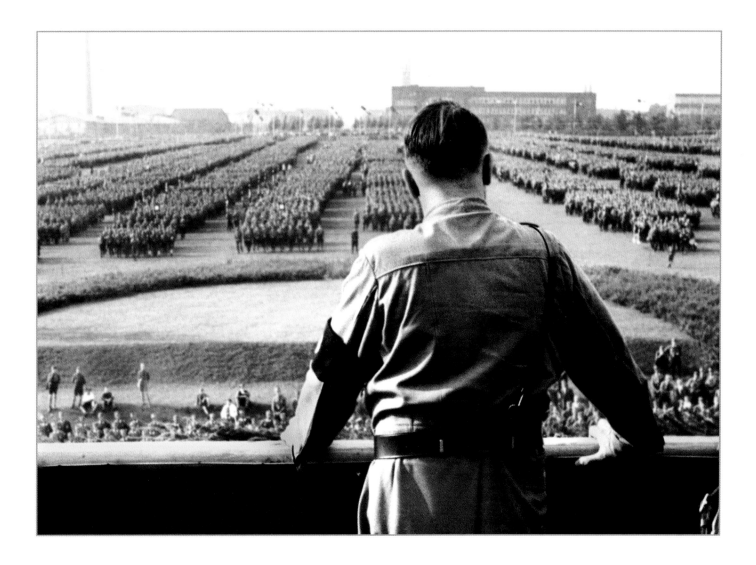

And he didn't like to work that hard. (In fact, he often slept into the afternoon.) Rather, he was a man of spontaneous intuitions, which his court considered revelations. He was always in precarious equilibrium between rationality and paranoia – over the years he became addicted to stimulants and tranquillizers – and he continued up to the very end to send expeditions into such places as Mexico, Amazonia, and Tibet to trace the most disparate myths of the occult. The doomed invasion of the USSR marked the beginning of the end. It was a premise for his suicide in a bunker, in a Berlin engulfed in flames, beside Eva Braun, the woman he loved – assuming Hitler was capable of love.

Hitler gives a speech to a Nazi gathering around 1930. The organization of events like this played a crucial role in the success of the Führer, who could count not only on his oratory but also on the skillful work of Joseph Goebbels. The Minister of Propaganda created impressive scenographies and controlled the media in order to ensure the greatest impact from every appearance of the Nazi leader.

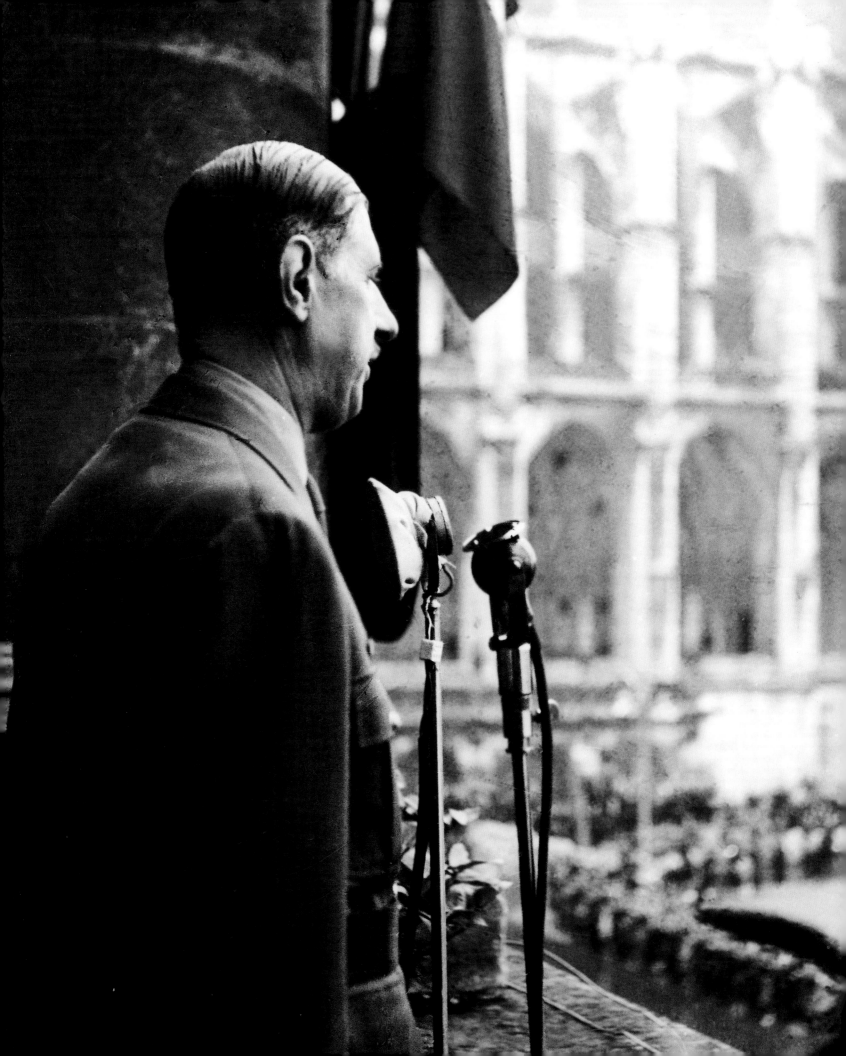

Charles de Gaulle

For thirty years, he was the general who was the face of free France. First leading her in the war against the Nazis, Charles de Gaulle then brought his country out of the colonial era.

It was not so common in the 1960s for a general, a war hero, to endure long make-up sessions. But Charles de Gaulle, who was not only a general but also President of the French Republic, had known for some time that the effective use of the mass media was at least as important as making a battle plan. He was described as "the first media president," but behind his attention to his image was not just his concern for support: rather, de Gaulle aimed to represent the idea of France to the world. And before speaking to the country on television – a medium he used quite frequently, since he disliked debates and parliamentary procedures – he left nothing to chance: he rehearsed his speech repeatedly and relied on the best experts, including Brigitte Bardot's make-up artist.

In fact, he entered history speaking to the microphones, broadcasting a speech over the radio. It was June 18th, 1940: "Speaking in full knowledge of the facts, I ask you to believe me when I say that the cause of France is not lost. [...] For, remember this, France does not stand alone! She is not isolated!"

He spoke these words in Britain, on the BBC, while at home Marshall Philippe Pétain – by a twist of fate, his ex-commander – signed an armistice with the Nazis. At the time, de Gaulle was a brigadier general with little political experience; he'd been under-secretary of defense for only a few days. But with the slogan *"France libre,"* regardless of the death sentence imposed on him by collaborationists, he managed to strengthen the Resistance and effectively fight the Nazis. When he returned in triumph to liberated Paris, it was as leader of the provisional government.

October 7th, 1944. Charles de Gaulle visits Le Havre, a city heavily bombed and liberated from Nazi occupation less than a month before. In his speech, the General pays homage to the people of the city and their courage. In the Golden Book of the Commune he writes: "To Le Havre – injured for the sake of France, but alive! And which will be great!"

November 22nd, 1890, Lille, France • November 9th, 1970, Colombey-les-Deux-Églises, France

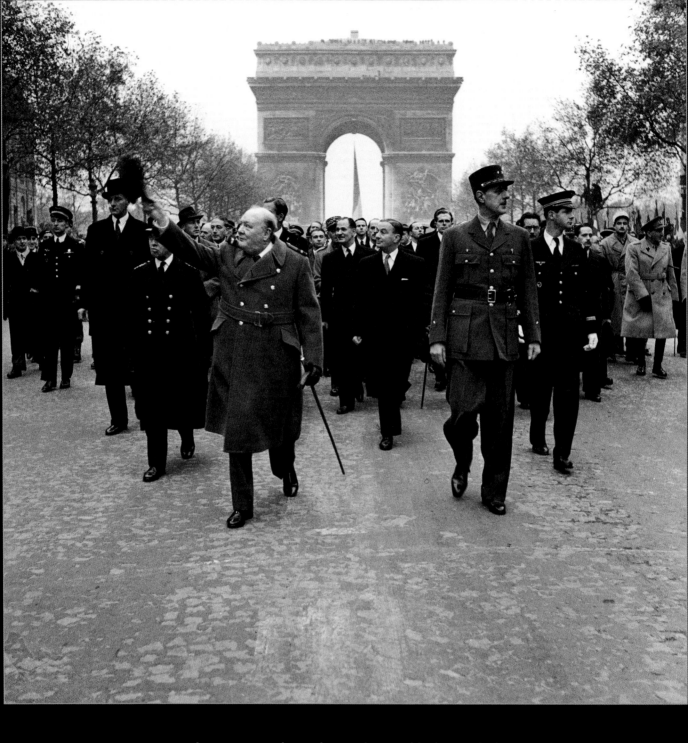

He was a proud interpreter of French *grandeur*, and before and after 1944 he never expressed any form of humility to the Allies: in fact, he returned to the United Kingdom all the financial support it gave to the Resistance. There thus began a new phase of his life, that of statesman. Among the first measures passed was one that granted women the right to vote.

His political career appeared to be finished with his electoral defeat in 1953. But five years later, France called him back to be leader, granting him wide powers and confirming its support for him until 1969.

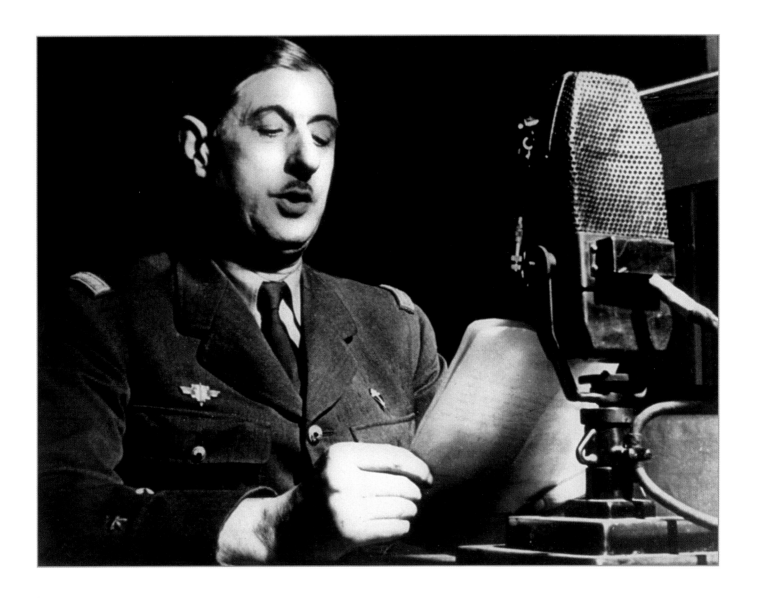

92 On November 11th, 1944, General de Gaulle and the British Prime Minister Winston Churchill proudly lead a parade along the Champs-Élysées in Paris. They are celebrating the armistice concluding the First World War in 1918. The parade has strong symbolic value for France and the United Kingdom: victory in the Second World War is within reach.

93 De Gaulle spoke on BBC radio to deliver his famous speech of June 18th, 1940. The recording of that appeal has been lost; neither is there original photographic documentation: only the written manuscript remains. However, the tapes of his second radio speech (June 22nd), as well as photos of later speeches, have been preserved.

France needed his reputation, his ability to make difficult decisions, and his strategic vision in order to face the situation of an emerging post-colonial Africa: it was de Gaulle who negotiated the independence of Algeria, ending a long war. Under his leadership, institutions were restored and strengthened, and France began to recover a position in the first rank on the international scene. He was anti-Communist, but also against the leadership of English-speaking countries: de Gaulle condemned the American intervention in Vietnam and opposed the entry of the United Kingdom into the European Community. De Gaulle, who linked his destiny to France at the moment of her defeat, only left his country after having acquired an independent nuclear arsenal.

There is enough to justify the words used by his successor, Georges Pompidou, on the announcement of his death: "General de Gaulle is dead. France is a widow."

Between December 9th and December 13th, 1960, Charles de Gaulle, as President of the Republic, visits Algeria, which is still a French colony. At Aïn Témouchent, a town not far from Oran, considered "quiet," the authorities have organized a festive welcome for the General. Soon violent protests in favor of independence will break out in the city and throughout Algeria.

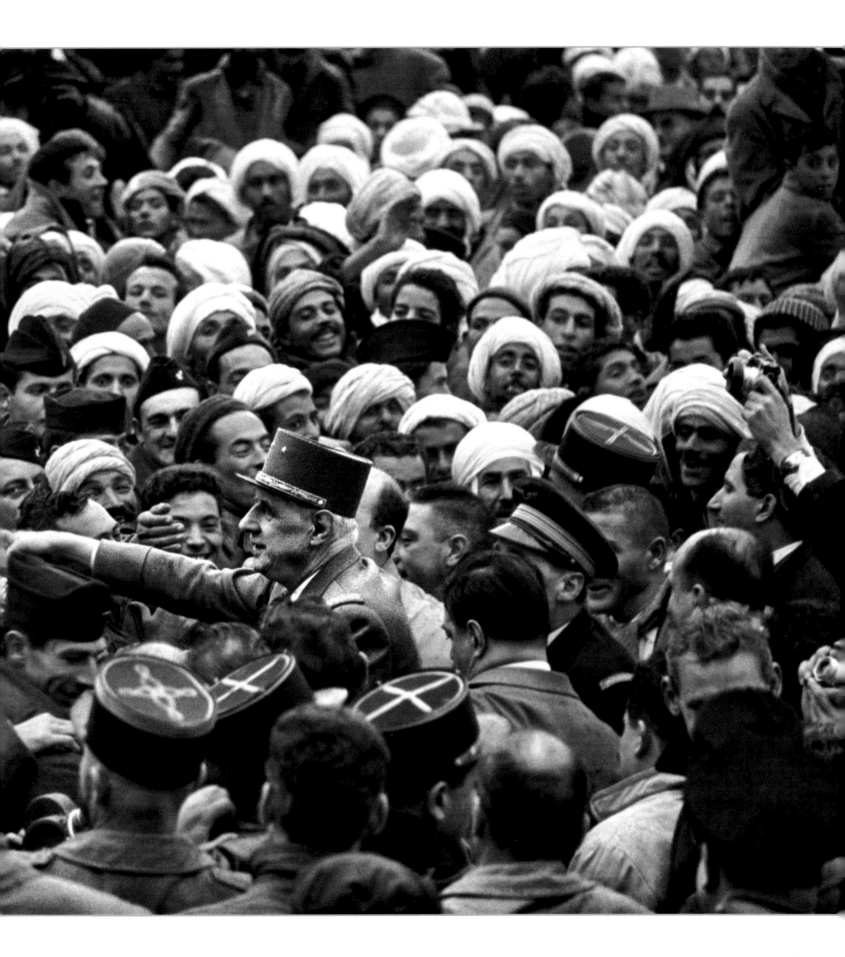

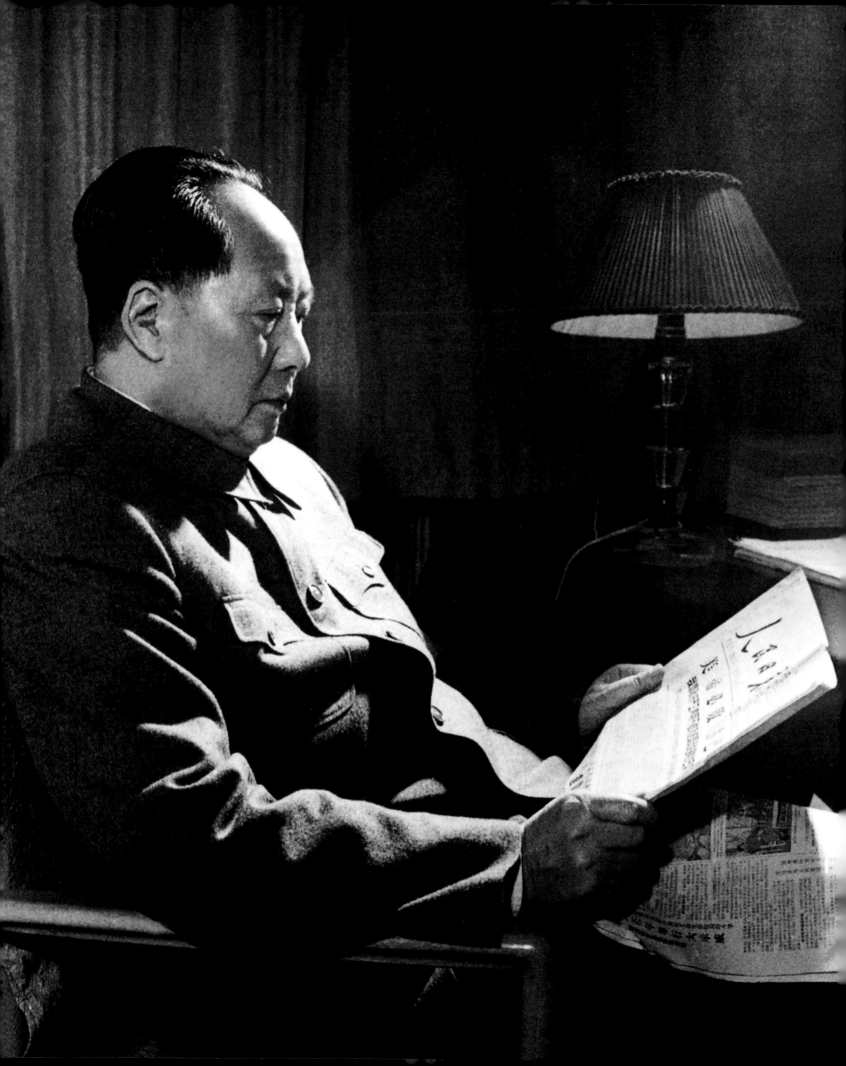

Mao Zedong

Through the Long March, a Communist, Mao Zedong, succeeded in gaining power in the most populous country in the world. He would govern it with an iron fist.

Even today, the man's face looms large in Chinese culture, from his portrait in Beijing's Tiananmen Square to the remotest provincial localities, like the village of Zhushigang, where in 2016 a statue, nearly 130 feet tall, was dedicated to him. It was covered entirely in gold. In his country, Mao Zedong remains the Great Leader and the Great Helmsman, honored as an emperor and praised in the rhetoric common to every regime.

While the empire had collapsed in 1911, it was not until 1949 that Mao proclaimed the birth of the People's Republic of China "under the guidance of the Communist Party." But the man who was about to lead that vast and immensely poor country, which had just come out of a civil war between Communists and Nationalists, did not come from a noble dynasty. He was a soldier whose exploits were already legendary, with a personality that – to quote the journalist Edgar Snow, witness of the Revolution – conveyed "a certain force of destiny, a kind of solid elemental vitality." He was also a refined intellectual. He was the son of farmers, and wanted to transform China into a Marxist state to release her peasant class, the poorest and most numerous one, from extreme poverty. It was a titanic task, possibly even an impossible one.

But for a long time, the success of the Red Army in the Civil War had also seemed impossible. And yet Mao managed to transform into victory the Long March, an interminable retreat of the Communist army besieged by government forces. After escaping the enemy, he rebuilt his army and led his men through dramatic events, from the Japanese invasion during the Second World War to the defeat of Chiang Kai-shek, the leader of the Nationalist Government, forcing him to flee to Taiwan.

Mao Zedong reading the *People's Daily*, the newspaper published by the Communist Party: in fact, it was edited by Mao's secretary. In 1961, the year of this photo, China suffered a great famine, which the press attributed only to misfortune. In reality, it was one of the consequences of Mao's "Great Leap Forward," a program of forced collectivization and industrialization.

December 26th, 1893, Shaoshan, China • September 9th 1976, Beijing, People's Republic of China

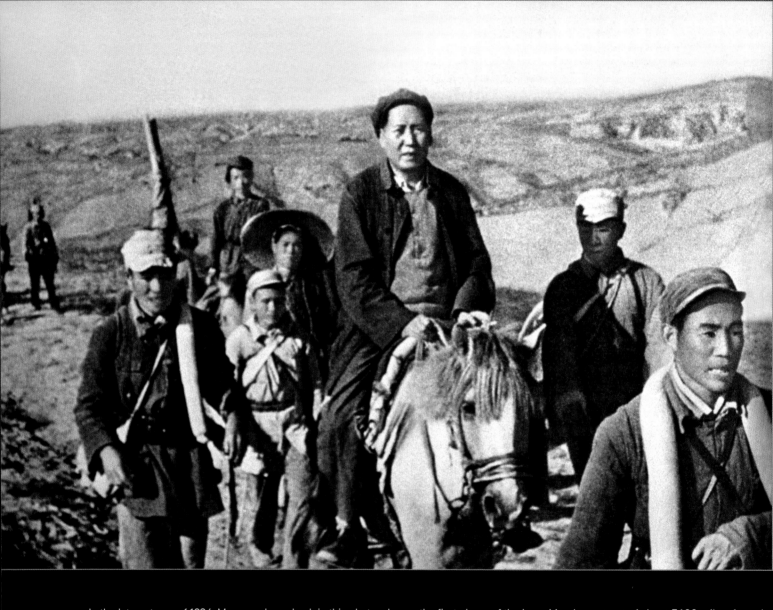

In the late autumn of 1934, Mao – on horseback in this photo – began the first phase of the Long March: a retreat of about 5600 miles, from the province of Jiangxi to Shaanxi. It will conclude in October, 1935. Because of exhaustion and fighting, only 10,000 of the 100,000 men and women who left with Mao will conclude the march: among them is the leader's third wife, He Zizhen.

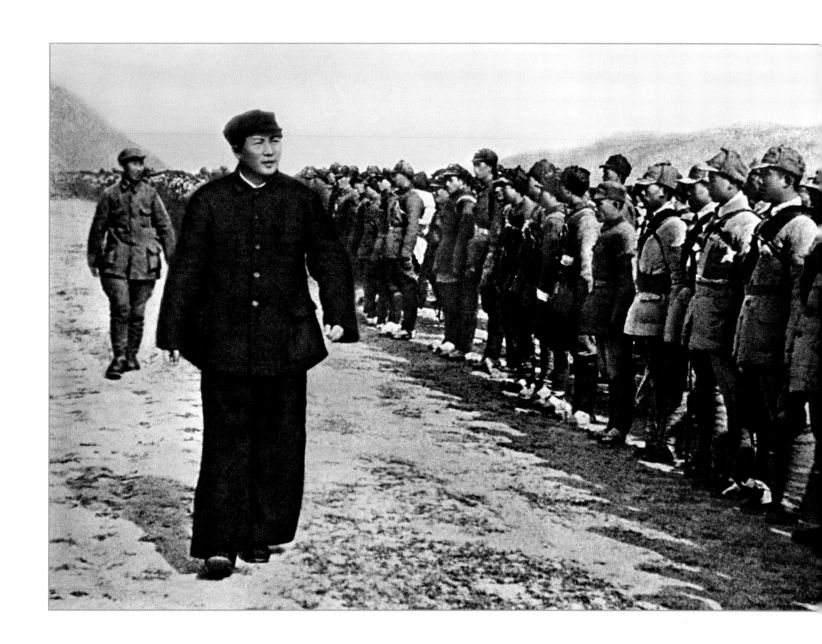

Mao reviews the troops of the Eighth Route Army, an important unit in the war against Japan (1937-45). The division was led by Mao himself, along with Zhu De, the future commander-in-chief of the People's Liberation Army. It was stationed in Yan'an, a Communist stronghold from the years of the Long March until 1948: the houses the two leaders had there remain standing and are now historical landmarks.

Once he came into power, in fact, Mao led the State for over 20 years. He surrounded himself with a "red" court in which the intrigues and pleasures of imperial times were not unknown: it seems he had a harem available of beautiful, very young women, who were also used as secret agents to defend revolutionary orthodoxy. In fact, they lived by one of his many mottos: "Wherever there are counter-revolutionaries, they must be eliminated."

With forced industrialization programs, land collectivization, and mass literacy programs, in Communist China the economy began to expand and the people's living conditions improved, but the entire landowning class was exterminated. While children in school learned the aphorisms of Mao contained in the so-called *Little Red Book,* every dissenting voice was suppressed. This was especially the case after 1966, with the Great Cultural Revolution, during which an enormous number of intellectuals and party officials were imprisoned or killed. Mao's fourth wife, Jiang Qing, and the ruling group that surrounded him, the so-called "gang of four" that in the last years took advantage of the decline in the leader, were largely responsible for this decimation of the party. Only after the death of the Great Helmsman, and in a trial that carefully protected his image, was Jiang Qing herself charged and sentenced for atrocities that occurred in the Cultural Revolution.

Mao Zedong

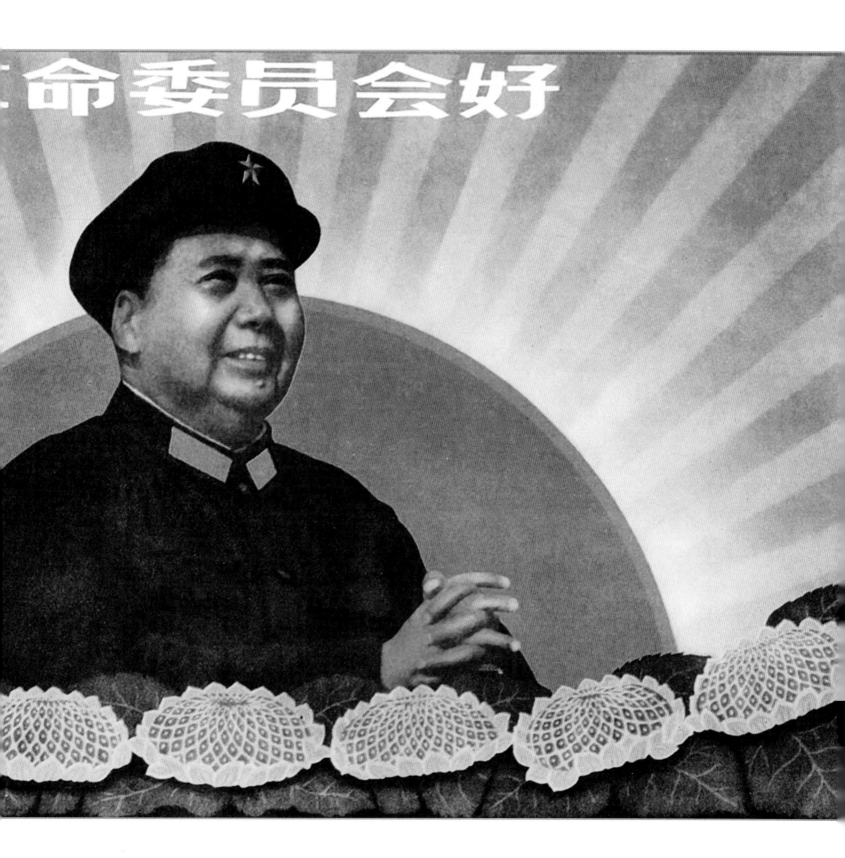

A poster celebrating the Revolutionary Committees: in the propaganda, Mao represents the sun, and the people are the sunflowers. The Committees, founded in 1967 and 1968 during the Cultural Revolution, were to enable communication between the Party and the people. In reality, they had little success, and would soon be transformed into extensions of the political-military apparatus.

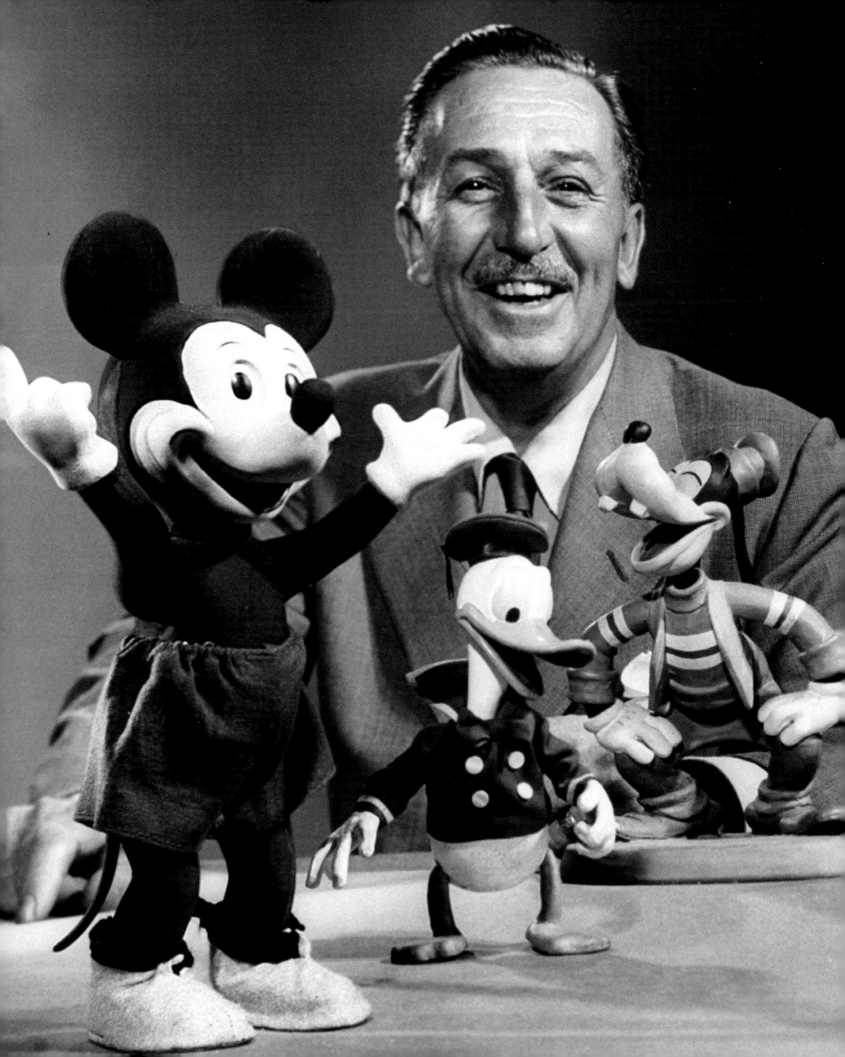

Walt Disney

A pioneer of cinema animation, Walt Disney's stories created dreams for millions of people. His imaginative heritage has been shared by generations – and "it was all started by a mouse."

December 5th, 1901, Chicago, Illinois, United States • December 15th, 1966, Burbank, California, United States

Cartoon characters also have birthdays. Mickey Mouse greeted the world from the cockpit of an airplane on May 15th, 1928, in a silent short, *Plane Crazy*. It was not successful. Some months later, however, on November 18th, Mickey returned, whistling at the helm of a steamboat, in *Steamboat Willie*. It was the first cartoon with a synchronized soundtrack, and it was a triumph. And for Walter Elias Disney, 26, its creator, it was the accolade that opened the way to an incredible number of Oscars (22, plus 4 honorary). Surprisingly, he was done paying his dues: in the early 1920s, Walt had begun to experiment with animation in a garage adapted into a studio. In 1923 he left for Hollywood with 40 dollars in his pocket. There he founded the future Walt Disney Company with his brother, Roy. In California, through film and print – the Mickey Mouse comics appeared in 1930 – he invented Peg-Leg Pete, Donald Duck, and many other characters that would transcend culture and time. But Walt was not satisfied. He wanted to create other universes, to think big. He had a project in mind that seemed mad: making an animated feature film. His motto was "If you can dream it, you can do it," and in the end he proved himself right: *Snow White and the Seven Dwarfs* came out in 1937. Other masterpieces followed, all with the aura of magic that made Disney the greatest storyteller of the century. In 1955, he fulfilled another dream: he opened Disneyland, the first theme park in the world. It was another enormous business success. Perhaps there is another side to the coin. It has been said that Disney was misogynistic, racist and anti-Semitic, and that he exploited his employees and stole their ideas. And perhaps there's some truth to the idea that, in Meryl Streep's words, "Along with enormous creativity come certain deficits in humanity." In any case, the machine created by Disney continues to create wonderful dreams for both children and the "children at heart" throughout the world.

In 1953 Disney celebrated a silver anniversary: Mickey Mouse's 25th birthday. Here we see the famous mouse in the foreground, in front of two other much-loved characters: Donald Duck, born in 1934, and Goofy, from 1932. And, of course, behind them all stands Walt, the man who gave his imagination to the world.

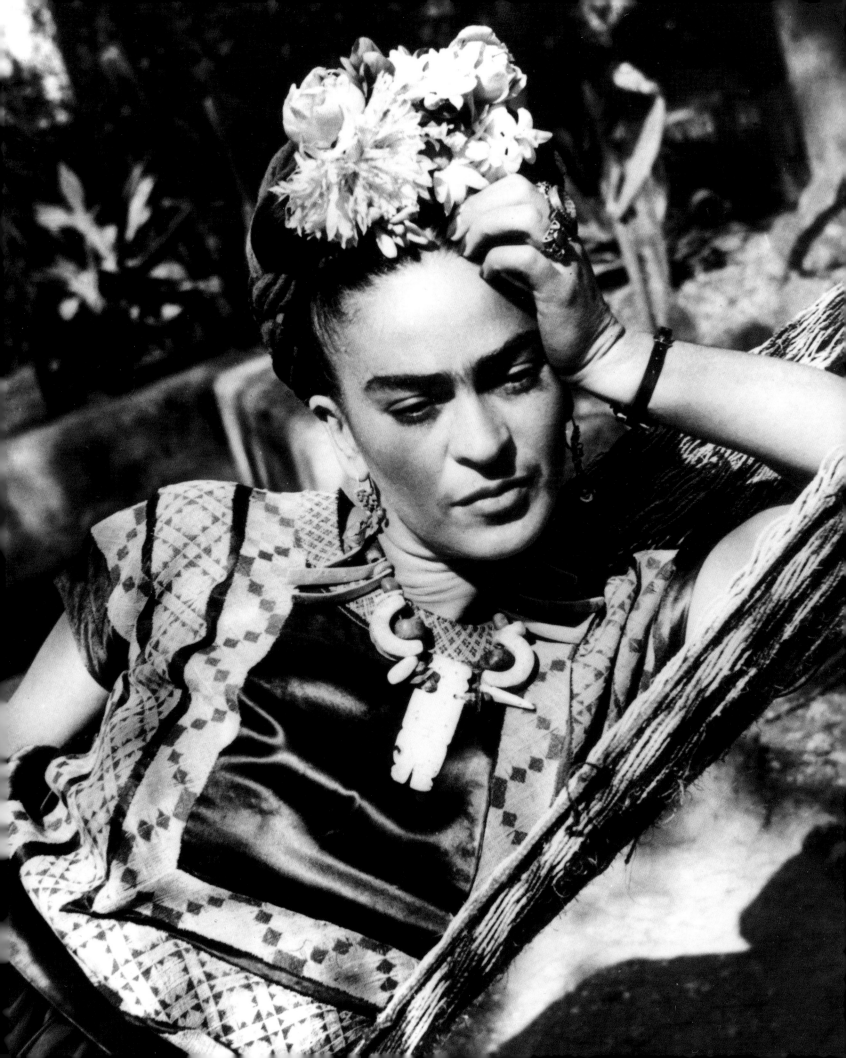

Frida Kahlo

Love and politics, nightmares and dreams: with passion and brazen sincerity, Frida Kahlo poured her whole self into art. Her works have become feminist and libertarian icons. For her, art was a joy in a life marked by pain: "I am not sick. I am broken. But I am happy as long as I can paint."

"There have been two great accidents in my life. One was the trolley, and the other was Diego. Diego was by far the worst." The best description of Frida Kahlo was by Frida Kahlo herself. The first accident took place in 1925. She was returning from school when the bus she was traveling on was hit by a streetcar. Her body was shattered: her legs were broken and her spine severed. Confined to bed for months, Frida began to paint self-portraits. The "accident" with Diego Rivera happened in 1928. She was 21, while he was 41 and one of the most acclaimed Latin American artists. They fell in love and married. Politically *engagés*, close to the Communist Party, they traveled the world. They were ambassadors for the cause of workers and for the indigenous people of Mexico. But it was a tortured relationship: she had an inexhaustible need for love, while he was an obsessive seducer, a serial cheater. In 1939, they divorced; they remarried the following year. Frida, however, was disenchanted, and learned how to get even with Diego. She was fascinating for women and men, and had passionate affairs with Lev Trotsky, the photographer Nickolas Muray, and the singer Chavela Vargas. Physically, she grew weaker day by day, and the constant torment she had to live with – through the anguish of three abortions, the sacrifice of a longed-for maternity, and the countless wounds caused by her love for Diego – could only be relieved by art. She painted iconic self-portraits, at the same time visceral and ethereal, in which her impassive, always identical face is accompanied by a mutable body: often nude, always disfigured, the body in her paintings is the theater of war, a metaphor for pain. Her style could not be reduced to any school and took time to be recognized. Only in her last years was she invited to exhibit in New York, Paris, and, in 1953, in Mexico City. The following year she died, at 47. There is a last note in her diary: "I hope the end is joyful, and I hope never to return." Beside the diary was the painting she was working on: a still life of watermelons with the words *Viva la vida*. Up to the end, Frida was happiest only in front of her easel.

A portrait of Frida Kahlo in 1950, at 43. She wears a traditional Mexican dress. The daughter of a German photographer and a wealthy Mexican woman, Kahlo was a spokesperson – together with her husband, Diego Rivera – for the rights of indigenous people well before post-colonial struggles against discrimination became a global concern.

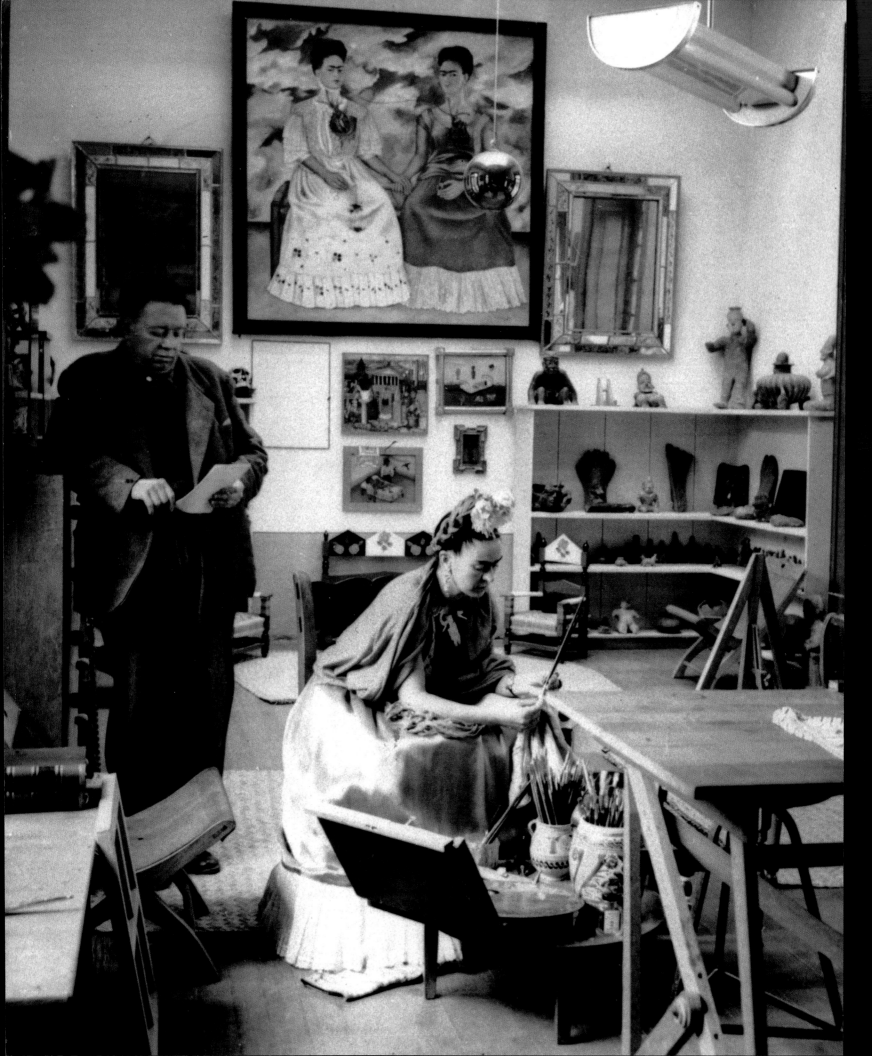

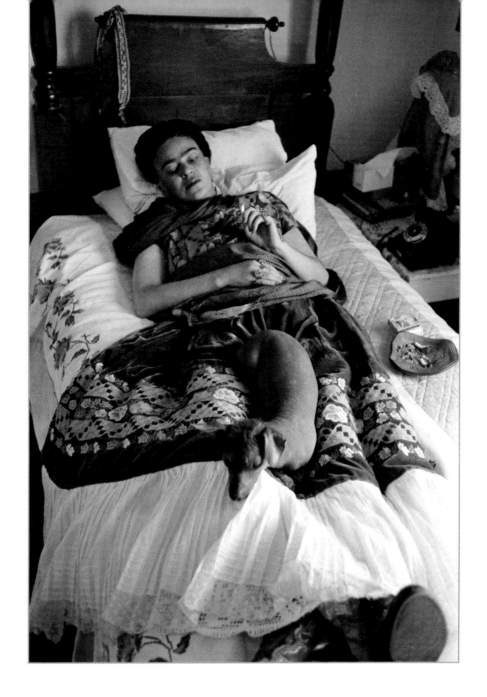

106 Frida and Diego Rivera in her studio, in 1945. On the wall hangs *The Two Fridas*, a painting in which Kahlo portrays herself in a double and ambivalent form: in a bloodied Victorian dress with a battered heart on the one side, and in a Mexican dress with an intact heart on the other. Frida painted it in 1939, after discovering the *liaison* between her sister Cristina and Diego. For this reason, she divorced him; they remarried in 1940.

107 Frida in her bed in 1954, shortly before her death. The painter never recovered from the accident which she suffered when she was 18 years old, and throughout her life she was forced to rest for several hours a day. In 1953, her condition worsened, to the point that when an exhibit was dedicated to her in Mexico City, Frida attended the *vernissage* in her bed, which was moved there for the occasion.

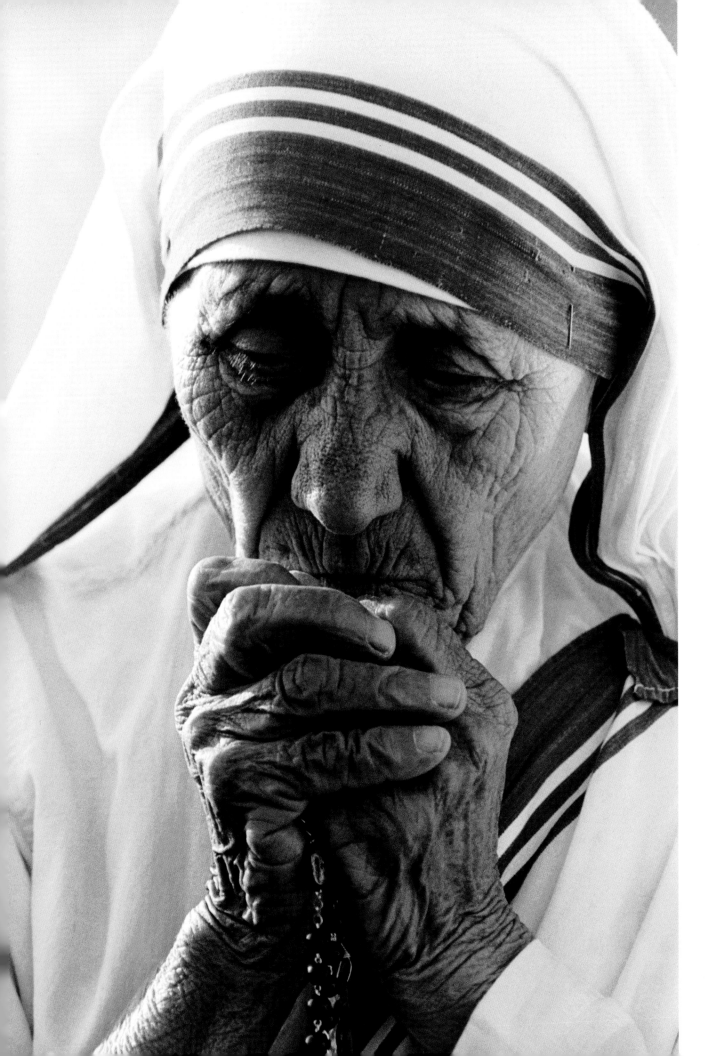

August 26th, 1910, Skopje, Ottoman Empire • September 5th, 1997, Calcutta, India

Saint Teresa of Calcutta

Of modern saints, Saint Teresa is the most popular and loved by the media, due in part to her ability to work with the poor and with world leaders.

When she was invited to the gala dinner for the Nobel Peace Prize, which she received in 1979, Saint Teresa asked for the event to be canceled and for the money saved (about $6000) to be given to the poor. "We ourselves feel that what we are doing is just a drop in the ocean. But the ocean would be less because of that missing drop," she liked to say. The episode encapsulates the life of the little nun. And although hers was a long, laborious life with the "poorest of the poor," it was not without some controversy. She caused a stir when she was in the spotlight, which was often with friends and celebrities like Lady Diana; in a sense, she was a star of charity. In fact, besides the Nobel Prize, she received a remarkable number of honors, including, from the U.S. President Ronald Reagan, the Medal of Freedom. Her popularity grew even more after her death, with her very rapid elevation by the Catholic Church: she was beatified in 2003, six years after her death, and canonized in 2016, after it was decided that she'd performed two miracles.

Her biographers describe both positive and negative aspects of her life: her total dedication to lepers and the hungry contrasts with a sometimes opaque administration of millions in funds; her contemplative vocation, inspired by Franciscan ascesis, is accompanied by doubts and crises in her faith. Merciful but intransigent, ecumenical but dogmatic (her campaigns against abortion and divorce are famous), Saint Teresa embodied the contradictions of the 20th century. Also for this reason, she remains the saint most representative of the century: a patron of voluntary work, she is the symbol for the ever-growing number who work in the voluntary sector.

June, 1985. Saint Teresa pauses for prayer and thought during the National Right to Life convention in Washington D.C. In her speech she addressed the right to life, and in particular the issue of abortion, which she always strongly opposed. When she accepted the Nobel Peace Prize, she described abortion and a woman's right to choose as "the greatest destroyer of peace."

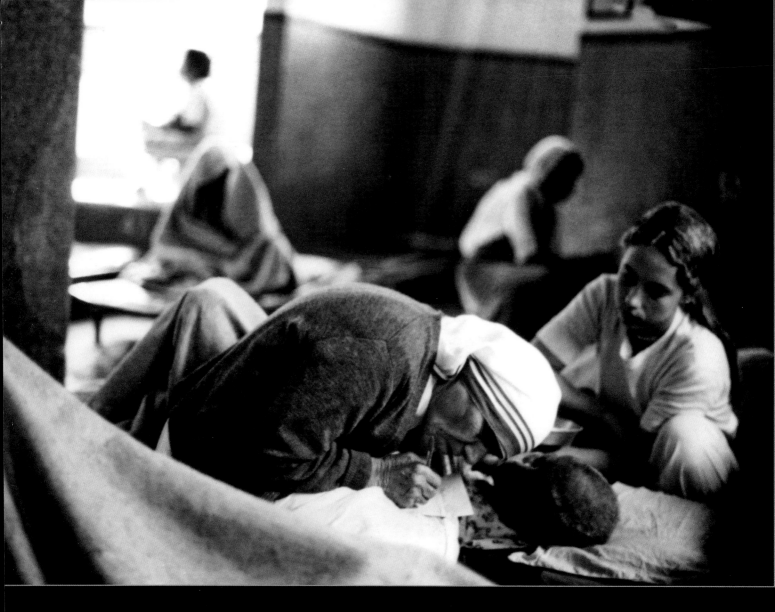

She was born in what today is Macedonia, into an Albanian family of Kosovar origin. At 18, she entered the Sisters of Loreto and in the first twenty years of her religious life she dedicated herself to teaching in a Catholic boarding school in Entally, India. In 1946, faced daily with poverty in the slums of Kolkata, worsened by the Second World War, her second vocation was formed: she obtained permission from the Vatican to leave her order so that she could live with the poor of the community. In a short time, other nuns joined her in the slum district of Motijhil, in Kolkata, and in 1950 it officially became the congregation of the Missionaries of Charity. They dressed in the distinctive blue sari with white and blue borders. One of the first initiatives of the new congregation was the Kalighat Home for the Dying, where the abandoned sick of every religion, Christians, Hindus, Buddhists, were received. This was followed by mobile clinics for lepers, reception centers, hospitals, and new communities in India and in many places throughout the world. The congregation even helped construct a homeless shelter at the Vatican. Today the congregation numbers 6000 nuns in 130 countries, and male congregations of the Missionaries of Charity have also formed: this growth is the real miracle of the Albanian girl who liked to describe herself as "a little pencil in the hands of God."

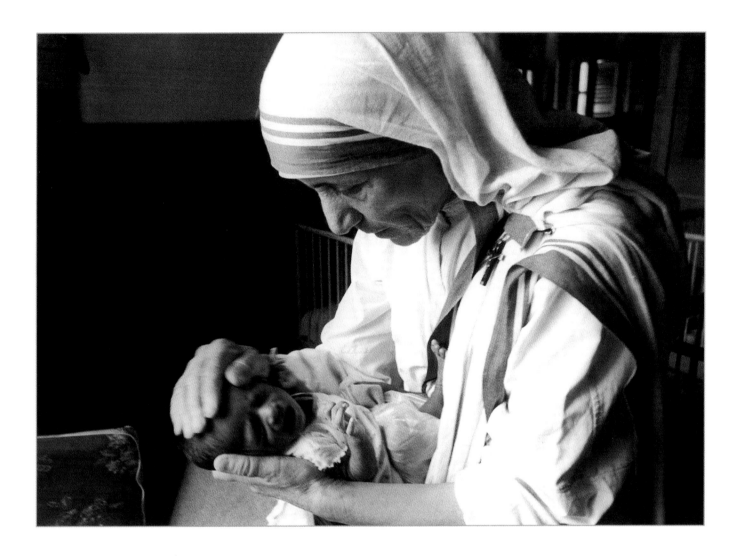

110 Mother Teresa, at a sick man's bedside, notes the words the man whispers in her ear, perhaps his last wishes before his death. The Kalighat Home (or Nirmal Hriday, "Home of the Pure Heart") was opened in 1952 to offer the incurably ill rejected by the hospitals a place to die with some medical care, independent of their religious affiliation.

111 In this photo from 1971, Mother Teresa holds a newborn in her arms in a Kolkata clinic. When faced with the problem of overpopulation and rapid demographic changes in India, she always opposed the use of contraception. It was a position that, for many, contradicted her commitment to fight poverty.

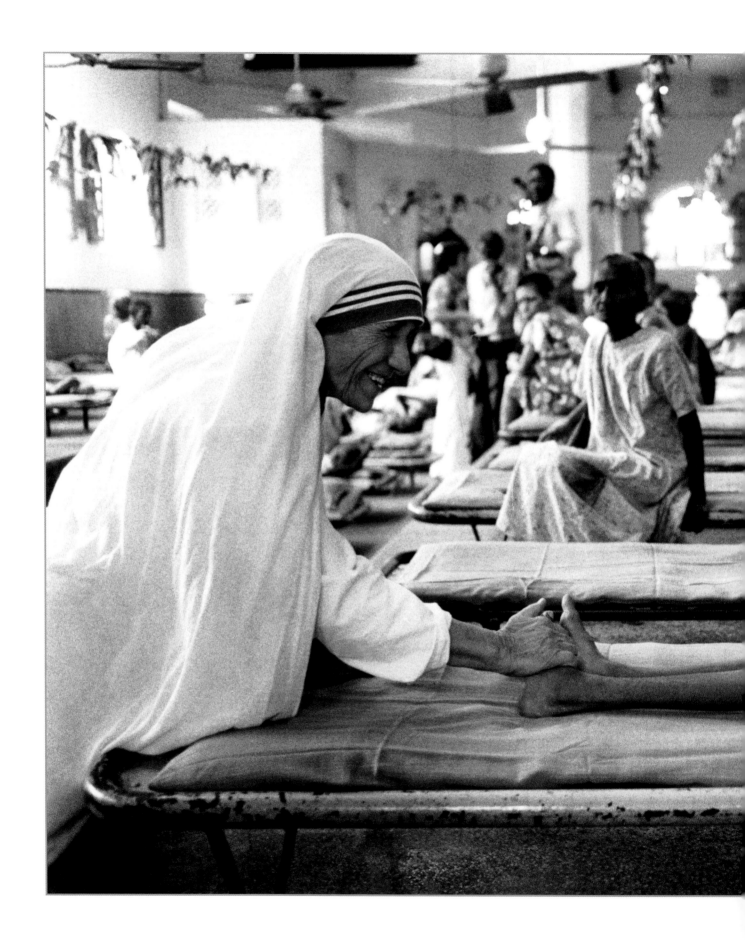

Saint Teresa of Calcutta

Saint Teresa, founder of the Missionaries of Charity, dedicated her life to the needy, inspiring many with her work. The cure of the sick was among the first and most important activities of her congregation. Here the nun is photographed in one of her Indian hospitals in the 1970s, the decade in which her name and work became famous throughout world.

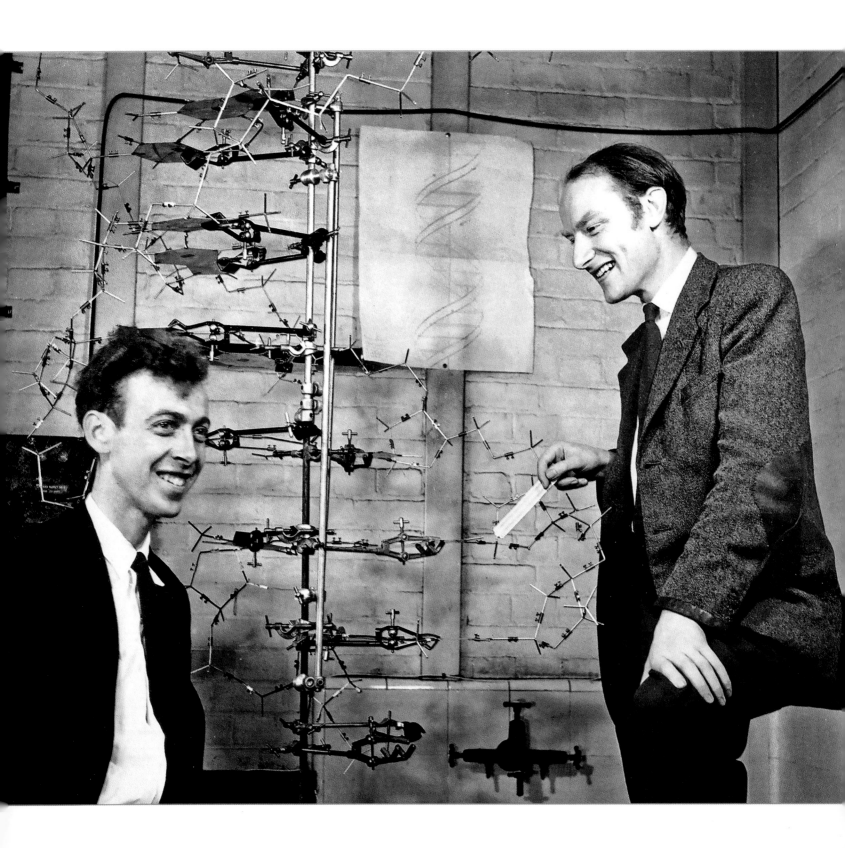

James Watson (left) and Francis Crick (right) smiling, satisfied with the three-dimensional model of the DNA molecule in the Cavendish Laboratory of the University of Cambridge. This photo was taken shortly after the publication of their discovery in the journal *Nature* (April 25th, 1953). Taped to the wall behind them is a sketch of the double helix by the painter Odile Speed, Francis Crick's wife.

James Watson and Francis Crick

Crick: June 8th, 1916, Northampton, United Kingdom • July 28th, 2004, San Diego, California, United States
Watson: April 6th, 1928, Chicago, Illinois, United States

The function of DNA was not discovered in a day. Many scientists worked on it for a long time. But we owe the fundamental intuition to two brilliant minds, an American and British scientist who combined all the pieces of the mosaic, completing a puzzle that was destined to revolutionize medicine.

In 1950, it was known that deoxyribonucleic acid (DNA) existed and that it contained genetic information. But the structure of this molecule, and the key to deciphering its content, were still unknown. Many scientists worked on this problem, competing feverishly in the search for a solution: understanding how DNA was organized would open the way to immense progress in medicine. It was in this context that, in 1951, two young scientists met at the Cavendish Laboratory in Cambridge. Francis Harry Compton Crick, British, was a 35 year old physicist; James Dewey Watson, an American biologist, was only 23 but, remarkably, had a doctorate and several years of research under his belt. The first was "almost totally unknown" and the second seemed "too bright to be really sound," to quote the words they would later use to describe each other; to their colleagues, the two young men were above all arrogant and overly intent on their careers. But Watson and Crick understood and respected each other. They began to collaborate, and in a short time succeeded in discovering what they described as the "secret of life." By integrating all knowledge of DNA, and drawing inspiration from the studies of Maurice Wilkins and Rosalind Franklin, they constructed a model that explained how the molecule, besides containing genetic information, also acted as a "mold" for its duplication. It was not yet the era of virtual simulations, so to represent it the two scientists had to get busy with wire and cardboard. The model, which had the fascinating form of the "double helix," was presented in the journal *Nature* on April 25th, 1953: that day marks the beginning of the molecular biology era. Almost inevitably, Watson and Crick, along with Wilkins, were honored with the Nobel Prize in Medicine in 1962. Then they took different paths, as happens with the DNA helixes during the replication: Watson dedicated himself to studies on cancer, Crick to neuroscience. And although there were some differences between them, their names will be united forever.

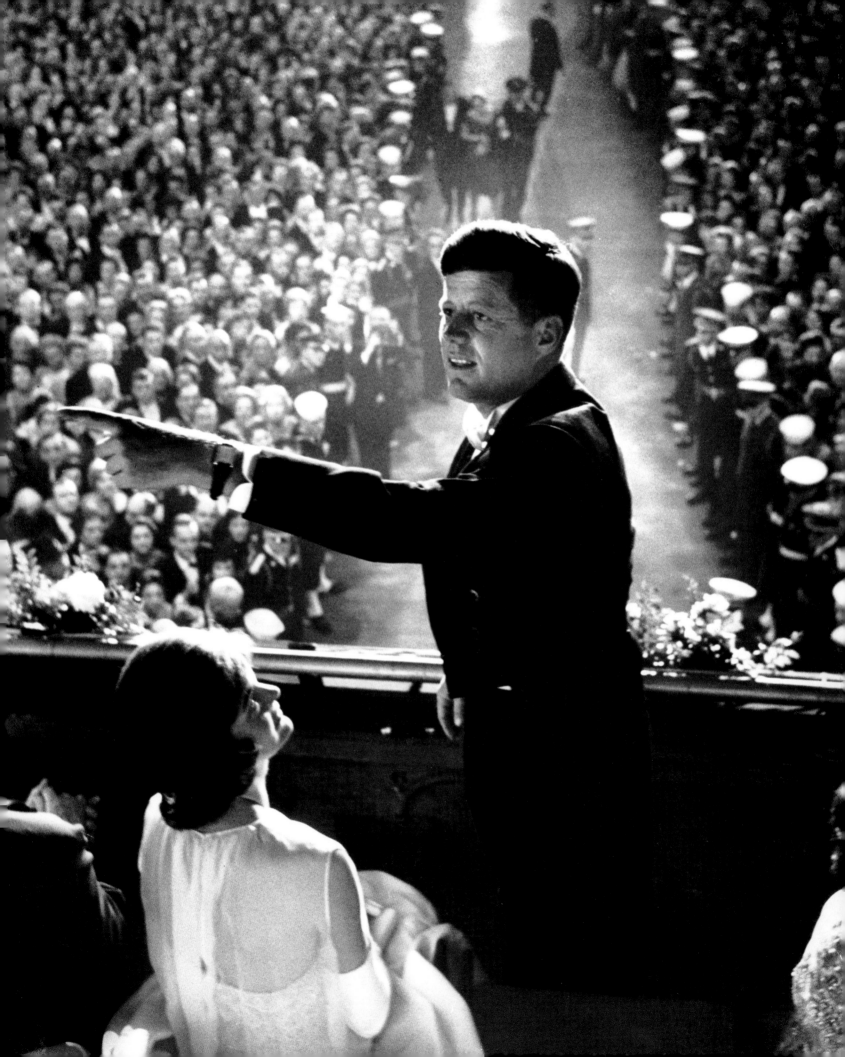

John Fitzgerald Kennedy

May 29th, 1917, Brookline, Massachusetts, United States • November 22nd, 1963, Dallas, Texas, United States

He was a young, brilliant, much-loved president. His election catapulted him right into the middle of the Cold War and domestic social tensions. On November 22nd, 1963, he became the victim of the most famous assassination in American history, an event wrapped in mystery to this day.

Destined for leadership, John F. Kennedy graduated from Harvard University at 23. During the Second World War he was wounded in the Pacific, but saved himself by swimming three miles to a small island. At 35 he became the senator from Massachusetts, and in 1957 he won the Pulitzer Prize for *Profiles in Courage*. As the culmination to a lightning rise in politics, in 1960 he became President at 43. He was the youngest man ever elected to the position, and the first president born in the 20th century.

John came from two families, the Kennedys and the Fitzgeralds, both of the upper echelon of Boston society. But he was not the classic WASP: he was Catholic, and before the Catholic archbishop of the city he had married a woman, Jacqueline, who was not only extremely beautiful, but was also a woman with charisma and exceptional *savoir-faire*. When they took up residence at the White House, they created a new way of conceiving of the presidency and the role of the First Lady. They invited to their home artists and intellectuals. Her style influenced fashion, and their private life filled the pages of magazines, which only increased the popularity of the President.

Millions of Americans hit by the recession of 1960-1961 relied on Kennedy, who was liberal and progressive. He was also a source of hope for African Americans, who were victims of anachronistic segregation. The President financed space exploration, increased defense expenditure, and sent soldiers and military advisers to South Vietnam.

Washington, January 20th, 1961. John F. Kennedy and Jacqueline celebrating at the traditional event launching the new presidential term. Kennedy has just been sworn in as President. His inaugural address is remembered for the famous words "Ask not what your country can do for you; ask what you can do for your country."

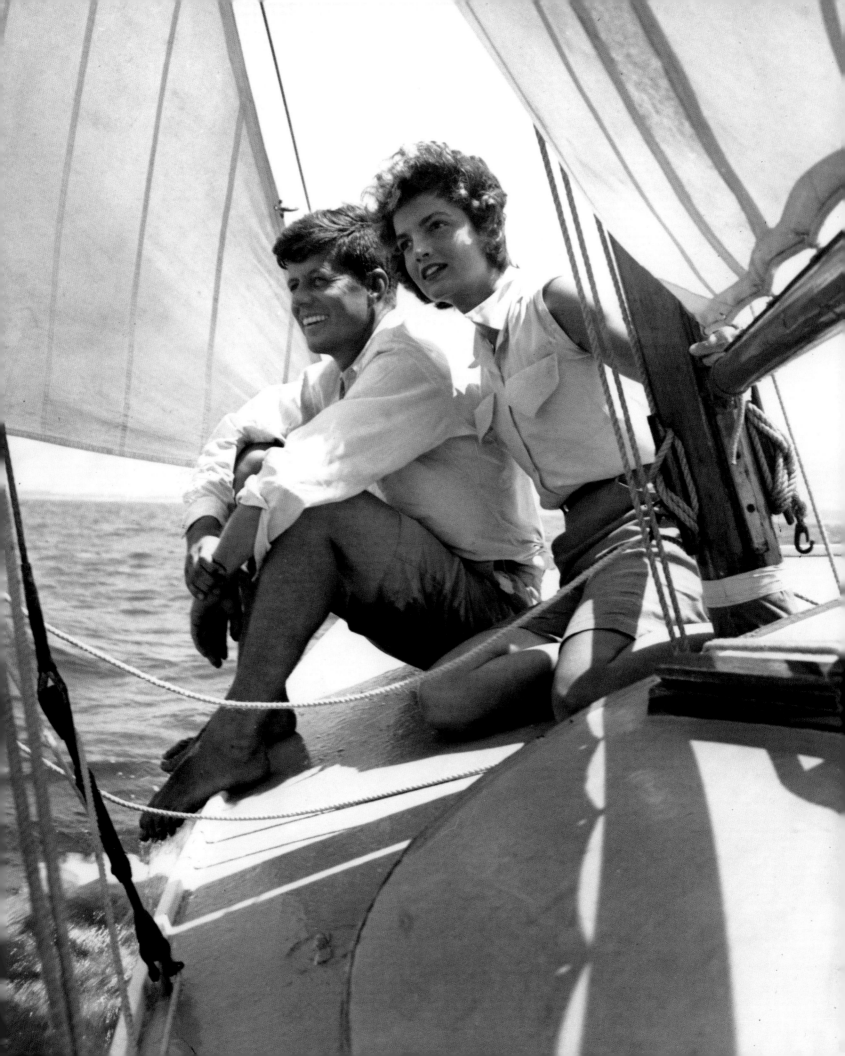

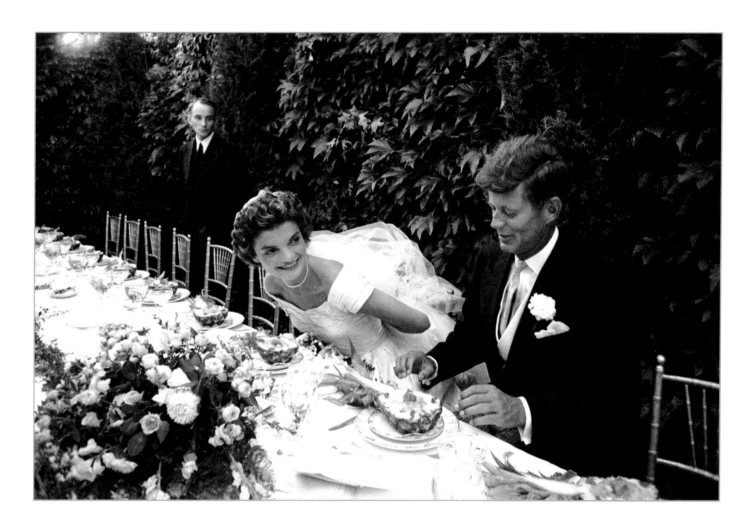

118 June, 1953. John and Jackie, during their engagement, on a sailboat off Hyannis Port, in Massachusetts. They had met only two years before, on the occasion of her article for the *Washington Times-Herald* on John's father, Senator Joseph P. Kennedy. Another politician interviewed by Jackie in that period was Richard Nixon.

119 John and Jackie at the table on their wedding day, September 12th, 1953. She was 24 years old and he was 36. The wedding banquet was held on Hammersmith Farm, Rhode Island, a property owned by the Bouvier family. In a few years it would become the "Summer White House." The Bouvier-Kennedy wedding, with about 700 guests, was the fashionable event of the season.

John Fitzgerald Kennedy

It was the middle of the Cold War, and it was precisely in the place where the Iron Curtain was most tangible, in the city divided by the Wall, where JFK perhaps best demonstrated his oratory, his ability to empathize with the crowd, when he said, "Ich bin ein Berliner" ("I am a Berliner"). The most critical moments of his presidency were during the Cuban Missile Crisis: the standoff with Khrushchev took the world to the brink of nuclear war. Fortunately for humankind, this war has been seen only in movie theaters.

His life was full of challenges overcome, and of messages for the future: "We find ourselves today on the threshold of a New Frontier – the frontier of the 1960s, the frontier of opportunities and unknown perils, the frontier of great hopes but also of grave threats." These perils and threats awaited him in the crowd one Friday morning in the autumn of 1963. The President was in the back seat of a Lincoln Continental limousine, proceeding along the wide, sunny boulevards of Dallas, when he was killed by an unspecified number of bullets. The unreliable Warren Commission would declare Lee Harvey Oswald to be the only assassin, also closing rumors about Kennedy's continuous extramarital affairs – in this regard, Marilyn Monroe had died in mysterious circumstances a year before.

During the presidential campaign, Kennedy and Jackie are greeted festively on Broadway. It is October 19th, 1960, and he will give a speech to union leaders in Union Hall Auditorium. The United States risks recession: as President, Kennedy would take various measures to help the lower class, like increasing unemployment benefits and the minimum wage.

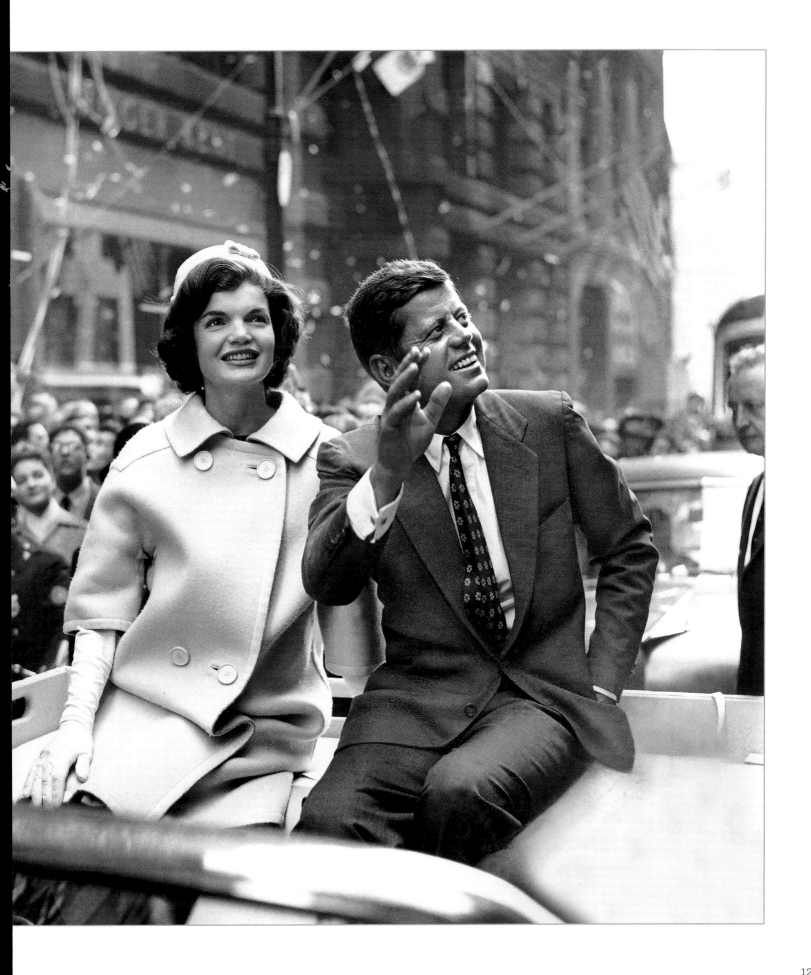

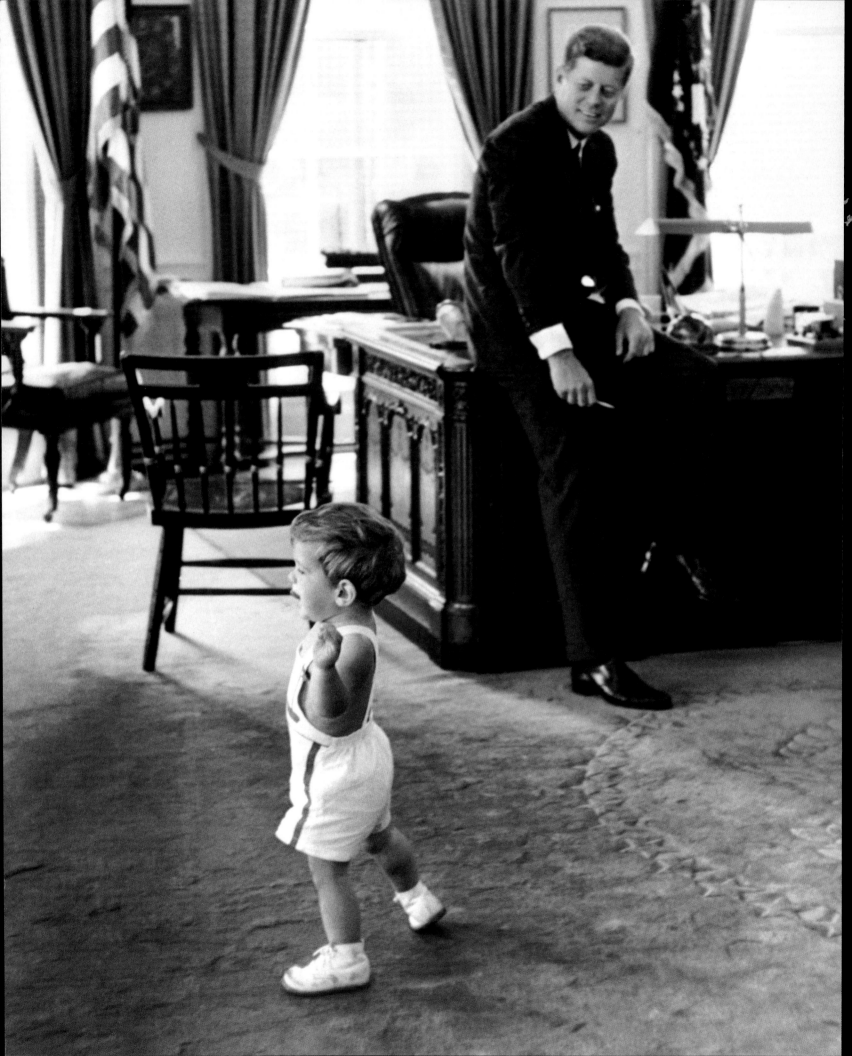

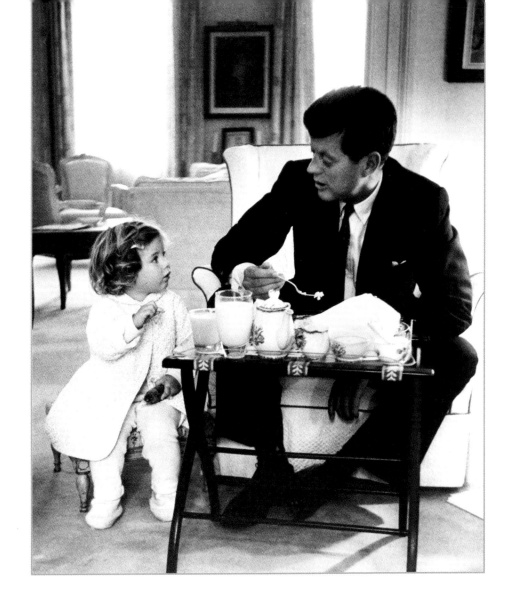

Beside him, in his last moments of life, was his wife Jacqueline, in a pink Chanel suit: a few hours later, still wearing the suit stained with her husband's blood, she boarded Air Force One, on which Lyndon B. Johnson was sworn in as President. Three days later, the funeral procession – headed by Jacqueline and her two children of six and three – was broadcast by NBC in 23 countries, including the Soviet Union: the entire world was shaken by the sudden death of a president who, more than any president before him, had been able to persuade, lead, and be loved by a nation.

122 Kennedy watches his son, John Jr., called John-John, taking his first steps in the President's White House office. John Jr. was born on November 25th, 1960, just after the election, and was John and Jackie's second child: in 1957 they had a girl, Caroline. In 1999, John Jr. will die in a plane crash off the coast of Martha's Vineyard.

123 Kennedy having breakfast with his daughter, Caroline, in 1961. In his 1036 days in office, Kennedy rejuvenated White House communication by authorizing the publication of snapshots of him in intimate and family moments. These would restore an image of the First Family that was reassuring and close to people's daily life.

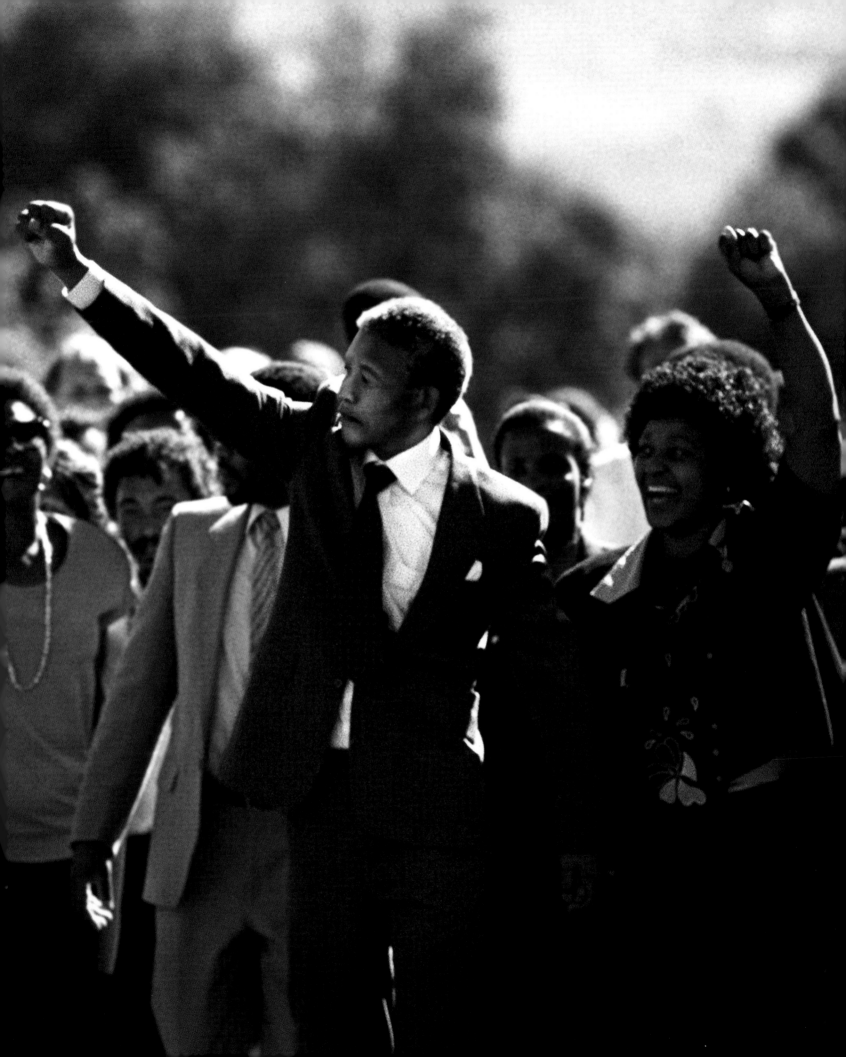

Nelson Mandela

Can 27 years in prison make a man give up when he deeply believes in his ideas? In the case of Nelson Mandela, who was committed for fighting the obscenity of *apartheid*, the answer is no.

In the South Africa of 1918, a man's fate was written before his birth. It depended on the color of his skin. The fate of Nelson Mandela, the son of a tribal chief of the Thembu, of the Xhosa ethnic group, was to be a citizen without rights. Even though the *apartheid* regime had not yet come into force, already in that era it was impossible for Blacks and Asians to work in certain sectors, travel without permission, go into politics, or freely choose where to live. But Mandela's middle name was Rolihlahla, meaning "trouble maker," and he was instinctively allergic to limitations on freedom, even those imposed by his own people. In his early twenties, for instance, in order to avoid an arranged marriage, he left his family, even though they had enabled him to attend the best schools. Obviously, these were schools for Blacks only. He moved to Johannesburg, where he concluded his legal studies while taking up socialist and pan-African ideas. Mandela enrolled in the African National Congress (ANC), which was formed to defend the rights of the Blacks. Initially, the struggle against segregation was peaceful: following Gandhi's example, Mandela organized strikes and demonstrations. Then, after a series of arrests, he went underground and, in 1961, joined the armed resistance.

He was captured a year later. In 1964, he was sentenced to life imprisonment for sabotage, incitement to strike and subversive activity. It was an excessive sentence, followed by inhumane imprisonment.

It is February 11th, 1990, and Nelson Mandela has just been released from Victor Verster Prison in Paarl, after 27 years' imprisonment. In this photo by Alexander Joe, the leader of the anti-apartheid movement holds the hand of his wife, Winnie Madikizela, whom he married in 1958. Moved and satisfied, they both greet the festive crowd by raising their fists in a sign of victory.

July 18th, 1918, Mvezo, Union of South Africa • December 5th, 2013, Johannesburg, South Africa

In the maximum security prison of Robben Island, locked in a cell four meters square, harassed by the prison guards, Mandela was forced to sleep on the floor and to break stone in a quarry under the hot sun, where, incidentally, he ruined his eyesight.

But there exist extraordinary men who are capable of transforming even decades of oppressive imprisonment into creative energy. Thus it was from prison that Mandela, instead of giving in, took up his battle again. He did this by reading poetry, because beauty helps us remain human, by studying Afrikaans, the language of his white jailers, and fighting, successfully, for the improvement of living conditions for the prisoners.

Meanwhile, numerous awareness campaigns abroad asked for him to be freed: but only in 1990, in a political context revolutionized by the imminent collapse of the USSR, international pressure succeeded in prevailing over South African resistance, which had until then been supported by Western complicity.

Nelson Mandela returns to visit the Robben Island maximum security prison, off Cape Town, where he spent 18 years. Jürgen Schadeberg, who photographed Mandela in 1952, captures this moment while the former prisoner looks through the bars of his cell, two meters by two. It is 1994: Mandela has just been elected President, the first black man to hold the position in the history of South Africa.

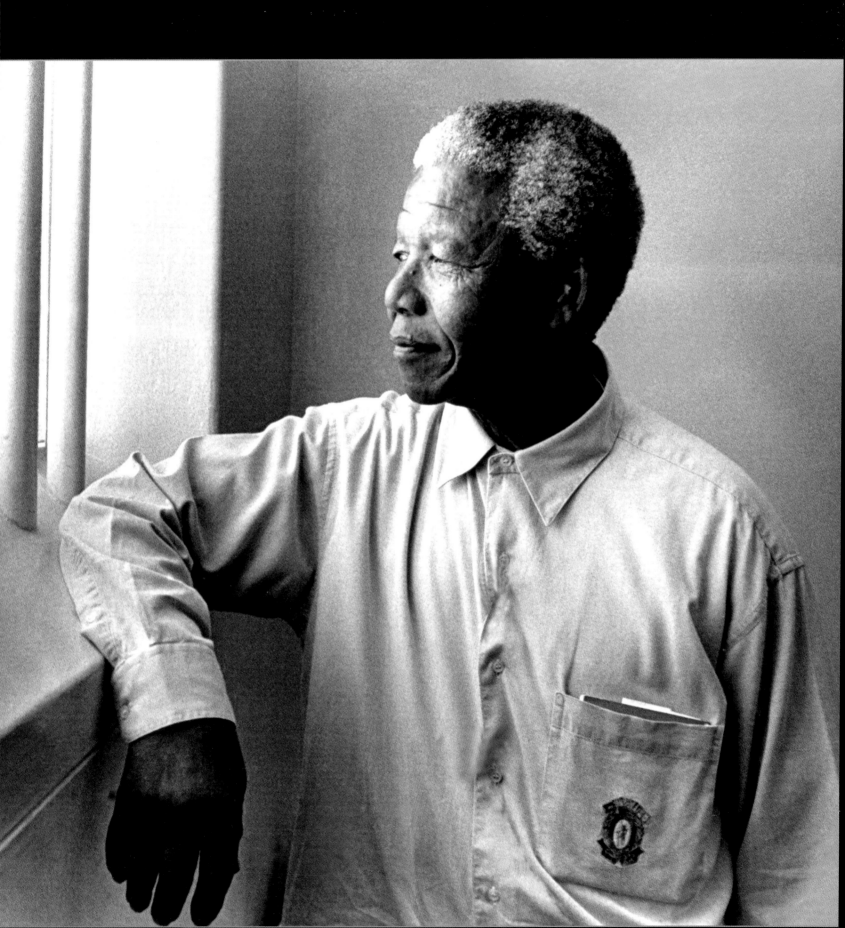

Nelson Mandela

On February 11th, the liberation of the life prisoner Mandela was much more than a transformative moment in the history of his country. It marked the end of an entire historical era, that of slavery and colonialism. And it decreed global condemnation not only for segregation policies but also for racism itself.

In 1993, Mandela, the smiling symbol of resistance against injustice, the symbol of every struggle for civil rights, was awarded the Nobel Peace Prize. In the following year he became President of South Africa. During his presidency, the watchword was reconciliation: he did not seek revenge and did nothing to remain in power. In fact, he yielded power after only one term, opening the way for a new generation, a new, young, free Africa.

Close-up of Nelson Mandela, smiling and with a lined face, by Paul Botes (1998): the President is in his office in Pretoria, during a meeting with foreign students. In the following year he will turn 80 and will decide not to run for office again. He will retire from politics. He will dedicate himself to philanthropic activities, to supporting human rights organizations, and to his family.

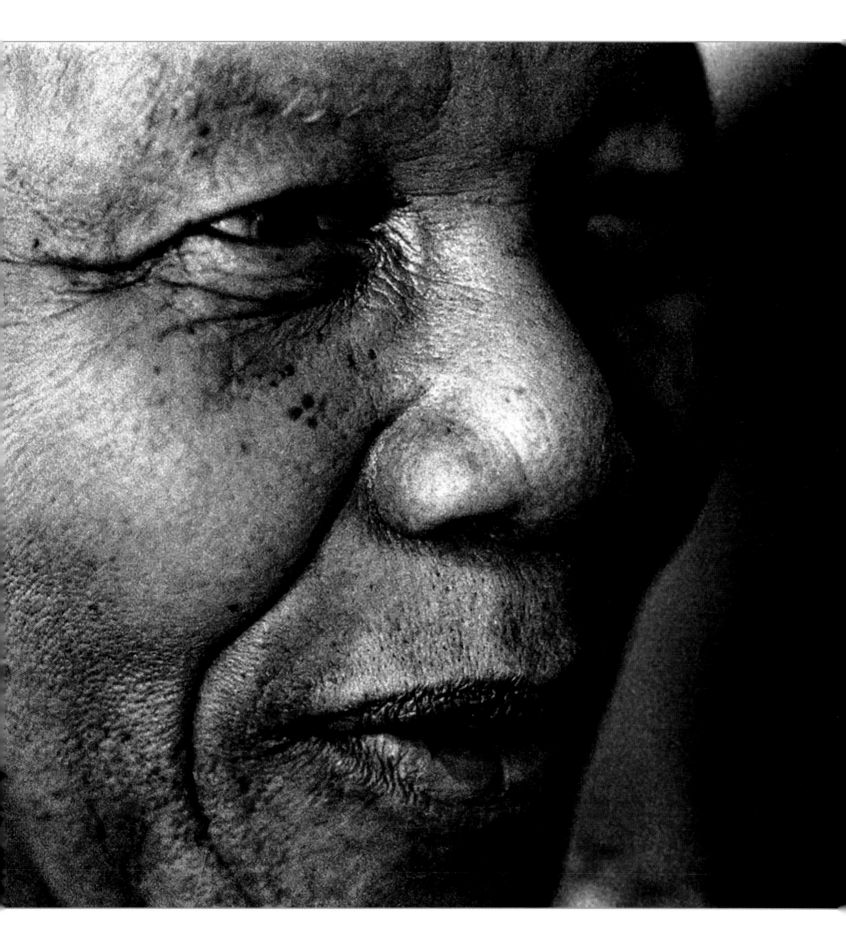

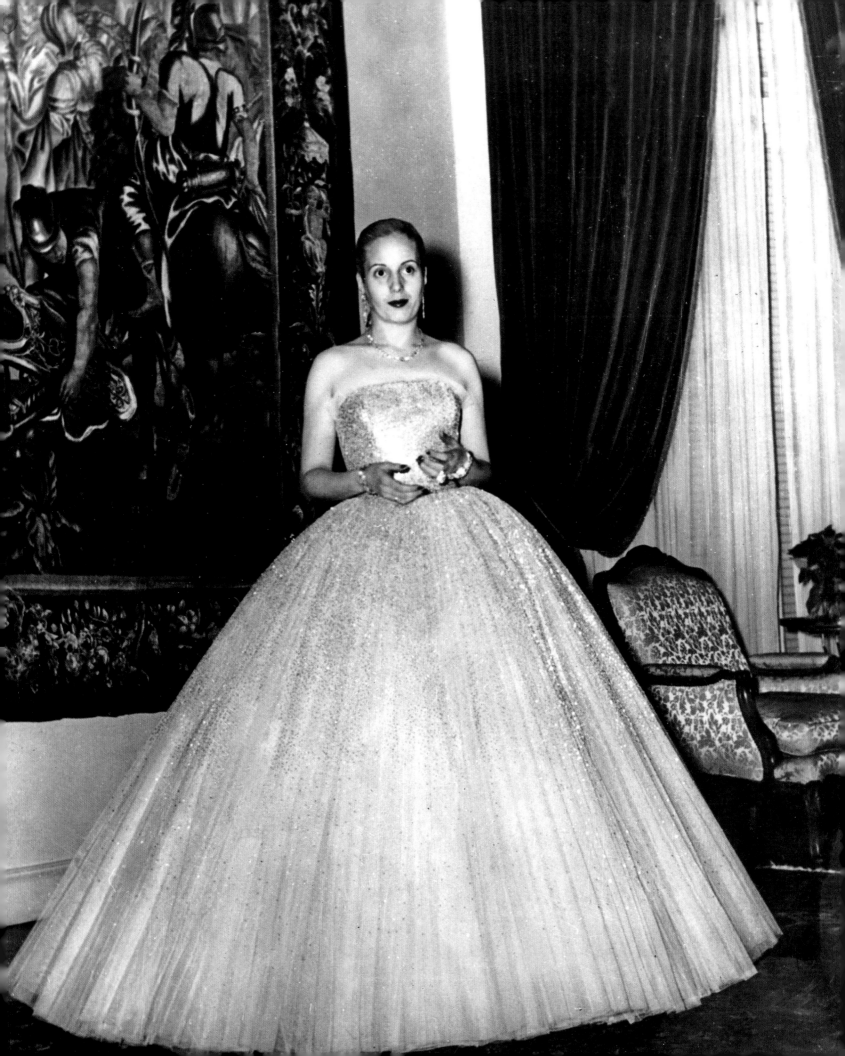

Eva Perón

Her life was short and controversial, made up of overwhelming, sometimes extreme, emotions. Like a modern fairy tale, in her lifetime she was already an icon, mysterious and unique in the collective imagination.

On June 4th, 1952, Eva María Ibarguren Duarte took part in a parade for the re-election of her husband, Juan Domingo Perón, the President of Argentina. She was extremely elegant, faithful to her star image, and stood in the presidential car, smiling and waving to the crowd. Although the people knew that Evita – her popular diminutive – was ill, they could not imagine that her condition was desperate. In reality, under her fur she hid a body wasted and kept upright only by morphine, a corset, and infinite pride. Thus the last act of a modern fairy tale played out.

The "spiritual leader of the nation," as Perón described her, Eva was only 33 when she died. Although cut short, her intense life and dazzling rise in society would prove worthy material for a Broadway musical.

Born the illegitimate daughter of a provincial landowner, she was wretchedly poor as a child. Despite this, and through hard-earned success in the world of show business, she eventually married the most powerful man in Argentina, a politician whose colorful populism she shared. The role of First Lady was one that Eva played in a revolutionary way. She intervened in her husband's policies, presenting herself as an advocate for women and the poor. She combined receptions and public speeches, glamour and generosity.

Eva's every move is followed and immortalized by photographers, who are drawn to her glamor and relaxed affability. In this photo taken on May 31st, 1951, she wears a gorgeous evening dress, and is about to leave the Presidential Palace in Buenos Aires to go to the theater. The theater has always been her passion.

In some ways, she was the precursor of figures like Princess Grace and Jackie Kennedy. She helped women gain the right to vote in Argentina, and as a liaison for the working class in the president's office, she had schools and hospitals built, all of which earned her the nickname "the Madonna of the humble." In one of her last speeches, she declared: "I have one thing that counts, and that is my heart. It burns in my soul, it aches in my flesh, and it ignites my nerves: that is my love for the people and for Perón. [...] If my people asked me for my life, I'd give it to them, singing, because the happiness of a single *descamisado* is worth more than my whole life."

The announcement of her death plunged the entire nation into mourning, but immediately began to create her myth: she was a queen in the collective imagination, and continued to be young, beautiful and generous. Her legend is still applauded on the stage in many countries.

In this photo, Eva, like a true queen, leans from a balcony of the Casa Rosada in Buenos Aires and waves to the crowd with her right hand, almost stealing the scene from her powerful husband beside her; he smiles proudly. It is October 17th, 1950, and Argentina is celebrating the fifth anniversary of the foundation of the Peronist Movement.

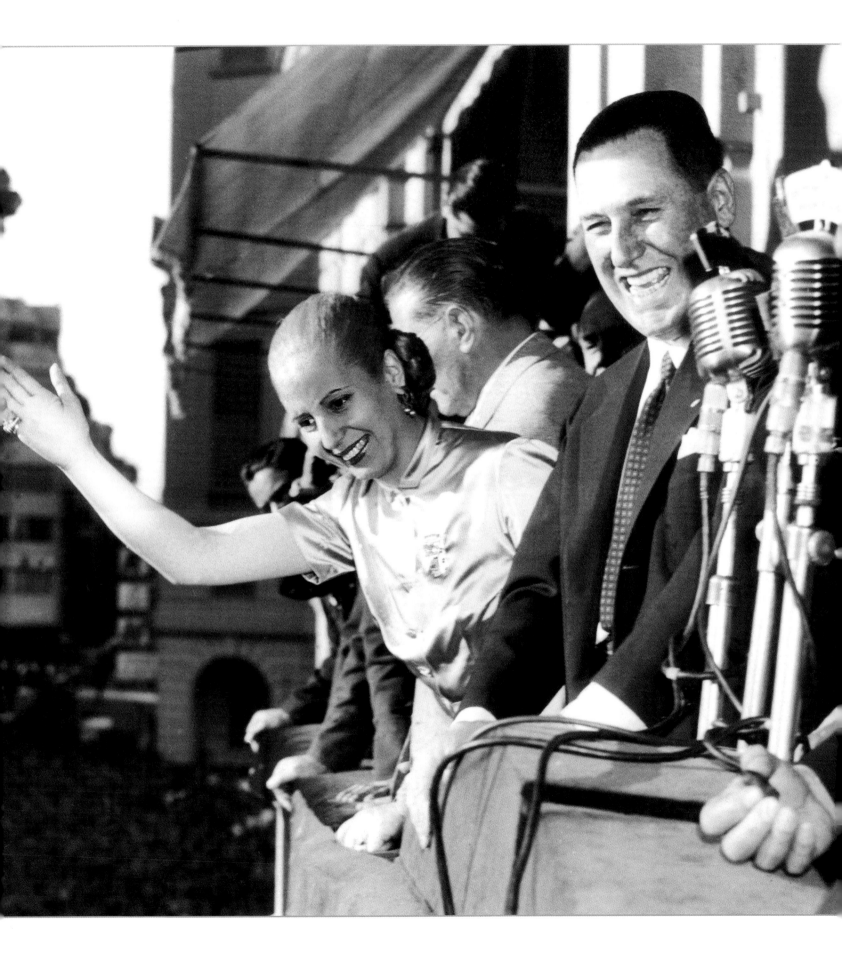

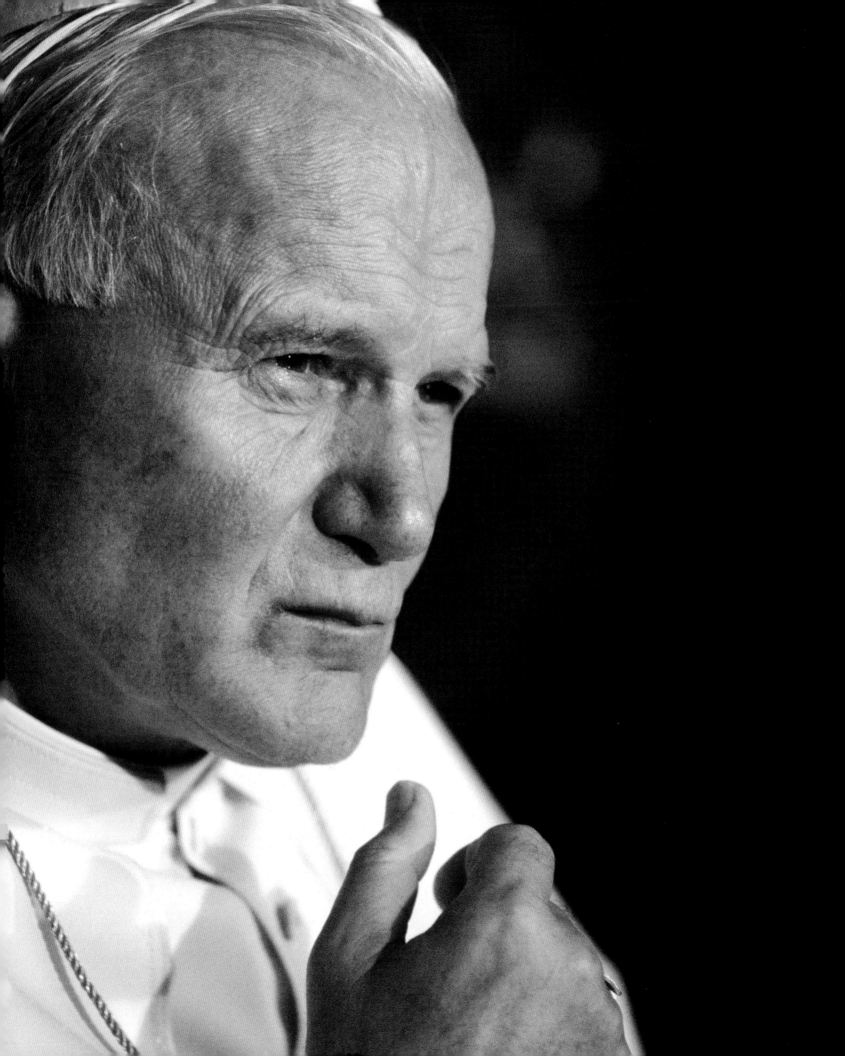

John Paul II

Karol Wojtyła was the first foreign pope after nearly 500 years of Italian nominations. He brought charisma, humanity and spirituality to his long pontificate, during which he emphasized evangelization and internal reforms of the Church.

Those who saw John Paul II's funeral on April 8th, 2005, will never forget the strong wind blowing in Saint Peter's Square. The purple vestments of the high prelates and the ties of the heads of State fluttered and swirled, disrupting the solemn funeral. The pages of the Gospel on the casket also danced in the wind, until the book was closed. In this way, the 27-year pontificate of the Polish pope concluded: a river of people had gathered in Rome to pay him homage. Like that wind, the actions of Karol Wojtyła had been restless, breaking with tradition. But on that day, as in past years, Catholics came from "far and wide" to demonstrate their great affection for the pope.

From the throne of St. Peter's, Wojtyła had pleaded the cause of brotherhood, forgiveness, and the unity of the Church. Right from his modest request, on October 16th, 1978 – "se mi sbaglio mi *corigerete*" ("if I make a mistake, you'll *corrict* me") – referring to his uncertainty in Italian, he gained the love and admiration of Catholics everywhere, drawing a smile from those receiving his blessing. He was immediately recognized as an unusual pope: humble, ironic, direct, and with an imposing physical presence – soon photographs appeared in the newspapers showing him on skis in the mountains. He was a pope who spoke many languages, and who entered the priesthood in secret, in the aftermath of the Second World War, when the pro-Soviet government imposed state atheism in Poland.

He declared himself to be the enemy of all "false prophets," of the ideologies that undermined religious freedom, of both unbridled Capitalism and Communism. From the start, he ventured into countries where he thought it was necessary to signal support for future change. He made more than 100 visits to often difficult places, from the Philippines to Africa, from Cuba to his own Poland, where he backed, with some criticism, the Solidarność movement contesting the Communist regime.

In October, 1986, Pope John Paul II was in Lyon, France. He spoke to the city's Jewish community and to teachers at the Catholic University. He also visited Le Prado, the female community in the industrial suburb of La Guillotière, for the beatification of the founder, Father Antoine Chevrier. The pope praised Chevrier's simple life and testimony to the Gospel.

John Paul II had a special relationship with the media. As if to reciprocate for the coverage, he made very dramatic gestures. In the Jubilee Year of 2000, he asked for forgiveness for all the sins committed by the Catholic Church: from the Inquisition to racial discrimination. The Pope was the channel for repentance; on his knees at the foot of the cross he set himself apart from those in the highest positions of the ecclesiastical hierarchy. In the same way, he bore witness to the "personal" forgiveness of the criminal Ali Ağca, who on May 13th, 1981, attempted to assassinate him.

He was deeply devoted to the Madonna, so much so that he dedicated his apostolic motto *Totus tuus* to her, and he encouraged everyone to share the words of the Gospel especially with young people. He began International Youth Days, immense gatherings for his "sentinels of the morning."

He remained a central figure even when, owing to illness, he became physically frail. After his death, a lightning canonization process proclaimed, in 2014, the sainthood of a man whose pontificate brought the Church into the Third Millennium.

136-137 On April 5th, 1995, on the occasion of the traditional Wednesday General Audience, Pope John Paul II crosses Saint Peter's Square in the "popemobile," the vehicle used by the Pontiff for official occasions. In the past, Pope Paul VI sometimes used an open off-road vehicle to greet the crowd during short visits, but Wojtyła was the first pope to regularly use a car designed especially for him.

138-139 In Lithuania, on September 7th, 1993, John Paul II visited the Hill of Crosses, donating a crucifix. The Pope was moved by the 400,000 crosses of every shape and size, memorials for the deportations and imprisonments suffered by Christians in Eastern Europe. Symbols of the Lithuanians' faith, they were removed several times by the Soviet regime, but each time they reappeared in greater numbers.

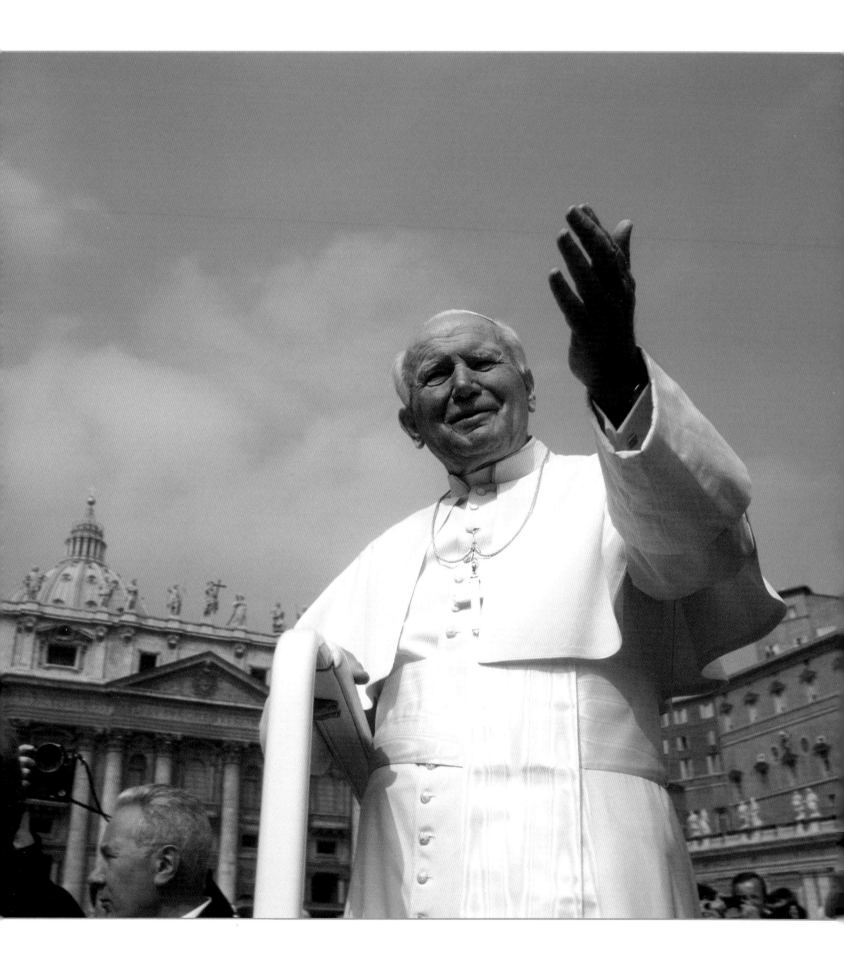

137

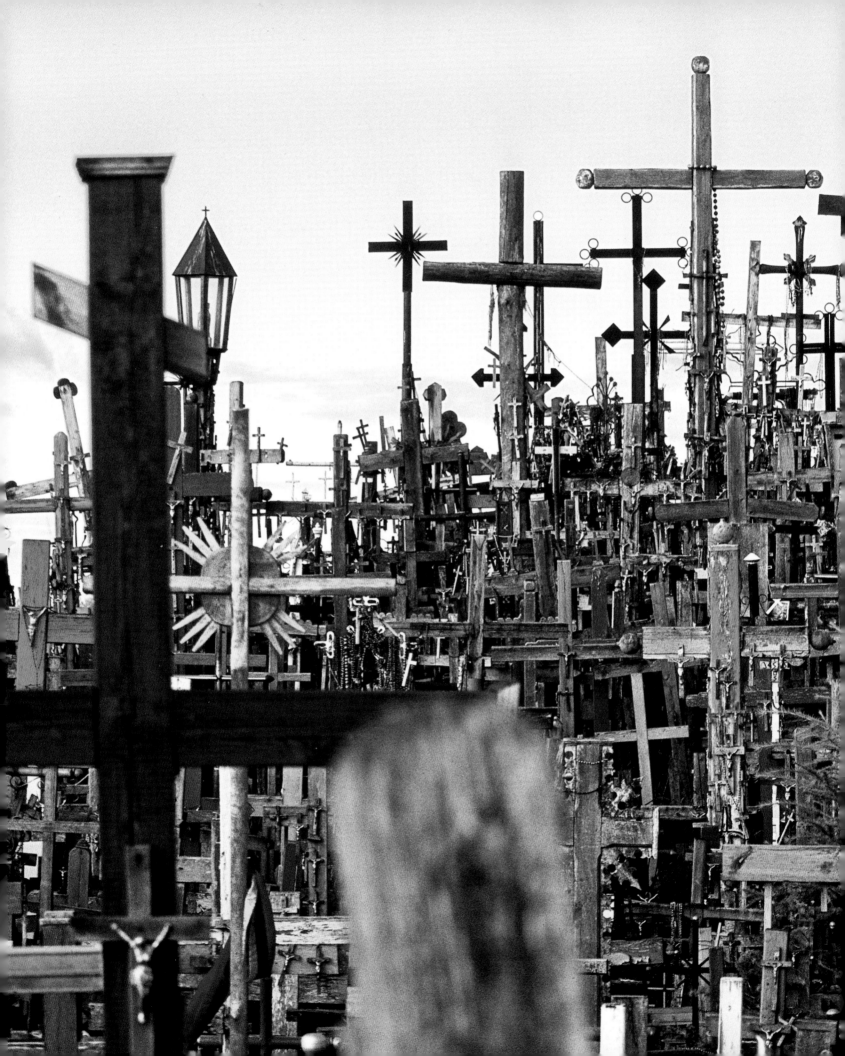

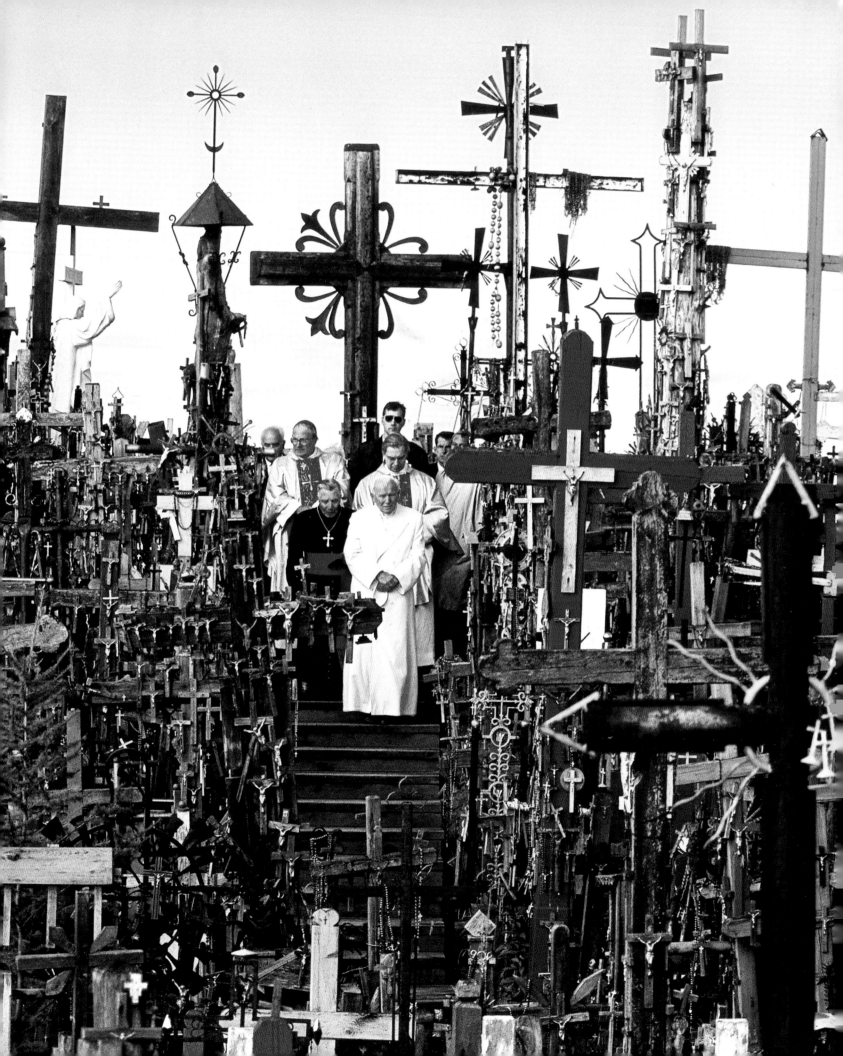

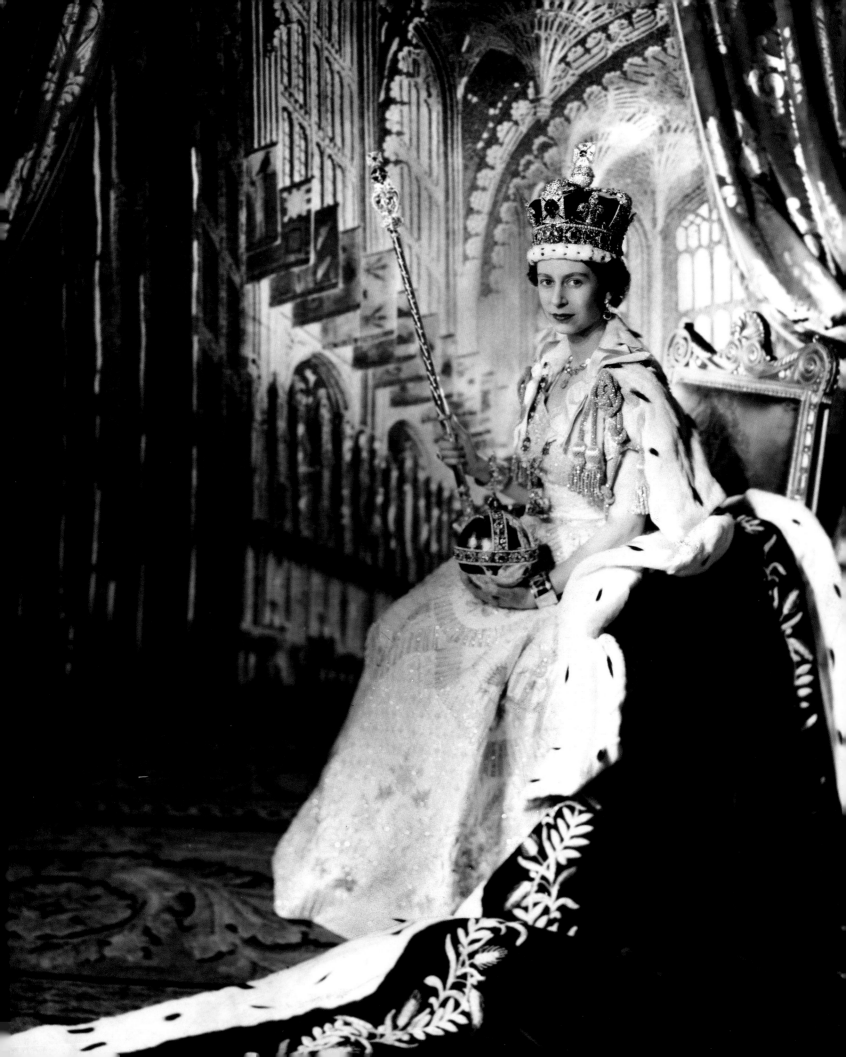

Elizabeth II

Armed with a hat, a handbag and a touch of lipstick, the longest-reigning British sovereign has lived through the decades without ever losing her aplomb. She represents the incarnation of the continuity of the United Kingdom, from the age of the colonies to that of the Web.

Elizabeth Alexandra Mary Windsor was not born to be queen, but became The Queen *par excellence*. Although the queen is a timeless symbol of the monarchy, of a world faithful to etiquette, sobriety, tradition and discretion, the reign of Elizabeth II has been marked by family events and scandals worthy of a soap opera. These began in the very way Elizabeth became heiress to the throne. In fact, she was born the elder daughter of the Duke of York, Albert, the second in line to the succession after his brother, Edward. But in 1936, Edward decided to abdicate to marry the American divorcée Wallis Simpson, a bewildering choice for the Royal Family and for public opinion. (This was before the popular and much discussed love story between Prince Charles and Camilla Parker Bowles.) So Albert ascended the throne as George VI, and "Lilibet," as she was nicknamed in the family, at the age of ten began to prepare for a future as queen. In view of the day when she would receive the crown, young Lilibet was apprenticed in private lessons and official meetings. The day arrived all too quickly: in 1952, Prince Philip, her husband for almost five years, brought her the news of the death of her father. She was 25. As queen, she chose to maintain her name, linking herself to Elizabeth I, one of the most iconic figures in British history. And then she found herself reigning over the largest empire in the modern era.

April 21st, 1926, London, United Kingdom

The coronation of Elizabeth II took place in Westminster Abbey on June 2nd, 1953, after a period of mourning for the death of George VI. In this official portrait by Cecil Beaton, the sovereign displays the symbols of power: the ermine cloak, the scepter, the orb, and Saint Edward's Crown. It is said that to become accustomed to the crown, Elizabeth often practiced wearing it in private.

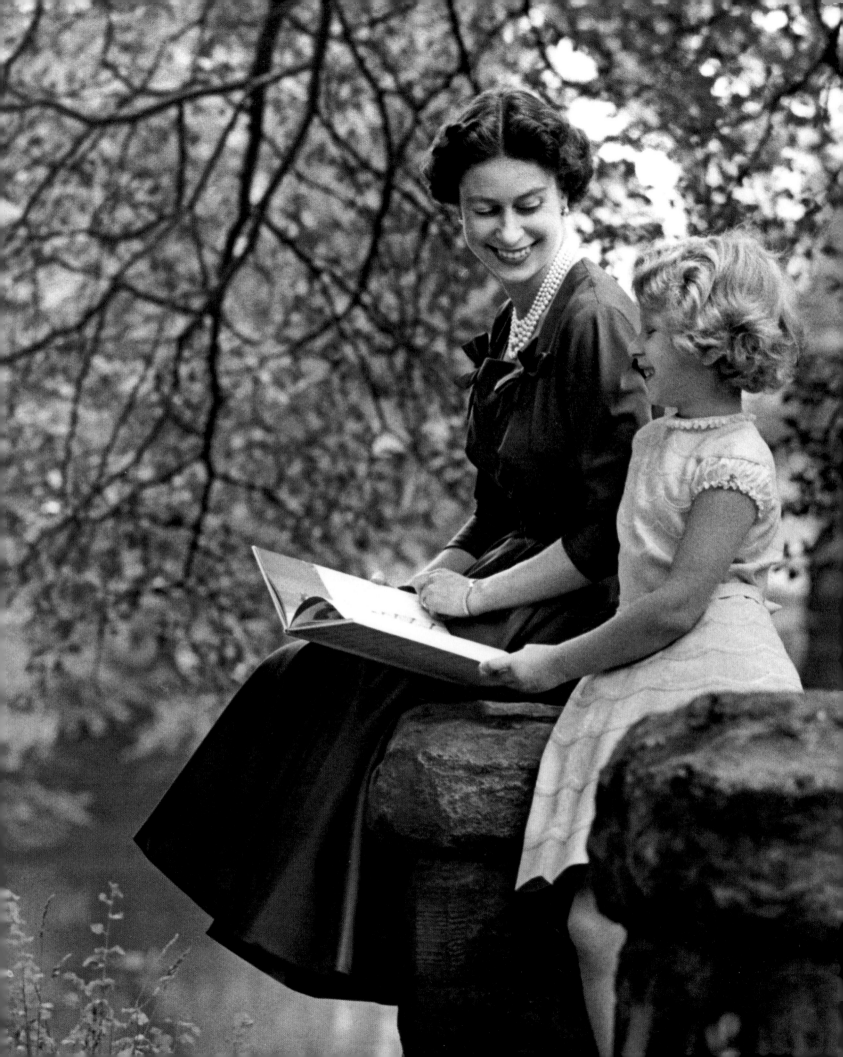

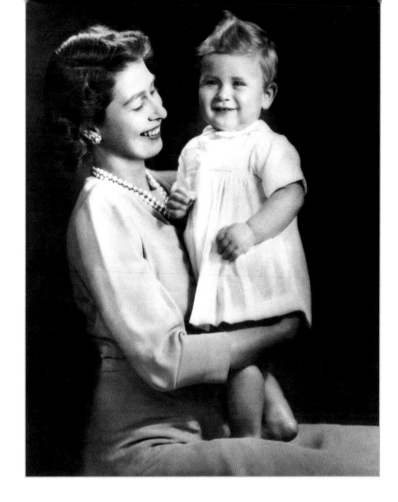

Elizabeth's character was no secret to the people of the United Kingdom. During the war, the future queen, at just 18, decided to serve voluntarily as a mechanic and driver in the Auxiliary Territorial Service. This boldness of spirit was confirmed for the whole world when, in 1953, Elizabeth decided to have her coronation ceremony broadcast on live television, in spite of opposition by Winston Churchill, who apparently described her as "a mere child."

Thus, she was a media sovereign right from the beginning. But she was also inscrutable, and totally identified with her role as representative *super partes* of the State: she has "survived" decolonization and 14 Prime Ministers without ever expressing her political positions publicly, although her dislike for the other female symbol of the United Kingdom, Mrs. Margaret Thatcher, was known.

142 The Queen in an intimate moment with her second child Anne, her only daughter, born in 1950. The photo was taken in 1957, in the Buckingham Palace garden, by Anthony Armstrong-Jones, the court photographer and future husband of Princess Margaret, the Queen's sister. Their unhappy marriage would be the first for centuries between a member of the royal family and a commoner: he would be named Earl of Snowdon.

143 A young Elizabeth with her first child, Charles, in 1949: the crown and its cares are still in the future. The relationship between the Queen and the heir apparent was tense for a long time, so much so that there was speculation that the throne might pass directly to her grandson, William. The Queen is now on better terms with her son. In any case, Charles is the oldest heir to the throne in the history of the United Kingdom.

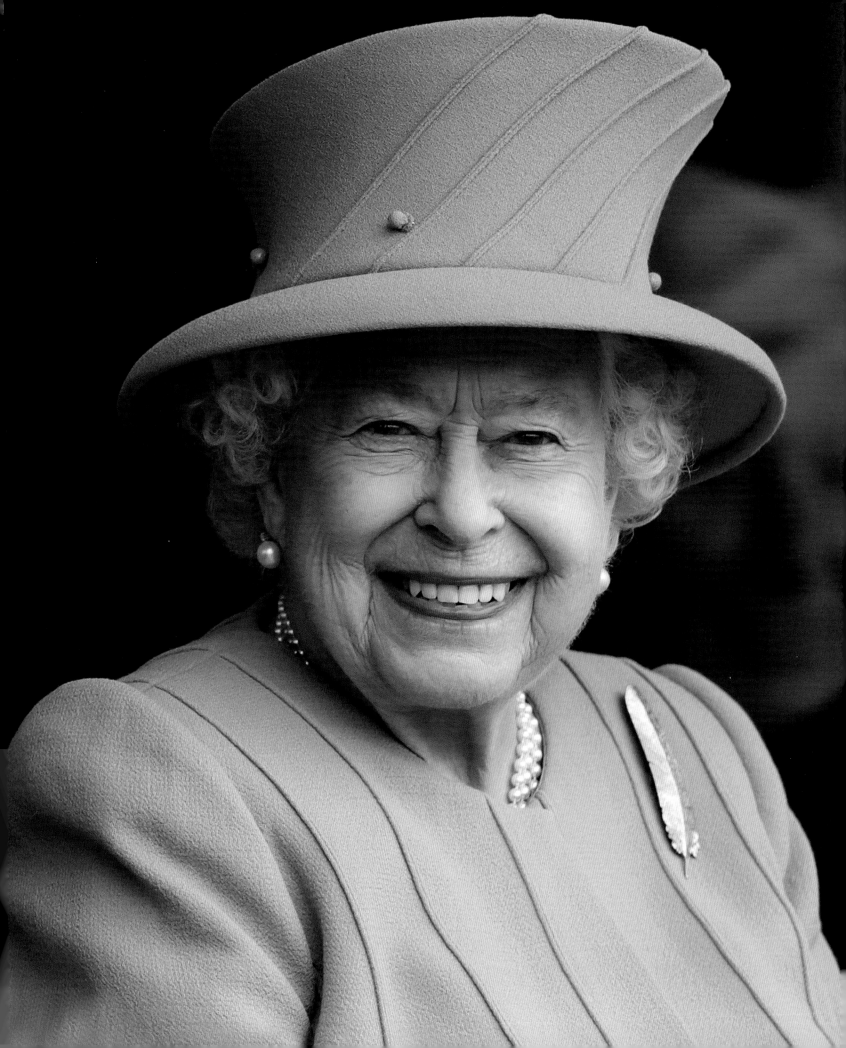

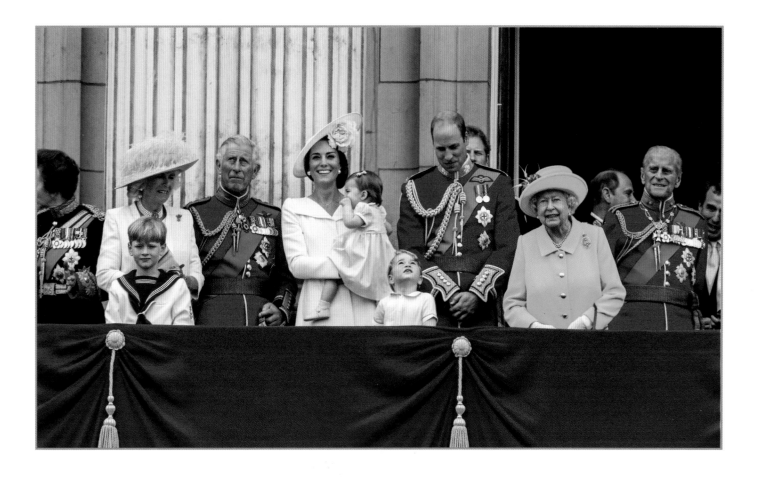

Precisely this manner of standing behind a facade of institutional imperturbability has risked making her lose contact with her people in the darkest moments of her very long reign: one such time was the tragic death of Princess Diana Spencer, the ex-wife of her eldest son Charles. In the days following the death of the Princess of Wales, Elizabeth refused to appear in public and her behavior was seen as an expression of inhuman coldness. This was even more so in comparison with the spontaneous style that characterized Lady Diana, who was much loved by the people and, it was rumored, unpopular with the Queen. But the Queen was undamaged by this squall. And so, on the 60th anniversary of her coronation, in 2012, *God Save the Queen* could be heard throughout the country.

144 The Queen's wardrobe is part of history. She's famous for her strange and perfectly matching hats and brightly-colored dresses, from the yellow at William's wedding to the greens and fuchsias visible even in a London fog. Apparently this is not only a personal choice, but a security measure: in this way, in fact, the sovereign is always perfectly visible in a crowd.

145 Since 1748, Trooping the Color has been the official celebration of the sovereign's birthday. On June 11th, 2016, for the Queen's ninetieth birthday, four generations of royalty met at the Horse Guards Parade, providing a colorful assembly of the past, present, and future of the British monarchy.

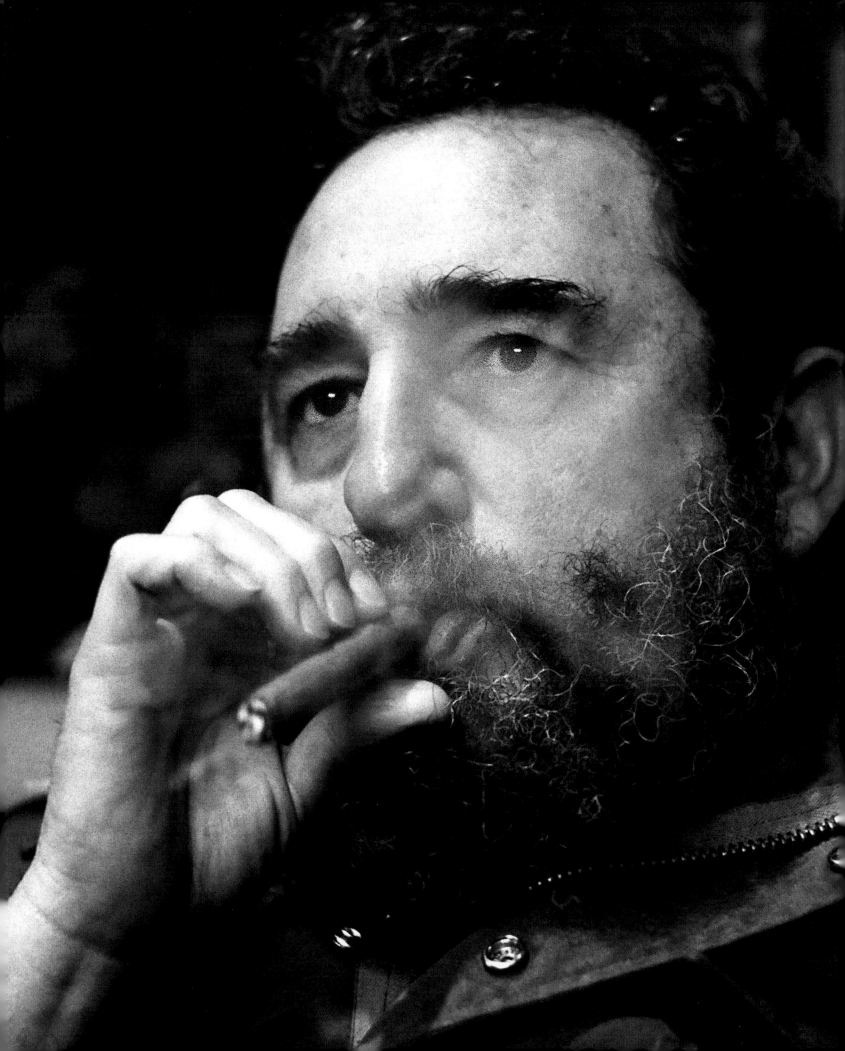

Fidel Castro

The Cuban *líder máximo* was not the first to challenge the greatest economic and military power in the world, but he was the first to get the better of this power. He did this at the height of the Cold War, from an island nation with a fraction of the population, natural resources, and wealth of the United States.

He came from Mexico on a boat, the *Granma*, landing in the east of Cuba. It was December, 1956. His objective was to overthrow the regime of Fulgencio Batista. But he and his men were intercepted by the dictator's army and, of the revolutionaries he was leading, only a dozen survived. With these soldiers, Fidel Castro began a military and political adventure of historic importance: preceded by his two most famous commanders, Ernesto Che Guevara and Camilo Cienfuegos, two years later, on January 8th, 1959, he entered Havana. He defeated Batista's army, who were armed and trained by the Pentagon. He quickly drove "Cosa Nostra" from the island, where it was transforming Havana into its headquarters. In the coming years, he would subdivide the great sugar-cane estates among the peasants and, finally, nationalize foreign companies. The United States in no way spared him. In 1961, the Kennedy administration supported an attempted invasion by Cuban counterrevolutionaries who had fled to Miami. This was followed, in October of 1962, by the establishment of a naval blockade that prevented the docking of Soviet ships full of nuclear missiles due to be installed in Cuba: the third world war was narrowly averted. The US also imposed a very strict economic embargo on all companies that had commercial relations with Cuba: those who traded with Fidel lost the US market. Finally, the Americans tried to physically eliminate the Cuban leader: the CIA was behind at least 638 assassination attempts.

For more than half a century, beginning in the 1960s, Castro represented the David who was capable of challenging the Goliath of the West, and who would not to accept defeat. In speeches at the United Nations, he defended the cause of the poor and marginalized; he sent Cuban advisers throughout the Global South; he became a reference point for countries, small and great, struggling against Colonialism

For many years, Fidel Castro was a great smoker of cigars, obviously Cuban. This close-up was taken in Havana in 1977. Fidel is smoking a Cohiba Lancero. He will quit in 1985, to promote a campaign against smoking, even though Cuban cigars were, and remain, one of the most important exports for Cuba. Cuban tobacco is considered the best in the world.

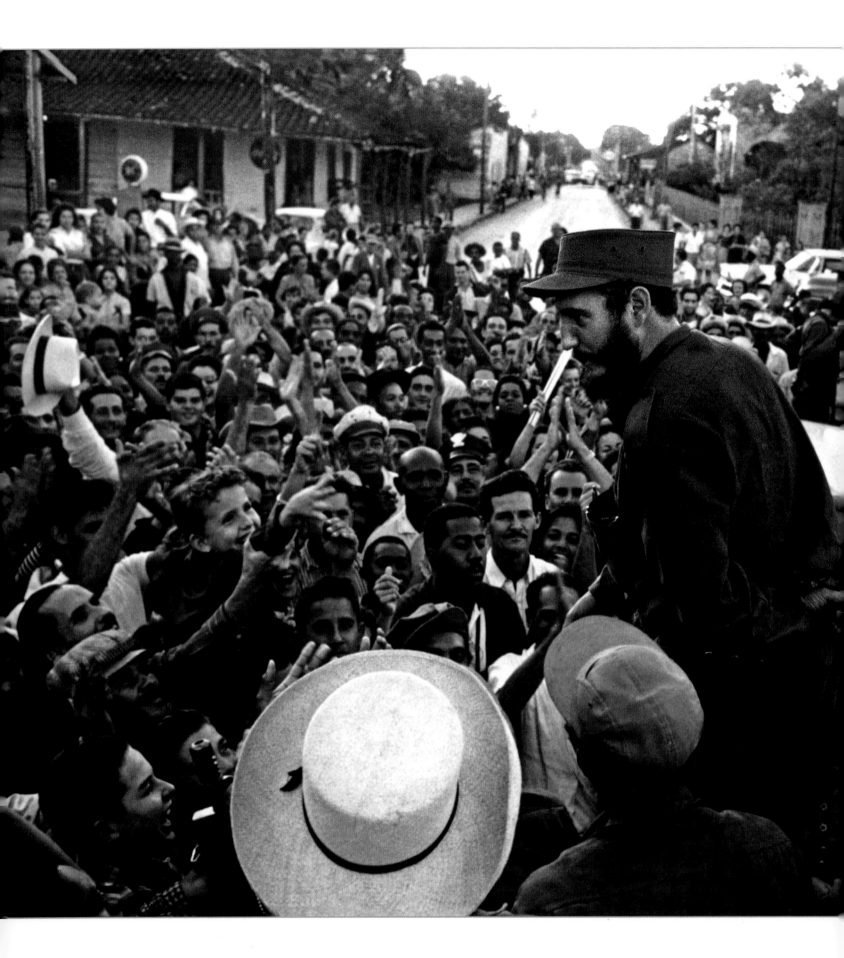

and economic servitude. Meanwhile, Cuba became a political, social, and cultural laboratory unique in the world: while Socialism under tropic palms often seemed like a slogan, it was in fact an experiment, full of contradictions but extraordinarily alive.

His bushy beard, his cigar, his interminable speeches full of figures, his great friendships, from García Márquez to Maradona, from Mandela to Arafat, the meetings with John Paul II and Pope Francis, his complicated family life, his uniform, even his last article in which he stated "We don't need the empire to give us any presents," directed at President Obama, who was visiting Cuba, were easy to caricature. But they were also his identity card. Born on a large farm in eastern Cuba, Castro was in power for 60 years, until he relinquished it because of illness in 2008. He died late in 2016, at the age of 90. His ashes were returned to the east, on a journey crossing the entire island, witnessed by millions of Cubans crowding the sides of the Carretera Central. He left no statues, squares, or avenues named in his honor. Rather, he forbade them and wanted no celebrations. Inevitably he was loved by many, hated by others, considered the father of the country but also an unscrupulous dictator. He was certainly one of the most charismatic icons and figures of the 20th century. As he foresaw, history has absolved him.

In the very first days of 1959, Fidel Castro made his way across Cuba, from Santiago to Havana. Here Burt Glinn shows him acclaimed by the people in a small town on the route. Moments like this occurred throughout the journey: Castro left Santiago on January 2nd, and arrived in the capital only in the afternoon of the 8th.

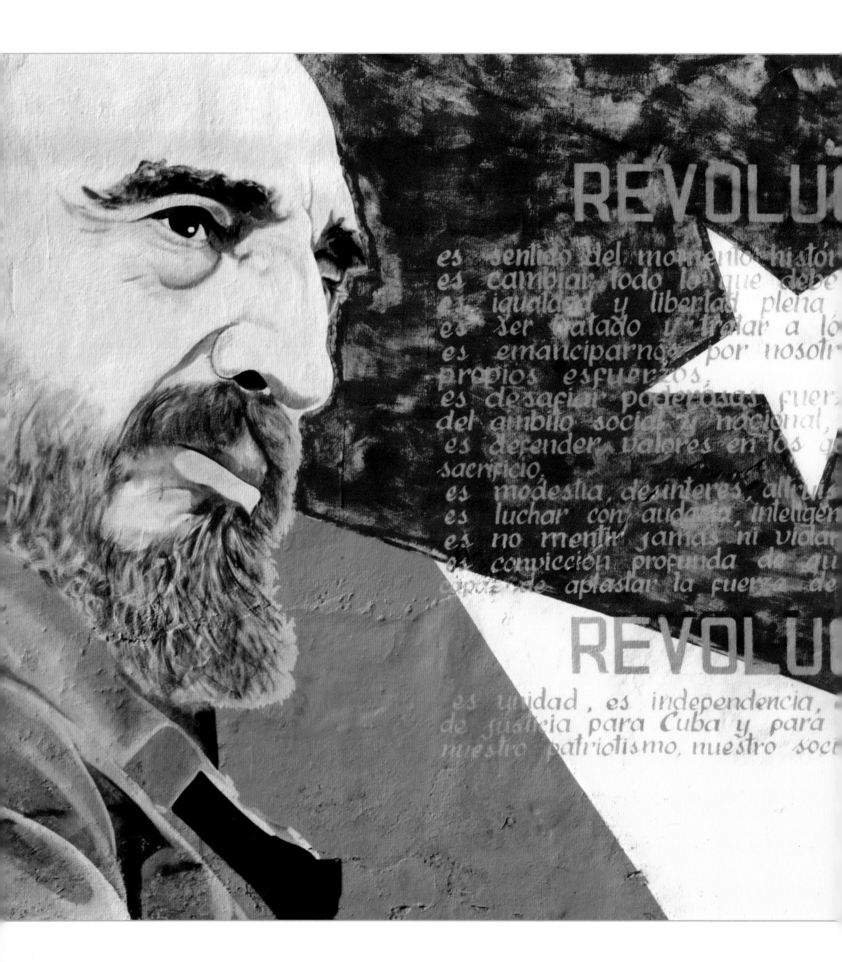

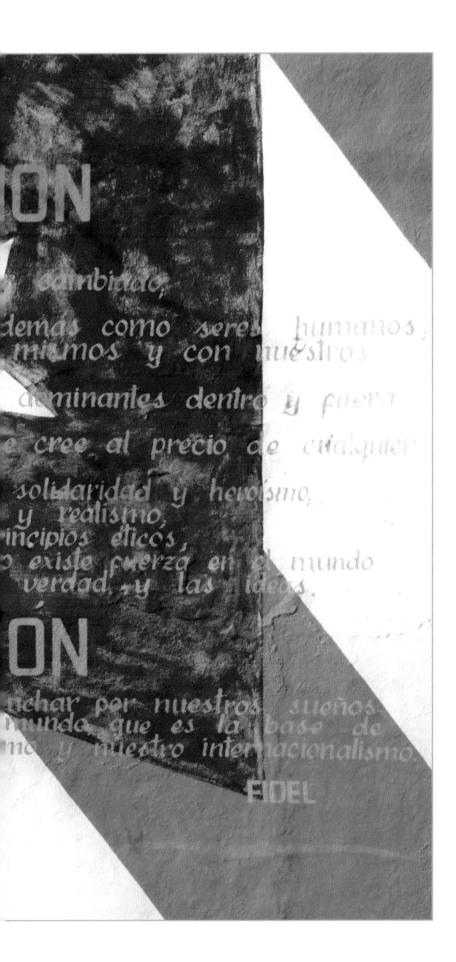

Cuba, the island of palm tree Socialism, is covered with murals and posters: on walls in cities and villages, on the façades of public buildings, along the streets, at intersections. They often portray the faces of national heroes, from José Martí to Fidel Castro. This one, in the city of Cienfuegos, is a lesson on the Revolution in the form of a mural: *Revolution is fighting for our dreams, for Cuba, and for the world.*

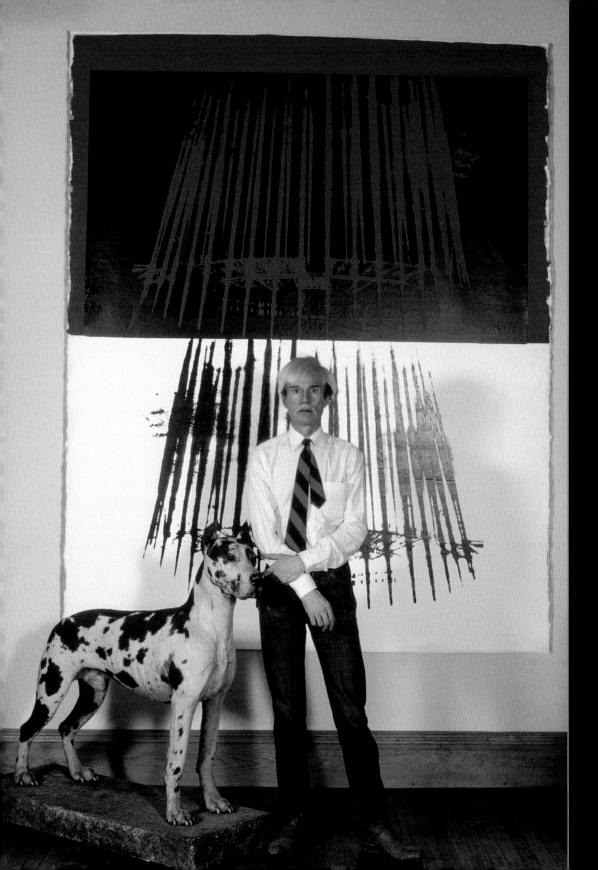

Andy Warhol

He transformed everyday, household objects into art, finding inspiration in a can of soup and in Hollywood stars. Breaking traditional boundaries, this artist became one of the first pop icons. Andy Warhol declared: "Don't think about making art, just get it done. Let everyone else decide if it's good or bad, whether they love it or hate it. While they are deciding, make even more art."

Coca-Cola, a dollar bill, detergent, and canned food. Mickey Mouse, Elvis, and Marilyn Monroe. But also Mao and Che Guevara, and photos of road accidents cut from newspapers. These were only some of the objects, faces, and scenes that in the 1950s and 1960s were paraded before millions via television, the movies, magazines and papers. Andy Warhol, born Andrew Warhola, regarded these things with particular, professional interest. The son of Slovak immigrants who found themselves immersed in consumer society, following high school he studied advertising art in Pittsburgh. After graduating, he moved to New York, where he worked as a window dresser, shoe designer and graphic artist, eventually selling work to such prestigious magazines as *Vogue*. Products of every kind, advertisements and glossy photos were his daily bread.

Warhol was drawn to the simplicity and colorful liveliness of this trivial form, and to how it exerted enormous power over the masses. So he began to create, and then reproduce in silk-screen prints, a sort of catalog of images from the post-war economic boom years. Critical, ethical, and aesthetic problems were not his concern: because "Buying is much more American than thinking, and I'm as American as they come." Thus Pop Art was born. It was an art for the people, of familiar objects, brightly colored and understandable. It was destined to obtain immediate success.

But Warhol did not limit himself by forcing his audience to the pompous world of galleries and museums. His true stroke of genius was to commercialize the work of art, transforming it into a consumer product. "Say you were going to buy a $200,000 painting," he said. "I think you should

Andy Warhol poses by Cecil, the embalmed Great Dane (apparently, the animal died in 1930) that the artist purchased in 1960 and always kept with him. Today it is on display in the Andy Warhol Museum in Pittsburgh. Eccentric details like this helped to define the "figure" of Warhol and his identity as an art icon in the second half of the 20th century.

take that money, tie it up, and hang it on the wall. Then when someone visited you the first thing they would see is the money on the wall."

Consistent with this, he did not work in an *atelier* but in a kind of factory, with a vision of mass production. He called his studio The Factory, and it was a real center of cultural production – besides being the location of legendary parties.

Next he began to transform even himself into a trademark and pop icon. The man became a figure. In public, he always wore a white wig, his eyes framed in an unmistakable pair of Miltzen eyeglasses, and he always appeared to be distracted, distant. He moved with total ease from museums to glamorous covers, from the most exclusive events to *avant-garde* theaters, from collaborations with Lou Reed to portraits in drag. It is difficult to understand how many of his poses belonged to the role he had chosen and how many were the result of true eccentricity. Certainly, Warhol did not simulate his fear of doctors, which derived from an incident when he was confined to bed with encephalitis.

His way of presenting himself as a star, as a symbol of culture, made him an ideal target for fanatics and psychopaths. In 1968, the feminist activist Valerie Solanas, who was always around the Factory, shot him at point blank range. By a miracle, Warhol survived. Fate had 19 more years of life in store for him, and a much less sensational death, which was due to none other than his hospital phobia and complications following a gallbladder operation. All in all, his exit from the world's stage was as banal as the subjects of his art.

154-155 The Manhattan studio in which Warhol worked until 1968 was known as the Silver Factory, because the interior was covered with silver paint and tin foil. It was here that Warhol, besides making paintings, silkscreens, and lithographs – on which he often worked horizontally, placing them on the floor – met with friends and artists of every kind, from Lou Reed to Truman Capote. In the Factory he also produced records, films, and photographic work.

156-157 A colorful homage incorporating Warhol's profile. The work, from the 1990s, after the artist's death, alludes to Warhol's numerous self-portraits from as early as the 1960s, which were always based on photographs and often transformed into vibrant colors.

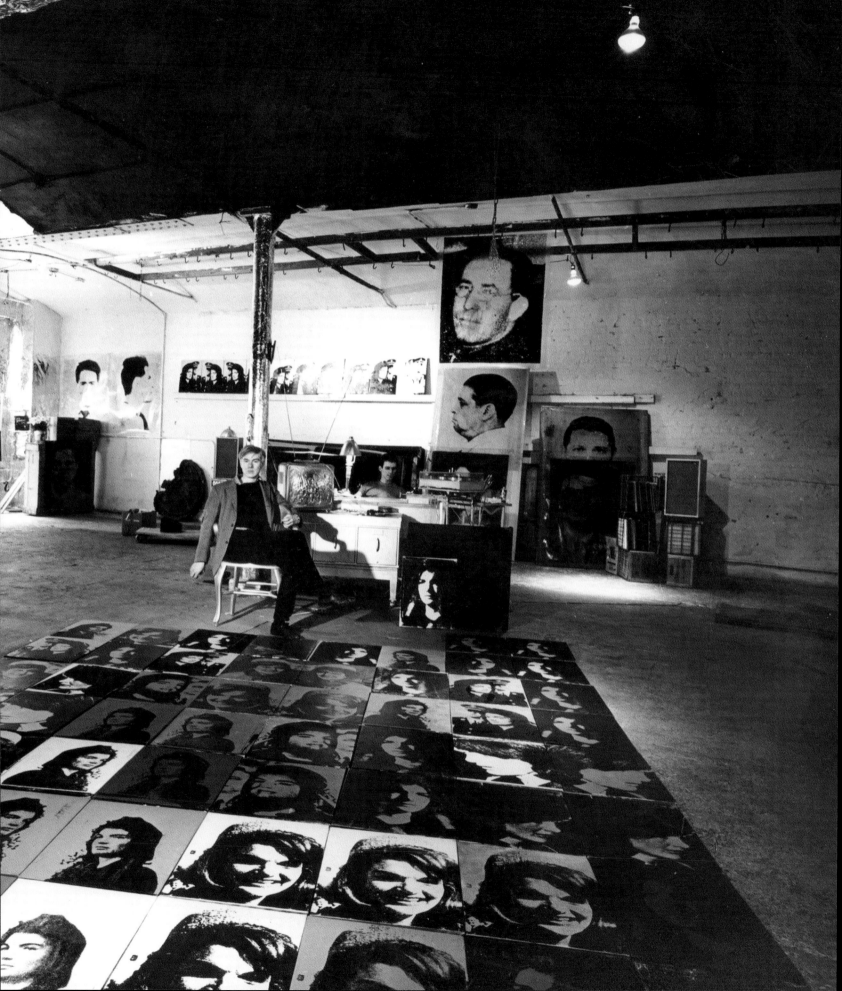

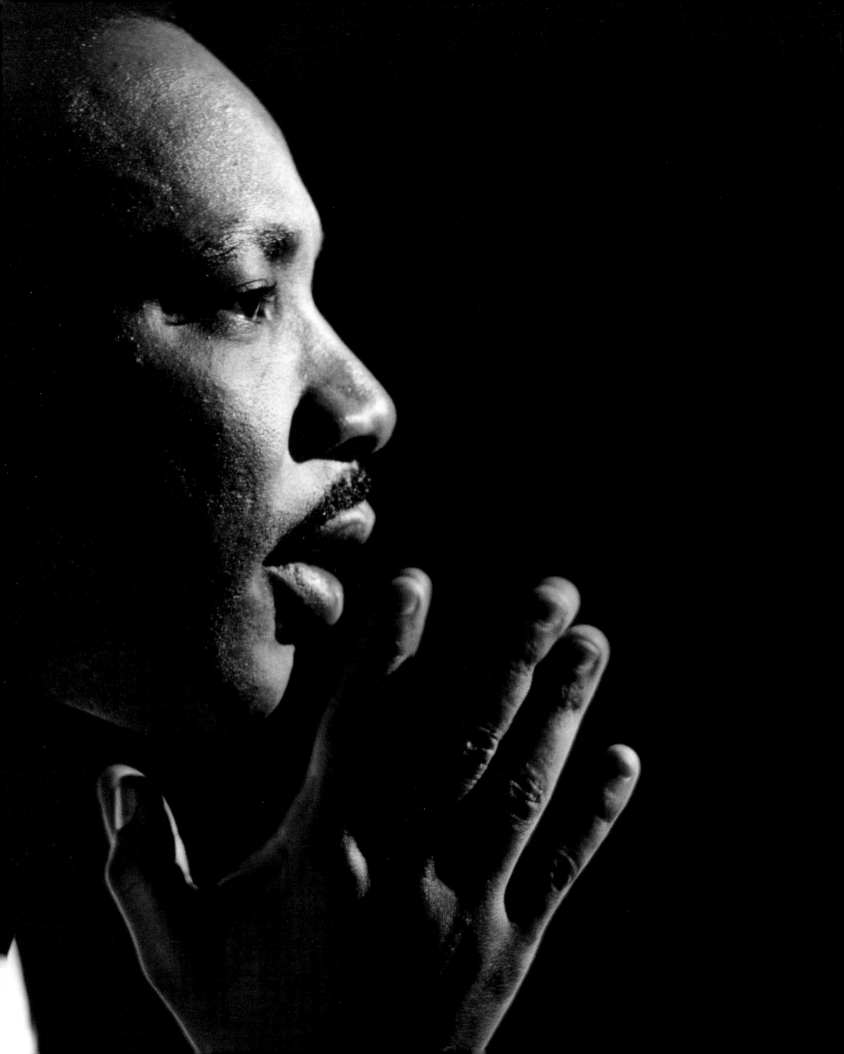

Martin Luther King

He preferred to describe himself as a man "of convictions, not of conformism," because he was able to converse with the powerful without compromise. Gifted with pragmatism, he was a dreamer who wanted more justice in the world.

"Dear Dr. King: I am a ninth-grade student at White Plains High School. While it should not matter, I would like to mention that I am a white girl. I read in the paper of your misfortune, and of your suffering. And I read that if you had sneezed, you would have died. I'm simply writing to say that I'm so happy that you didn't sneeze."

It was in all the papers on September 21st, 1958. The day before a psychopath had plunged a letter opener into Martin Luther King's chest, and just a sneeze would have been enough for it to pierce his aorta. After a long operation and difficult convalescence, the Baptist minister survived and returned more determined than ever in his battle against injustice.

The letter was symbolic of Martin Luther King's life in two fundamental aspects. First, it encapsulates the difficulties King had to confront in his commitment to rights, a road marked by abuses of power, arrests, and violence. As a wise and peaceful man, he was in love with a simple thought: to fight oppression with non-violent resistance. He learned this from Gandhi, whose example fascinated him more than the writings of theorists and philosophers. And so he decided to stand up against social injustice, discrimination against men and women of color, and the legal segregation in force in the United States at the time. In some Southern States, for example, neighborhoods, schools, buses, and public restrooms were segregated according to the color of one's skin.

January 15th, 1929, Atlanta, Georgia, United States • April 4th, 1968 Memphis, Tennessee, United States

A close-up of Martin Luther King Jr. in prayer. He was born on January 15th, 1929, in Atlanta, Georgia. His birth was registered as Michael King Jr., the same name as his father. But following a trip to Germany in 1934, King Sr., moved by the figure of the German theologian Martin Luther, the father of the Reformation, changed both of their names.

But the letter from the student also shows that King's battle was not one of "Blacks against Whites." In fact, the protest King led was a collective call to disobedience against unjust laws. Everything started with a 381-day bus boycott in the city of Montgomery, Alabama, when King was a simple minister at a church on Dexter Avenue: the black community came together to protest racial segregation laws in public transport. Facing skepticism at first, King succeeded in persuading not only African Americans but also many white citizens. It was his popularity, in fact, that made him appear dangerous to many. This was so particularly after the historic, peaceful march on Washington, on August 28th, 1963, which drew people of all ethnicities. It was on this occasion that King gave his *I Have a Dream* speech, one of his most visionary: they were the right words spoken at the right moment. The following year he was awarded the Nobel Peace Prize.

Meanwhile, the cultural movement King was at the center of had created all the conditions necessary for the promulgation of civil rights laws in 1957 and 1960, and the passage of the Voting Rights Act in 1965.

On April 4th, 1968, ten years after the first attempt on his life, another man, blind with hate, assassinated Reverend Martin Luther King at the Lorraine Motel in Memphis, Tennessee. King was only 39 years old. Still, he was not unprepared for the event: it seems he knew he might die at any moment. He was serene in the end, because he had succeeded in launching a revolution that was irreversible: he had taught African Americans everywhere to be courageous in the face of adversity.

On August 28th, 1963, 200,000 people assembled along the National Mall in Washington DC in a demonstration of solidarity for civil rights. Despite the enormous number of people, the event was entirely peaceful. On this occasion, King made the famous *I Have a Dream* speech and, together with the leaders of the movement, met with President Kennedy to press for passage of the Civil Rights Act.

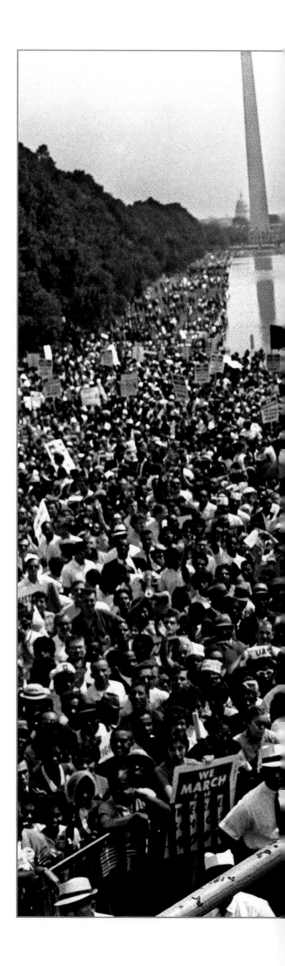

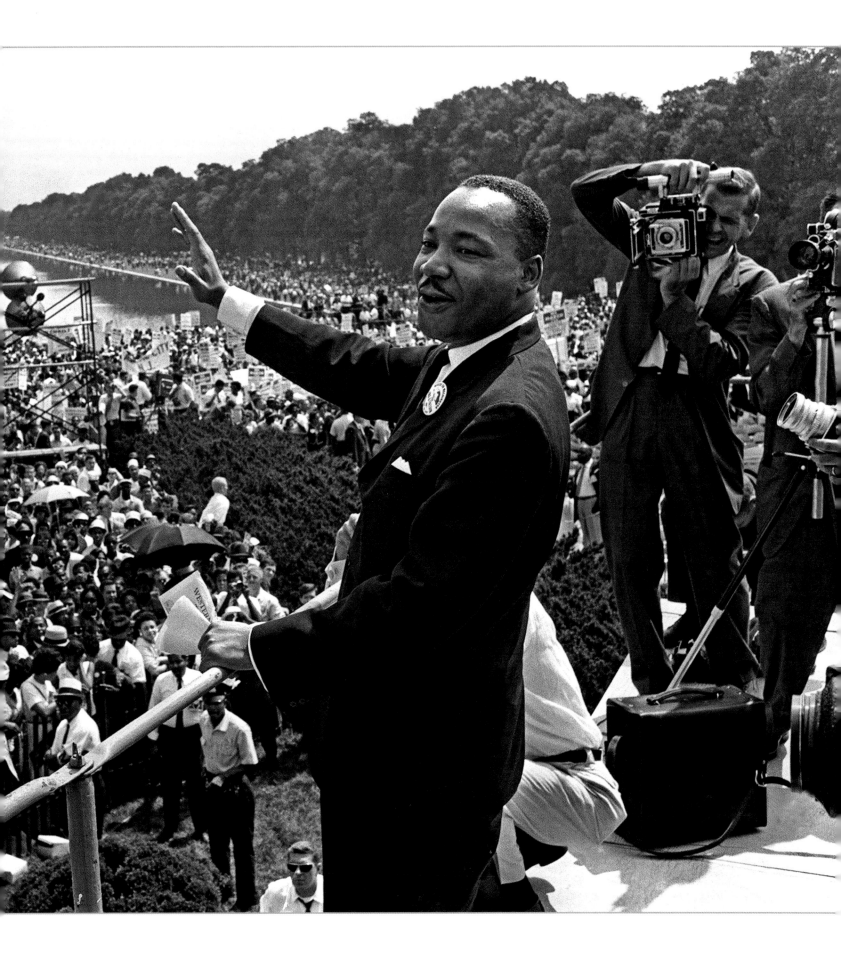

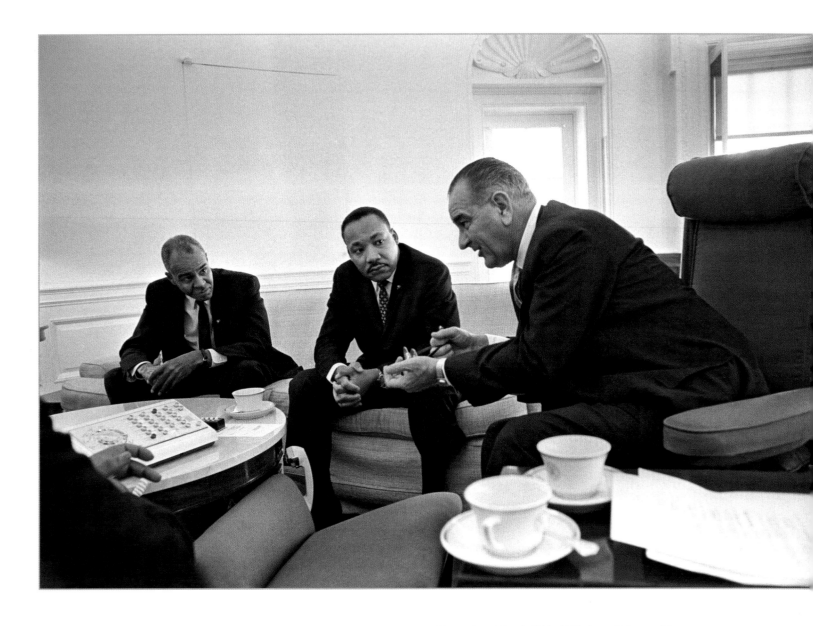

162 Proudly and resolutely, Martin Luther King leads the conclusion of a peaceful march on March 25th, 1965, from Selma to Montgomery, Alabama. It went down in history as the "third march." The first two attempts along the same route were violently stopped by state police. Only on March 17th did a federal judge recognize the demonstrators' right to march.

163 On January 18th, 1964, Martin Luther King is at the White House in talks with the President of the United States, Lyndon B. Johnson (right) accompanied by Roy Wilkins (left), who also had a leading role in the NAACP, the National Association for the Advancement of Colored People. In the same year, the Civil Rights Act was passed, making all forms of segregation and racial discrimination illegal.

Yasser Arafat

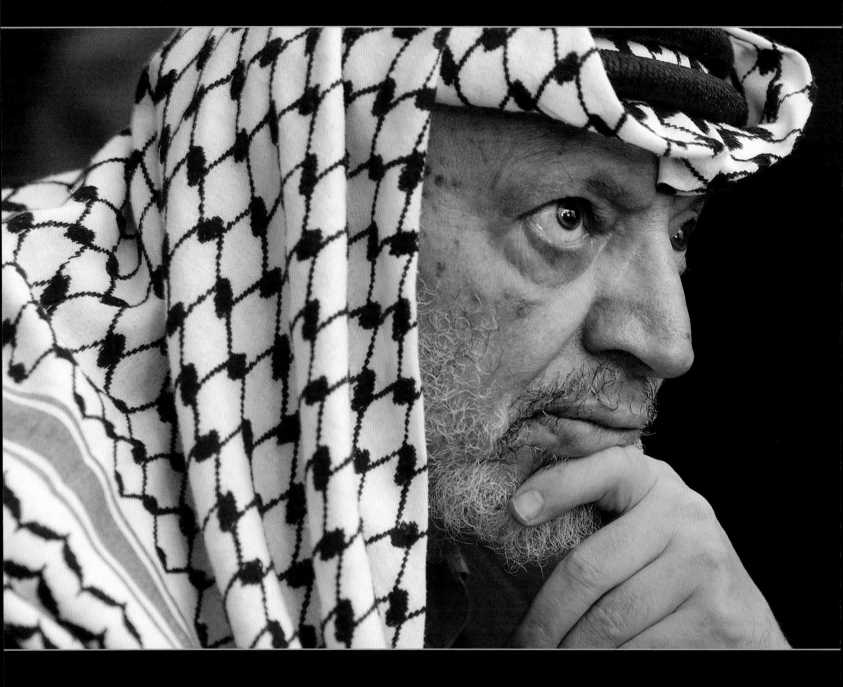

Yasser Arafat thoughtfully follows the prayers on Friday, May 17th, 2002, in Ramallah. The Palestinian elections planned for January have not yet taken place because it is impossible to hold free elections in Gaza and the West Bank. Even Arafat's headquarters, the Mukataa, was besieged by the Israeli army from the end of March until May 2nd.

August 24th, 1929, Cairo, Egypt • November 11th, 2004, Clamart, France

A leader crucial to Middle Eastern geopolitics, Arafat, from birth to death, was a controversial and often mysterious figure.

According to official documents, Mohammed Abdel-Raouf Arafat As Qudwa al-Hussaeini, the eldest son of a merchant, was born in Cairo on August 24th, 1929. Arafat, however, always maintained that he had come into the world about twenty days earlier, in Jerusalem, a city where he certainly spent his childhood after the untimely death of his mother. He returned to Egypt, and at 17 years old was already smuggling arms for the Palestinian Arabs in Gaza; at 19, he was struggling, with the Muslim Brotherhood and the League of Palestinian Students, against the establishment of the State of Israel. The birth of the State of Israel, in 1948, pushed him into political radicalization. He was leader of the Palestinian students, and after his degree in civil engineering (1956) he transferred to Kuwait, where he founded Al-Fatah, which was to become a powerful organization of armed resistance. By the early 1960s, he was a full-time revolutionary, and at the 1969 National Palestinian Council in Cairo he was recognized as President of the PLO, the Palestinian Liberation Organization.

From this date onwards, when one tries to write a biography of Arafat, it becomes almost impossible to separate his private life from events in the entire, painful story of the Middle East in the second half of the 20th century: the man played a role in, or was personally affected by, the conflict of Black September (1970), which followed an attempt to overturn the monarchy of King Hussein of Jordan by groups of Palestinian refugees; the massacre of Sabra and Shatila (1982), in which an unknown number of Palestinian refugees in Lebanon (perhaps as many as 3500) were slain by the Lebanese Phalange with the complicity of the Israeli army; and the terrorist attacks and Intifada of the 1980s. Arafat, always in a *keffiyeh* in public appearances, who survived various assassination attempts, thus became the very personification of Palestinian resistance. Thus in 1989, following the declaration of independence of the State of Palestine, he was elected its President, albeit in exile. It was he who declared to the General Assembly of the United Nations the commitment of the PLO to sustaining the peace process, and it was also he, on September 13th, 1993, who signed, with the Israeli Prime Minister, Yitzhak Rabin, the Oslo Accords.

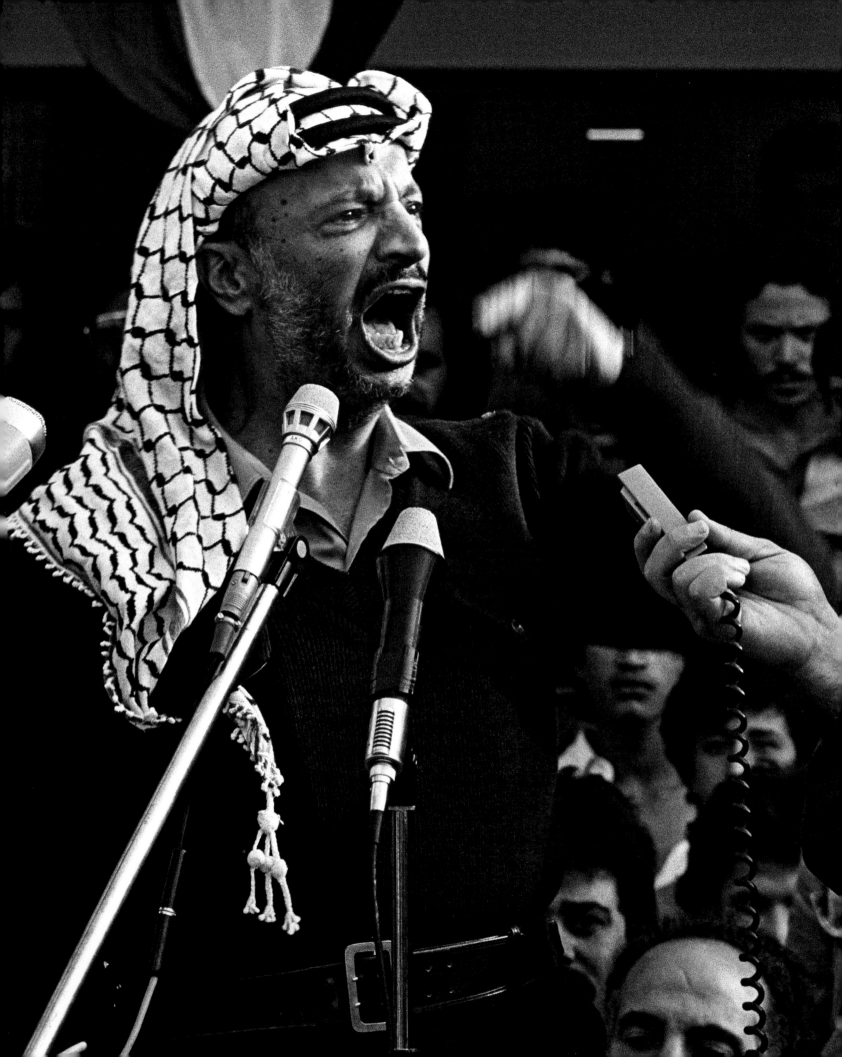

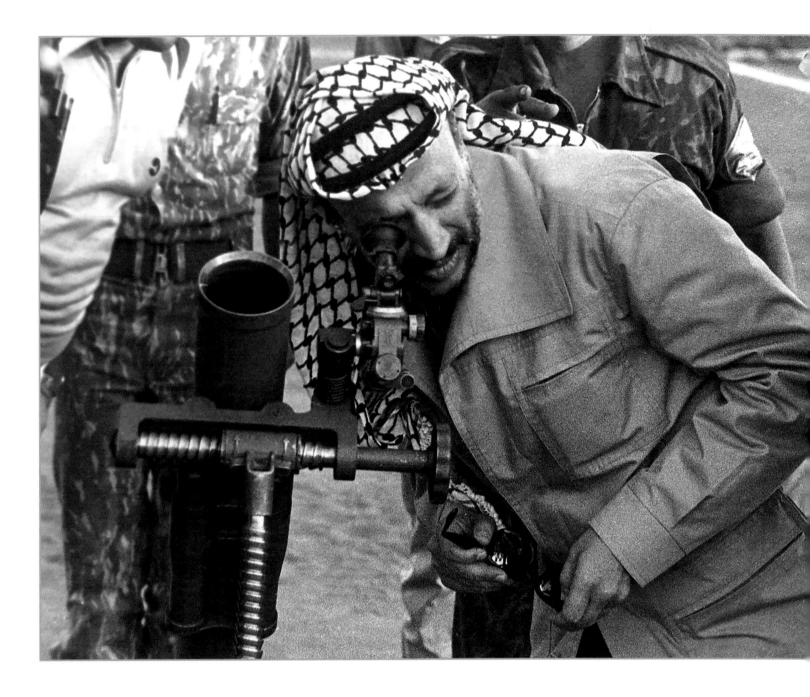

166 Arafat gives a passionate speech as President of the PLO Executive Committee, a position he was elected to in 1969. Arafat intends to make the PLO the political and military coordinator of the various groups fighting for independence. These include Al-Fatah (the political and paramilitary organization founded by Arafat in 1959) and the Palestine Liberation Army (PLA). In fact, he believes that only a unified organization can have international credibility.

167 1978 was the year of Operation Litani, the first Israeli invasion of southern Lebanon: in this climate of great tension, Arafat looks down the sight of a mortar. The invasion was in response to a terrorist attack on the Israeli coast by militia members of Al-Fatah who were based in Lebanon.

The photograph of their handshake, an unimaginable gesture until that moment, was to go down in history: their signatures on the accords earned Arafat, Rabin, and Shimon Peres, the Israeli foreign minister, the Nobel Peace Prize in 1994. But the support he offered to Saddam Hussein, and the loss of control over the armed groups of Hamas, eroded his international credibility and lead to the failure of the Camp David negotiations in 2000. When the Second Intifada broke out, Arafat was definitively expelled from negotiating institutions. Mahmoud Abbas was appointed Palestinian Prime Minister in 2003. On November 11th, 2004, Yasser Arafat died at the age of 75. He had been in poor health for years, but the situation had deteriorated in October, while the Israeli army had held him in isolation in Ramallah. Released for emergency treatment, he was flown in Jacques Chirac's private plane to a military hospital in Clamart, France. He went into a coma on November 3rd and never reawakened. The doctors diagnosed a serious blood disorder. Further investigations on the body, which was buried in Ramallah, revealed polonium poisoning. Thus the death, like much of the life of the Palestinian leader, remains shrouded in mystery.

168 In 1988, the year of the Declaration of Independence of Palestine, Tunisia was the fulcrum of political and diplomatic action for Arafat, who had been in exile for some time. Here the Palestinian leader is photographed while he leaves the PLO office in Tunis, where he works in close contact with Suha Daoud Tawil, the young journalist and activist whom he will marry in 1990.

169 Arafat reclaims his guns before leaving the PLO office in Tunis, in 1988. His life is in constant danger: three years before, on October 1st, 1985, the Tunisian office of the organization was hit by Israeli bombing, causing about 70 fatalities. Arafat was not killed only because at the time he was not in his office.

Yasser Arafat

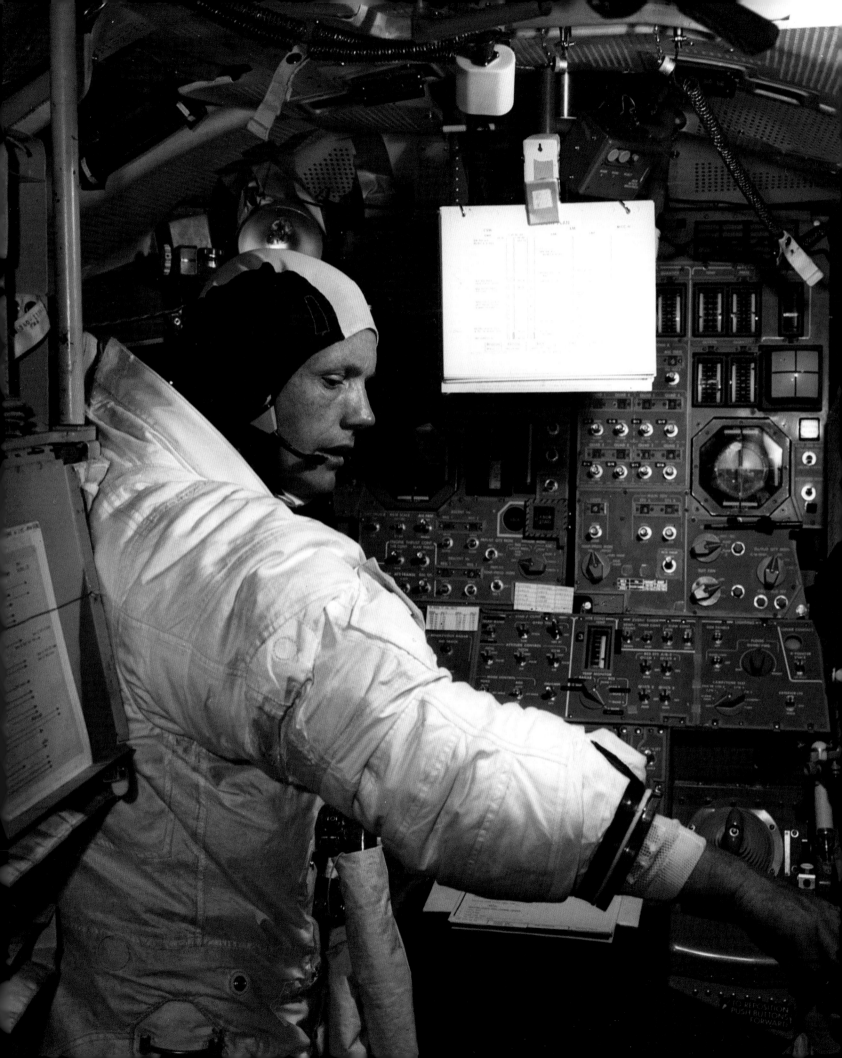

Neil Armstrong

August 5th, 1930, Wapakoneta, Ohio, United States • August 25th, 2012, Cincinnati, Ohio, United States

July 21st, 1969, was a watershed in the history of civilization: a human set foot on the moon (unless you are an inveterate skeptic). The first step was taken by the Mission Commander, Neil Armstrong.

Neil Armstrong had experienced many extreme emotions in his life. He had pushed an experimental aircraft to more than 3900 mph; he had been in orbit on Gemini 8; he was the first civilian to go into space for NASA; he had been hit by anti-aircraft fire during the Korean War, launching the emergency parachute just in time. But he had never felt anything like he felt on that July 21st, 1969, with the weight of history on his shoulders, a weight that not even lunar gravity could lighten. Only nine steps separated him from the surface of the most romantic satellite in the Solar System. He descended, and the visual record of the event was immediately relayed around the Earth, into the homes of 600 million people. Then, his voice breaking, Armstrong pronounced the words that would immediately become famous: "One small step for a man, one giant leap for mankind."

A little more than a century had elapsed since Jules Verne, in 1865, published *From the Earth to the Moon*. Science fiction had become reality following the Apollo 11 mission and the courage of three men. In fact, along with Armstrong, there was Edwin "Buzz" Aldrin, who came down the ladder second, and Michael Collins, who remained in orbit, in the Command Module. As often happens in life, so happened on that July 21th: there could only be one "first," and Neil drew the long straw. Once they returned to Earth (and after 18 days of quarantine, to avoid the risk of lunar epidemics) the interviews, magazine covers, and crowds of people were particularly focused on him. Armstrong was a star, a great American hero, and he could have asked for anything. But he resigned from NASA, declined invitations to run for office, sued those who used his name without permission and gave the damages obtained to charity. He preferred to work, to teach. When he died, his family provided a statement that ended with these words: "The next time you walk outside on a clear night and see the moon smiling down at you, think of Neil Armstrong and give him a wink."

Neil Armstrong in the lunar module simulator. It is June 19th, 1969, and the astronaut is completing his training: a month later, television stations throughout the world will transmit the moon landing. Some will question the authenticity of the event, saying that it was staged (and directed by Stanley Kubrick) to allow the United States to overtake the USSR in the "space race."

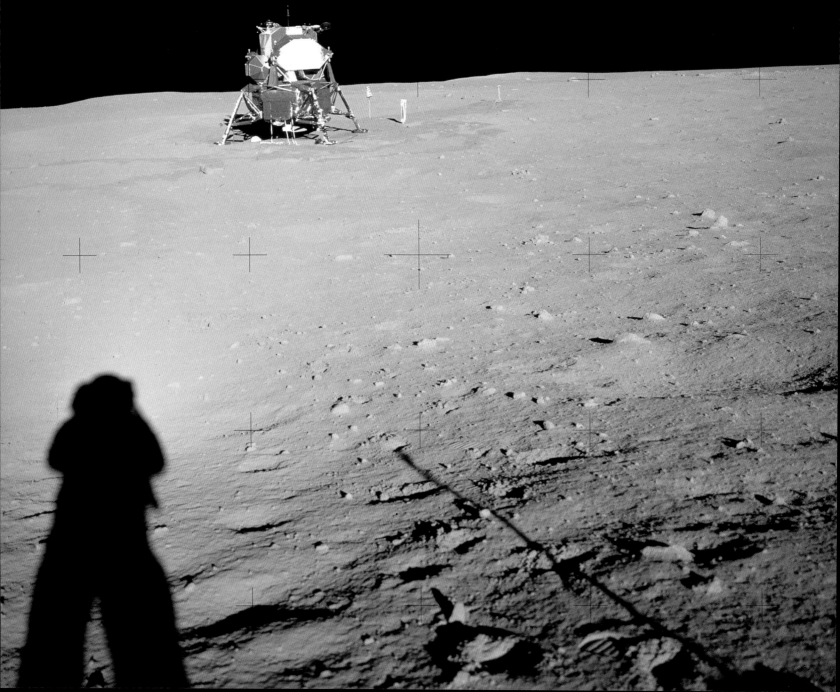

172 Neil Armstrong casts a shadow on the moon's surface while he takes a photograph of the landing site, the Sea of Tranquility: he's using a Hasselblad EDC that has been specially modified for NASA. The US flag has just been planted beside the LEM (Lunar Excursion Module) Eagle. It is July 21st, 1969. Moments ago, he became the first man to set foot on the moon.

173 After leaving the LEM Eagle, Neil Armstrong photographs a print of his right boot on the surface of the moon. It is a tangible sign of humans' arrival. Since there is no wind or other atmospheric agents on the moon, the footprint is destined to remain more or less intact for a very long time. Armstrong, with Aldrin, will walk in the Sea of Tranquility for about 2.5 hours, gathering rock samples.

Mikhail Gorbachev

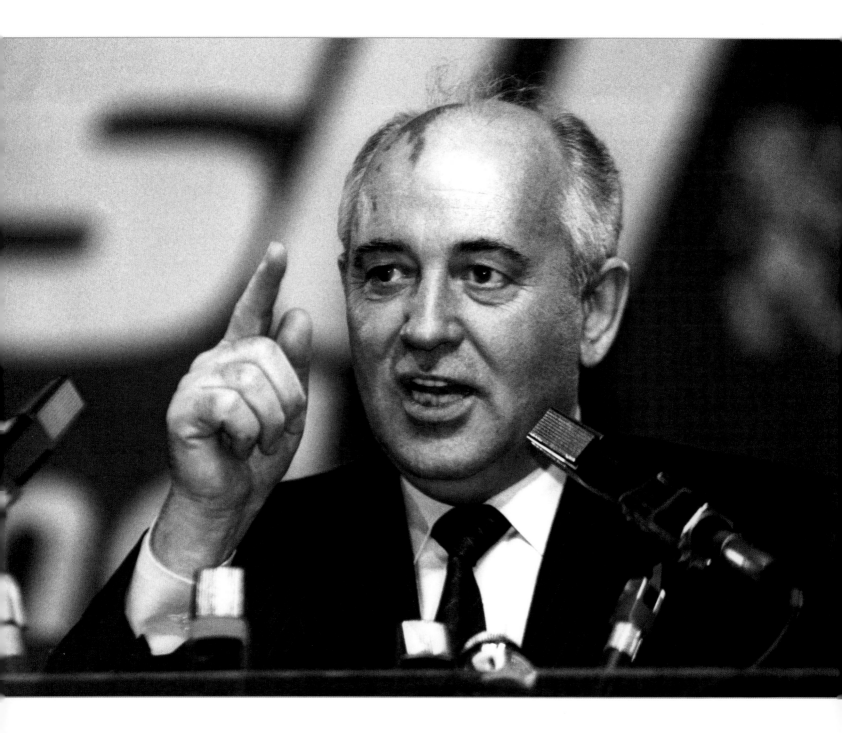

Mikhail Gorbachev, the ex-Secretary General of the Communist Party of the Soviet Union, gives a speech in the Hofbräuhaus, one of the most famous beer halls in Munich, on March 1st, 1992. The Soviet Union broke up a few months before; Russia is now governed by Boris Yeltsin. But Gorbachev is destined to remain popular for a long time, at least in the West, where he will receive numerous prizes and degrees *honoris causa*.

He was the last leader of the Soviet Union. With the watchwords *perestroika* and *glasnost* he attempted to bring about democratic reform, an endeavor that led to the end of the Cold War – but also to the disintegration of his country.

In 1985, when Mikhail Gorbachev became leader of the CPSU, the Communist Party of the Soviet Union, no one in the world, not even Gorbachev himself, could have foreseen that this man, with his unmistakable birthmark under his receding hairline, would radically transform the geopolitics of the planet. He was anything but a revolutionary: the pragmatic son of peasants, he made his career in the party under the wing of Yuri Andropov, the director of the KGB and Brezhnev's successor. He intended to re-invigorate the rigid, rusty Communist system, by renewing it on the principles of *perestroika* (restructuring) and *glasnost* (transparency). In the western world, these words became synonymous with the opening to democracy and the capitalist system.

Gorbachev was a courageous man who was used to challenges and difficulties: as a child, he saw hunger first hand, during the terrible famine of 1932-33 that claimed more than 5 million victims, and then again as a witness to the Nazi invasion, which resulted in an even greater number of deaths. In his foreign policy, he opted for dialogue with the United States of Ronald Reagan, he reduced nuclear arsenals and withdrew the Red Army from Afghanistan, acts which earned him the 1990 Nobel Peace Prize.

At home, however, his policies had unexpected consequences. Citizens certainly enjoyed greater freedom, but they also faced an unprecedented economic crisis combined with a sudden rise of nationalism, from the Baltic to the Caucasus. These were problems that the party could no longer answer. The Soviet Union melted like snow in the sun.

The situation was such that in 1991 there was a coup by a group nostalgic for the regime: Gorbachev was imprisoned for several days in his dacha in the Crimea. When he was freed, he appeared fragile, confused, in stark contrast with the figure of Boris Yeltsin. There was no alternative but to step down. It was a great defeat for a politician: "I did all I could," he later said. In any case, today the world recognizes his courage in trying.

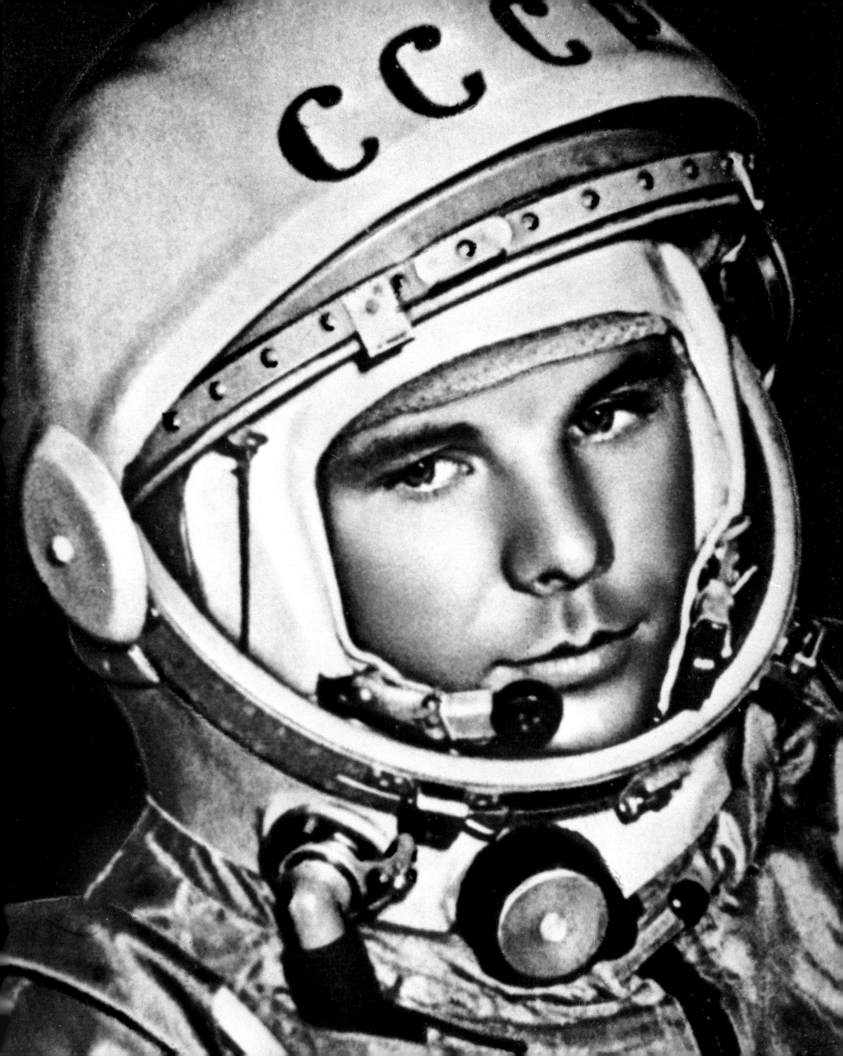

Yuri Gagarin

Gagarin, the first man in space: following a long training course and numerous physical tests, this young man, out of 3461 candidates, was chosen. He was 27, and short, at 5 feet and 2 inches tall. But you had to be small if you wanted to get inside the capsule and still be able to breathe.

His smile – open, honest, generous – was his identity card. That was not something you would expect from a military man, or from a boy who survived the Nazi occupation, who grew up in a microscopic village in the center of the Russian plain, who was raised in professional schools and barracks, and who was destined to become a national hero. To be precise: the name of the village was Klushino, and the smile was that of Yuri Alekseyevich Gagarin, the first man to complete an orbit in the earth's stratosphere. He began to work at 16, and took flying courses in the evening and on the weekend. In seven years, he progressed from foundryman to MiG-15 pilot in the Soviet Air Force. It was 1957. He rose rapidly through the ranks, becoming Senior Lieutenant. At the base in Murmansk, he tested flying equipment in spite of the freezing conditions and gusting Arctic winds. Around that time, he also began training for the space program. Among Gagarin's character traits: he had a fantastic memory, he was extremely attentive to every detail of the context he was in, he was modest, he never refused a drink while off duty, he handled celestial mechanics with great facility (he was a goal keeper in ice hockey), he was excellent at higher mathematics, he was less than perfectly faithful in marriage (but he did nothing unforgivable), and he was optimistic about life.

And so we come to April 12th, 1961: Baikonur Cosmodrome, Kazakhstan, Soviet Union. The Vostok 1 Orbiter. When it was detached, immediately before liftoff, they wished him a safe journey over the radio. *Poyekhali!* "Let's go!" he replied. Then he watched the marvel of the Earth from space for an entire orbit: it was a privilege never before granted to any human being. In his re-entry he survived an emergency parachute opening unexpectedly: closed with leather straps, it was an imperfect technology. Sadly, he would not survive a trivial accident on one of his beloved MiGs seven years later.

Gagarin poses for Soviet photographers tasked with documenting the "terrestrial" part of the Vostok 1 mission. The cosmonaut wears a space suit, perfected during training, with the visor raised. In close-up, we can clearly see the microphone, the air tube at the bottom right, the light-colored fireproof suit around his head, and the letters CCCP, the Cyrillic spelling of USSR.

March 9th, 1934, Klushino, USSR • March 27th, 1968, Kirzhach, USSR

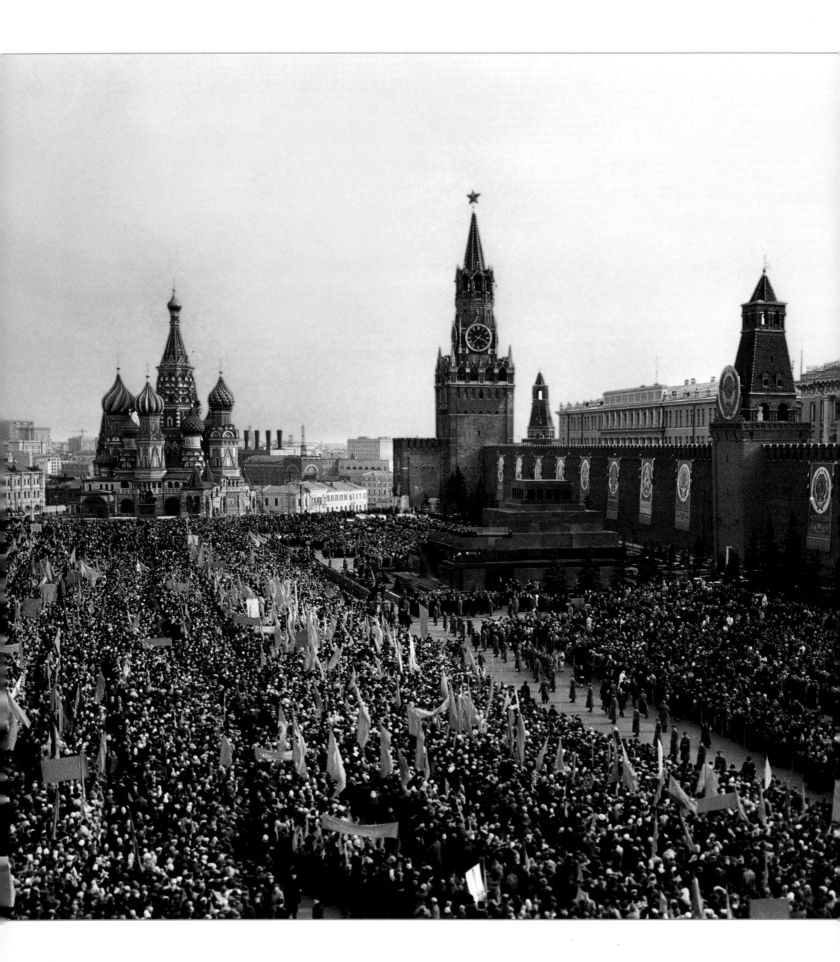

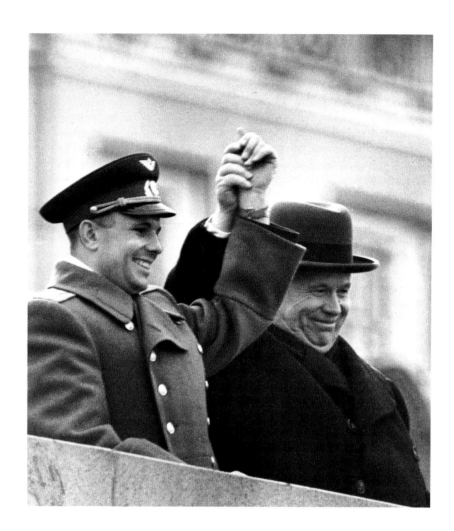

178-179 April 14th, 1961. All of Moscow is in Red Square, from the highest state authorities to ordinary people, to see and celebrate the first man to fly in space. On the same day, State and Party leaders received Gagarin at Vnukovo airport: from there, a procession of cars entered the city center, applauded by crowds on either side.

179 Gagarin and Nikita Khrushchev, the Secretary of the Party and Chairman of the Council of Ministers of the Soviet Union, greet the crowd from the tribune of the Lenin Mausoleum. There is a military parade in Red Square in honor of the cosmonaut. Gagarin's achievement represented an extraordinary political success for the USSR during the Cold War.

Yuri Gagarin

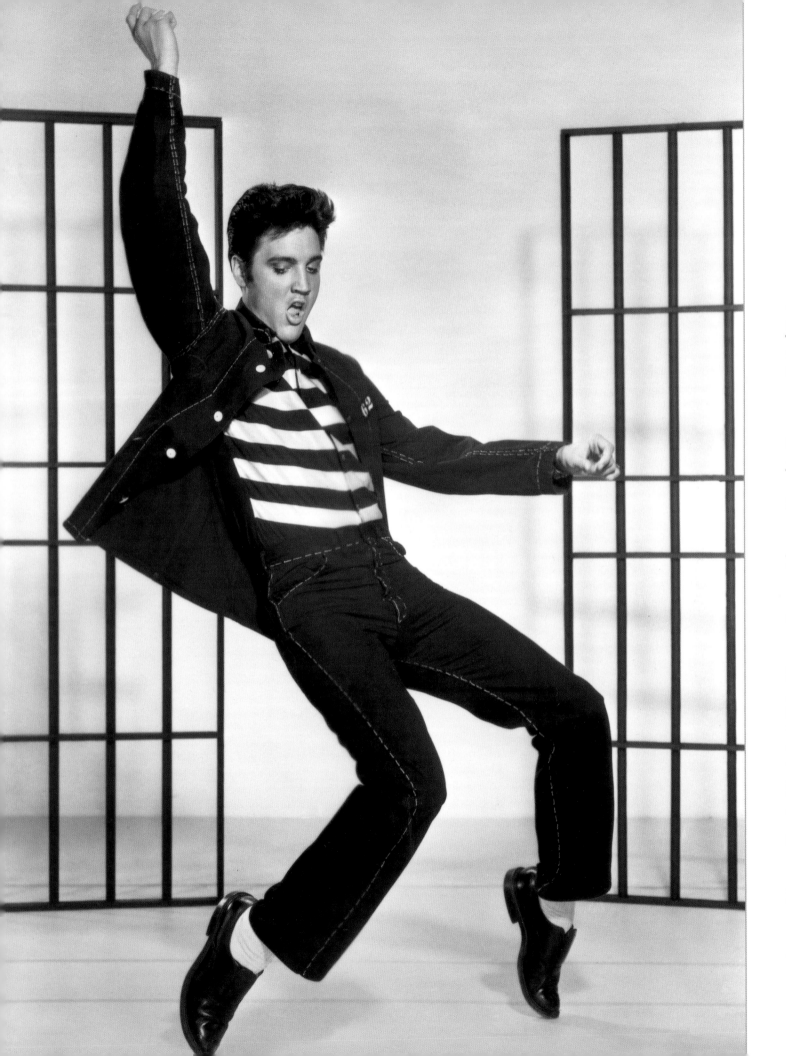

January 8th, 1935, Tupelo, Mississippi, United States • August 16th, 1977, Memphis, Tennessee, United States

Elvis Presley

He was the singer who created rock'n'roll, changing the tempo of an entire generation. Both loved and hated, nobody disputes the fact that Elvis, standard-bearer of US show business, reinvented the image of the musician forever.

It started on July 5th, 1954, when a very young Elvis Presley recorded his first tracks at Sun Studios in Memphis, Tennessee: among the recordings was *That's All Right*, which, broadcast a few days later by a local radio station, triggered the perfect storm and changed the soundtrack of life on the entire planet. It was rock'n'roll, a revolution whose key figures – Fats Domino, Little Richard, Jerry Lee Lewis, and above all Chuck Berry – would go on to produce material sometimes better than that of Presley's. But Elvis was the driving force: his face, his voice, the way he moved his body, he brought to music the ideal mixture between black and white culture, between blues and country. Radio, television, and juke-boxes spread rock'n'roll like wildfire to every corner of America and then, practically overnight, to the rest of the world. Presley, partly due to his brilliant and unscrupulous manager, Colonel Tom Parker, achieved enormous success, and became the first global icon of the music revolution. He was "the King," a show business superstar, surrounded everywhere by scenes of collective hysteria. But his rise to fame came at a price. First of all, his art became predictable. While the early Elvis was an incredible writer of sensual and unique songs, his brilliance was soon diluted by too many second-rate performances on the big screen. He slid into conservatism and, in later albums, turned his back on musical novelty, of which he himself had been the prophet. Additionally, on a physical level the price Elvis paid for success was extremely high. His behavior became ever more eccentric, he abused prescription drugs and stimulants, he was subject to terrible mood swings, and he developed an obsessive relationship with food. He became pathologically fat. He died at 42, apparently due to an overdose of barbiturates, in his fairy-tale villa, Graceland. Tens of thousands of fans soon gathered. For years, many refused to accept the fact that Elvis Presley was dead. But there are also those who, resigned to mourning, continue to keep the man a prisoner of his myth, a hero forever young and handsome.

Elvis Presley in a promotional photo from *Jailhouse Rock*, directed by Richard Thorpe in 1957. It is his third film. The scene in which Elvis dances to *Jailhouse Rock*, with costumes and scenography evoking a prison, is considered one of his best performances and a forerunner to modern music videos.

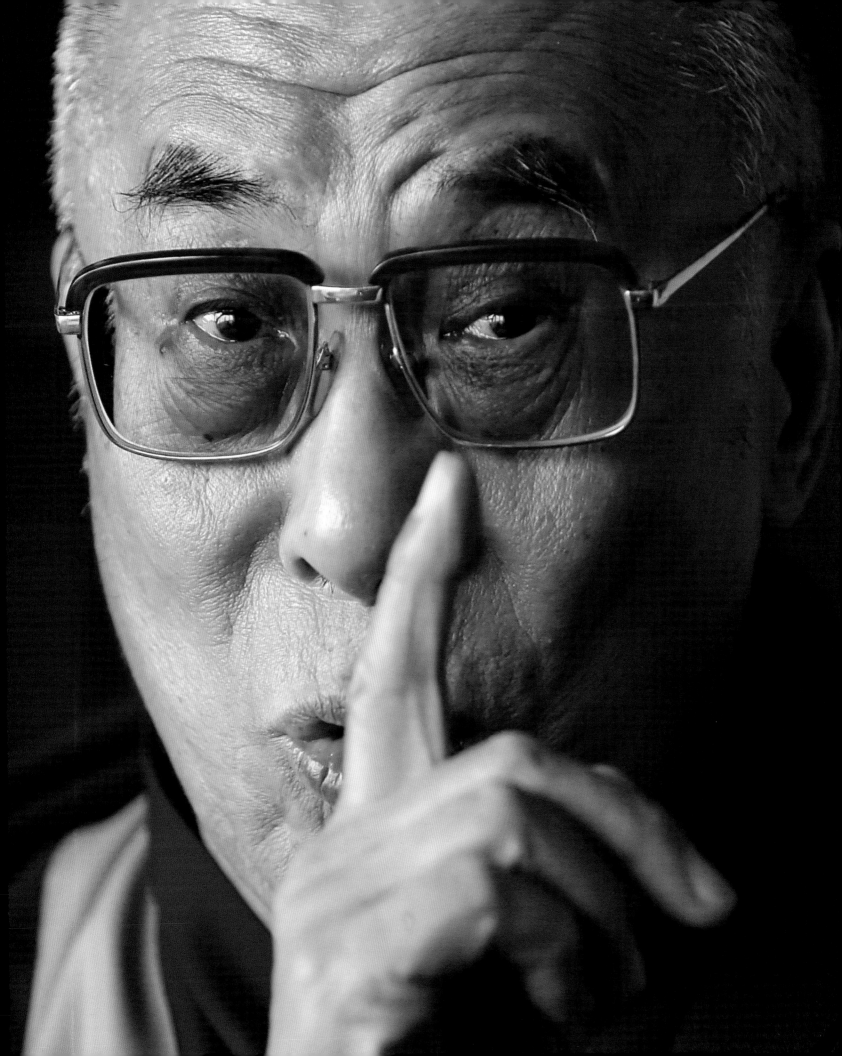

Tenzin Gyatso

Tenzin Gyatso, the 14th Dalai Lama, is the supreme authority of Tibetan Buddhism. He is a life teacher for millions of people in the East and West, and the symbol of the non-violent struggle of Tibetans against Chinese oppression.

Lhamo Thondup was only two years old when some monks came to the door of his house, a humble peasant dwelling in a village in the northeast of Tibet. Guided by intuition and enigmatic visions, they were seeking the reincarnation of the 13th Dalai Lama, who had died four years before, and of all his predecessors. The destiny of the Dalai Lama, who according to Tibetan Buddhism is the manifestation of the Buddha of Compassion, is to continue to be reincarnated: the Dalai Lama, in a gesture of total altruism, sacrifices the prospect of Nirvana in order to show humankind the way of illumination.

Without revealing their mission, the monks, choosing from the seven brothers and sisters living in the house, were drawn to him, Lhamo Thondup. They interrogated him, and from his answers they understood that they had found a "master of oceanic wisdom." (This is, more or less, the meaning of the title Dalai Lama.) They renamed the little boy Tenzin Gyatso and, in spite of many difficulties, they succeeded in bringing him to Lhasa, to instruct him and prepare him to become the new spiritual and political guide of a Tibet that was still feudal and theocratic.

But when Tenzin Gyatso, at 15, officially ascended the throne, it was apparent that the Tibetan social structure and the new Communism in China were incompatible. China intended to take possession of the region.

On May, 23rd, 2008, Tenzin Gyatso is in London, where he meets several journalists. His listeners are struck by his ironic and informal behavior, but these gifts are not always enough to ensure he has talks with Western politicians. Many leaders, including Pope Francis, have avoided receiving the Dalai Lama in the last few years in order not to compromise diplomatic relations with China.

July 6th, 1935, Taktser, Tibet

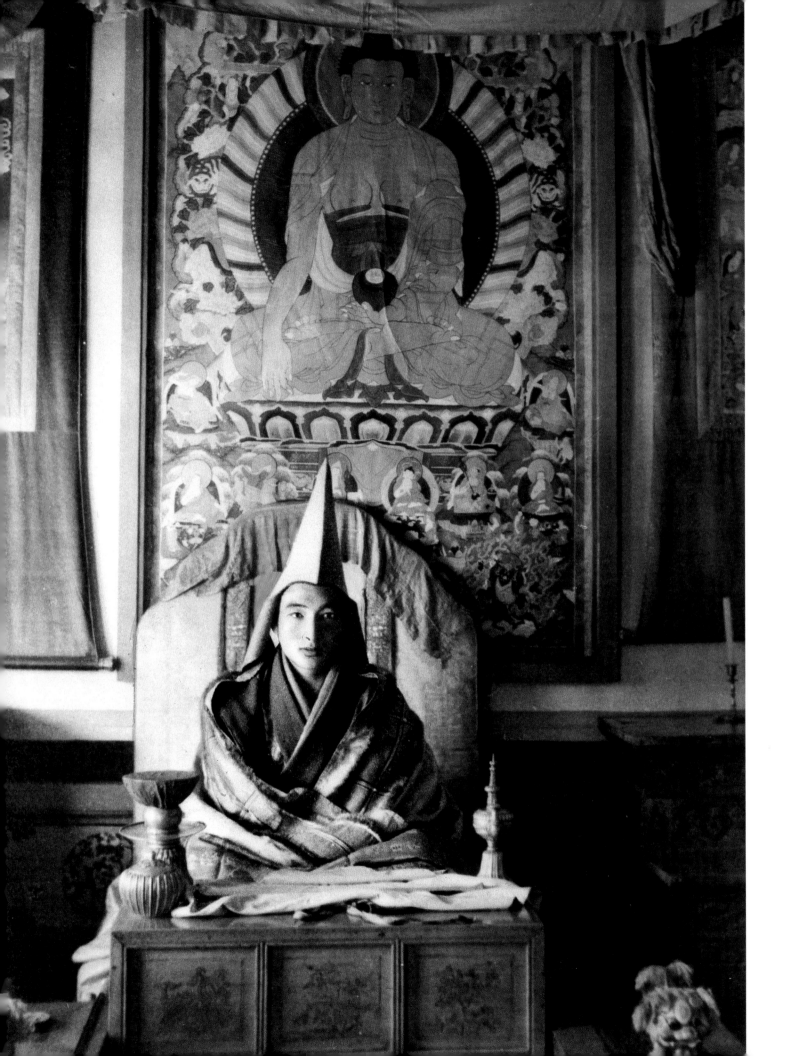

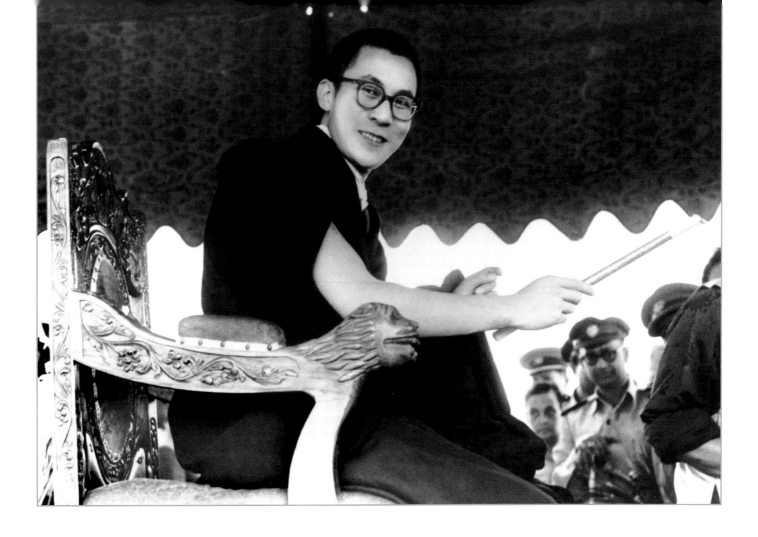

In 1959, after nine years of resistance and attempts at mediation, the Buddhist leader took refuge in India, where he formed a government in exile. He launched a non-violent struggle, based on civil disobedience, following in the footsteps of Gandhi – but also based on a modern use of the media, to inform the world about the "Tibetan question." His popularity began with the romantically-tinged accounts by the Austrian climber Heinrich Harrer, the author of the novel *Seven Years in Tibet* (1952); it increased with his exile, and in 1989, when he was awarded the Nobel Peace Prize, the Dalai Lama became an international figure.

184 The young Tenzin Gyatso sits on the throne in the Potala Palace, in Lhasa. He wears a yellow hat, symbol of the Gelug, his religious school. As soon as he was invested with political powers, the Dalai Lama visited China to meet Mao Zedong, but without the desired result. Today, because the Dalai Lama is forced to live abroad, a statue dressed in his clothing sits on the throne.

185 The Dalai Lama's first official visit to India took place in 1956 and 1957, on the occasion of the festivities for the anniversary of the birth of Buddha in 560 BC. The Indian people gave him a warm welcome, as shown in this photo in which Tenzin blesses the crowd in Kolkata. On this occasion, he also met the Prime Minister, Nehru, who would offer sanctuary to the Tibetan government-in-exile.

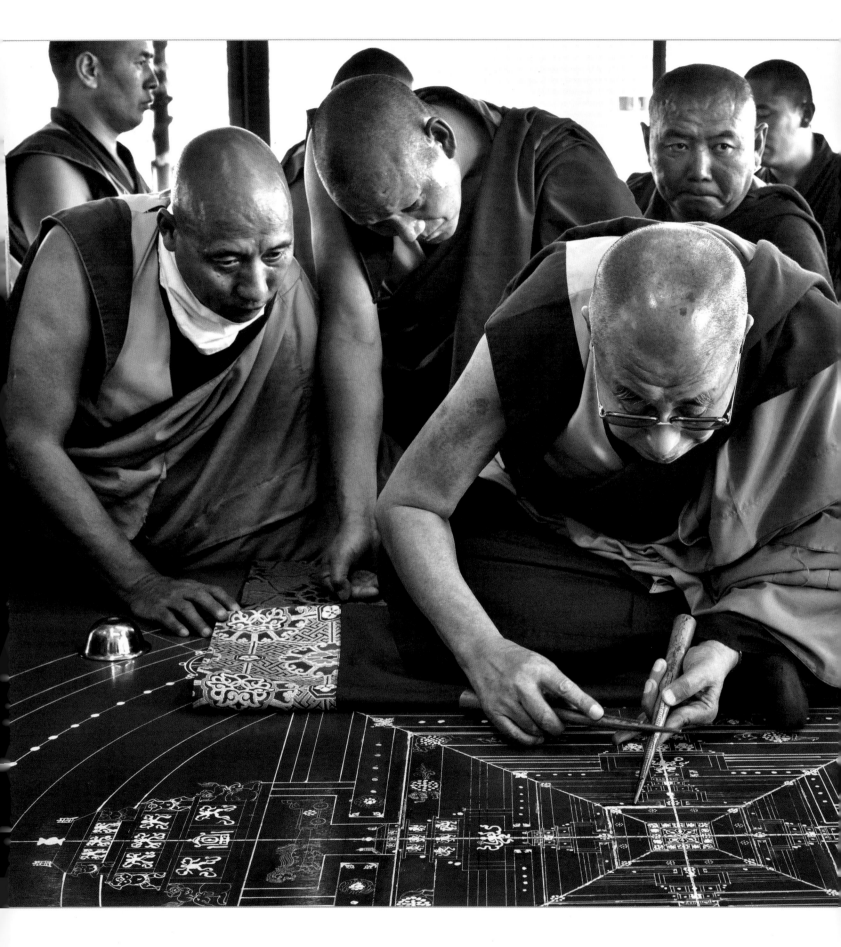

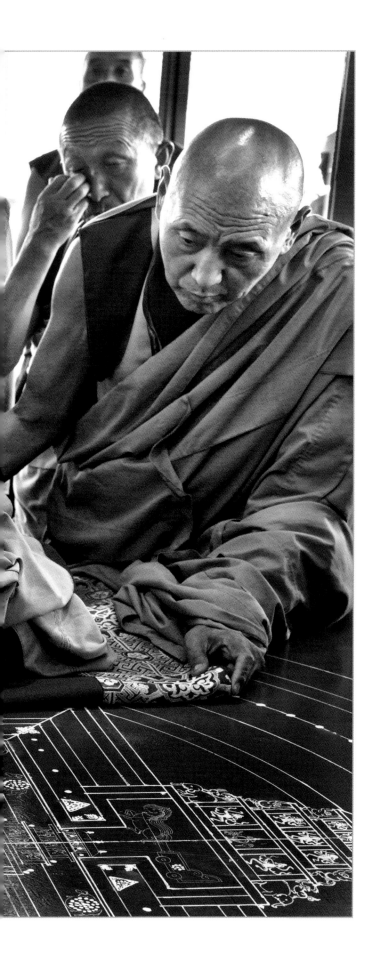

In recent years, it seems there's no politician or show business persona who has not received from the Dalai Lama a *khata*, a white scarf "of happiness." He's given them to John Paul II, Desmond Tutu, Luciano Pavarotti, and Carla Bruni Sarkozy; even George W. Bush (who he's friends with, despite some criticism) has a *khata*. The smile and wise words of Tenzin Gyatso have gone far beyond the press, reaching even an Apple advertising campaign and the cartoon series *The Simpsons*. Thousands of people throng to hear his words of serenity and peace, a message which contrasts with the dominant logic of contemporary society. Meanwhile China, which claims to have brought modernity and education to a world controlled by serfdom, has accused Tenzin Gyatso of cloaking himself in his spiritual authority to carry out political campaigns. These are insinuations the 14th Dalai Lama has answered by stating that today he is not fighting for independence, but for the "legitimate and significant autonomy" of Tibet. In 2011 he gave up his role as Tibet's political leader. And to prevent Beijing from interfering in the identification of his successor, he has stated that, following his death, he might not be reincarnated.

Surrounded by a group of monks, the Dalai Lama prepares a mandala for a Kalachakra initiation ceremony in Leh, India, in 2014. It is an artistic-religious practice shared by the Buddhist and Hindu traditions. Using colored sands, the monk creates an image of complex symbolic value: said to represent the Universe, it is destined to be destroyed as a sign of the transience of earthly things.

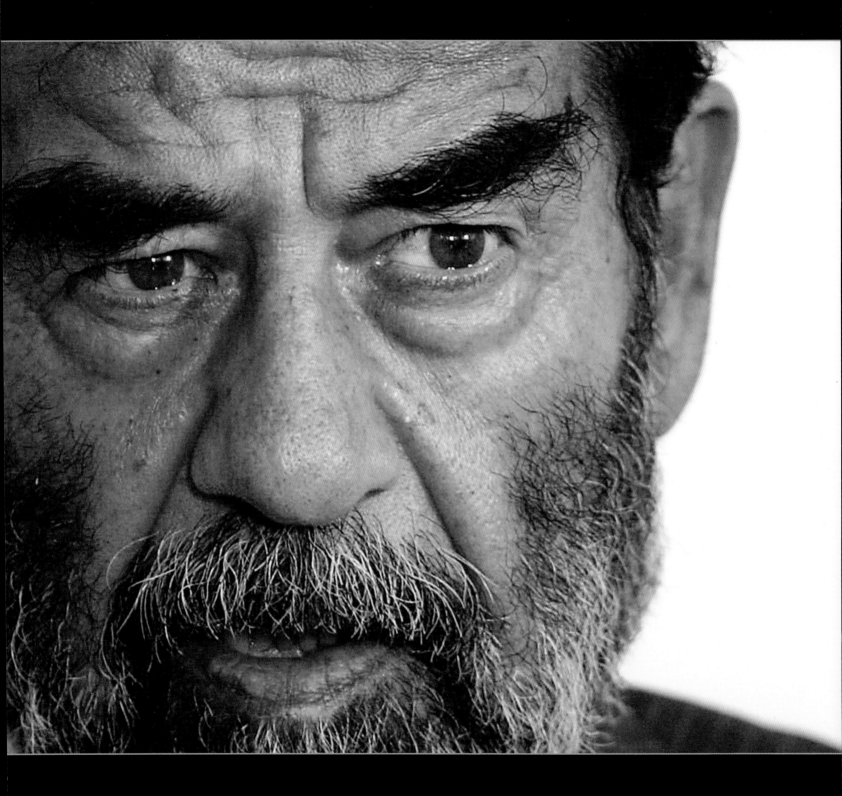

His is the story of the rise and fall of a man who embodied the role of Arab dictator *par excellence*. Once an ally of the West, he would become its number one enemy.

Motionless, at the bottom of a shelter that was more like a grave than a bunker, Saddam Hussein listened to the footsteps of the soldiers overhead. Perhaps he still hoped to save himself. But when the trap door above him opened he realized that the end of his story was imminent. It was December 13th, 2003. They found him among the date palms of Tikrit, the city where he was born, the son of a wretchedly poor Sunni family. Soon there would be a trial, and sentencing, and he'd be hanged in Baghdad, his head high amid the derision of those present. "We shall die in this country, and we will maintain our honor," he once said. In a certain sense, he was as good as his word. In the photos showing his capture – his long beard, tired expression – there is no trace of the arrogance with which he tyrannized Iraq for 24 years, becoming at once a key figure in the dramatic history of the Middle East, drenched in blood and oil, and a litmus test for the hypocrisies of the West. Once he came into power (1979), Saddam Hussein immediately showed himself to be ruthless, ordering mass executions of his opponents, and of Shiite and Kurdish minorities. In 1980, he dragged Iraq into war against Khomeini's Iran, taking advantage of weapons and support from the West. But in 1990, he committed the tactical error of invading Kuwait, which made him the number one enemy of the United States. In the First Gulf War, Iraq was defeated but the dictator remained in power. That changed after the attack on New York City's Twin Towers in 2001, when Washington identified Saddam as an ally of al-Qaeda. Presenting false evidence, George W. Bush and Tony Blair declared that Iraq was in possession of weapons of mass destruction and ordered an invasion. Saddam and his forces did not surrender and fought to the last man. The conquest of Iraq was described as the beginning of democratization in the Middle East. In the end, the invasion turned out to be the fuse that destabilized the entire region. With terrorist attacks and massacres occurring on a regular basis, the post-war period opened ground for the rise of militant Islamic fundamentalism.

In this photograph following his capture, Saddam Hussein appears for the first time before a special tribunal. It was July 1st, 2004. The charges were serious: among other things, the recently-deposed dictator was accused of war crimes and crimes against humanity. Saddam responded by contesting the legitimacy of the court and declaring that the real criminal was the American President George W. Bush.

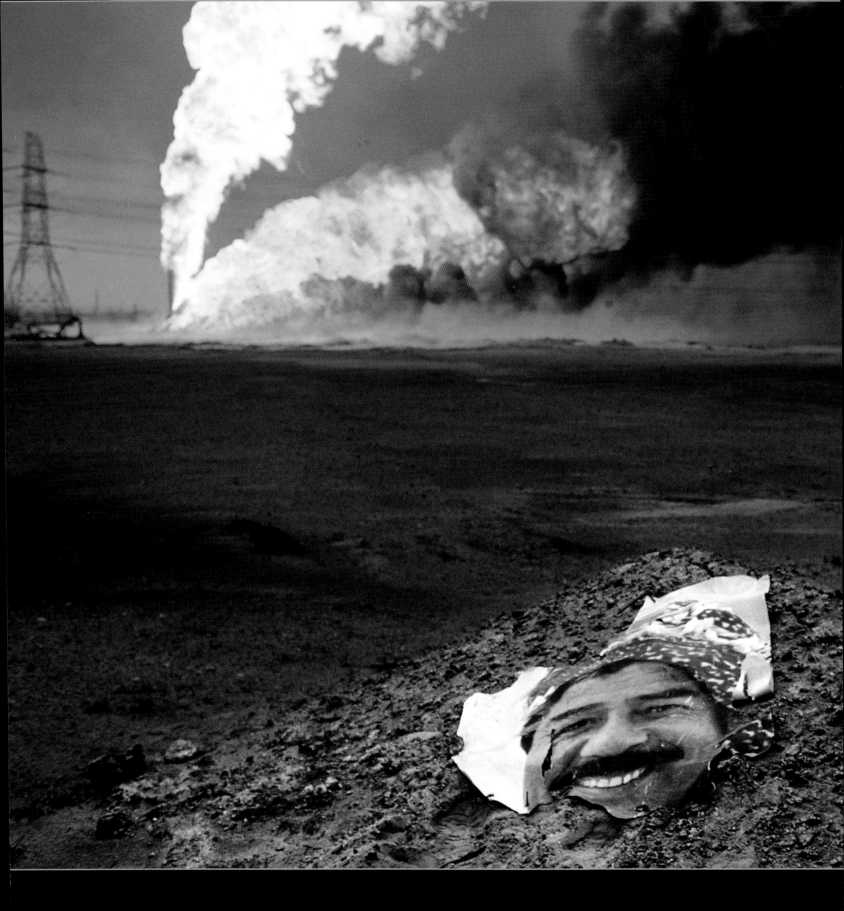

In the final phase of the First Gulf War (1990-91) the great photographer Abbas Attar focuses on a fragment of a poster that ended up in the dust of the desert. On the poster, Saddam Hussein smiles, indifferent to the devastation of war. In the background, oil wells burn. The shot is in some ways prophetic: despite the military defeat, the dictator will remain in power until 2003.

Saddam Hussein

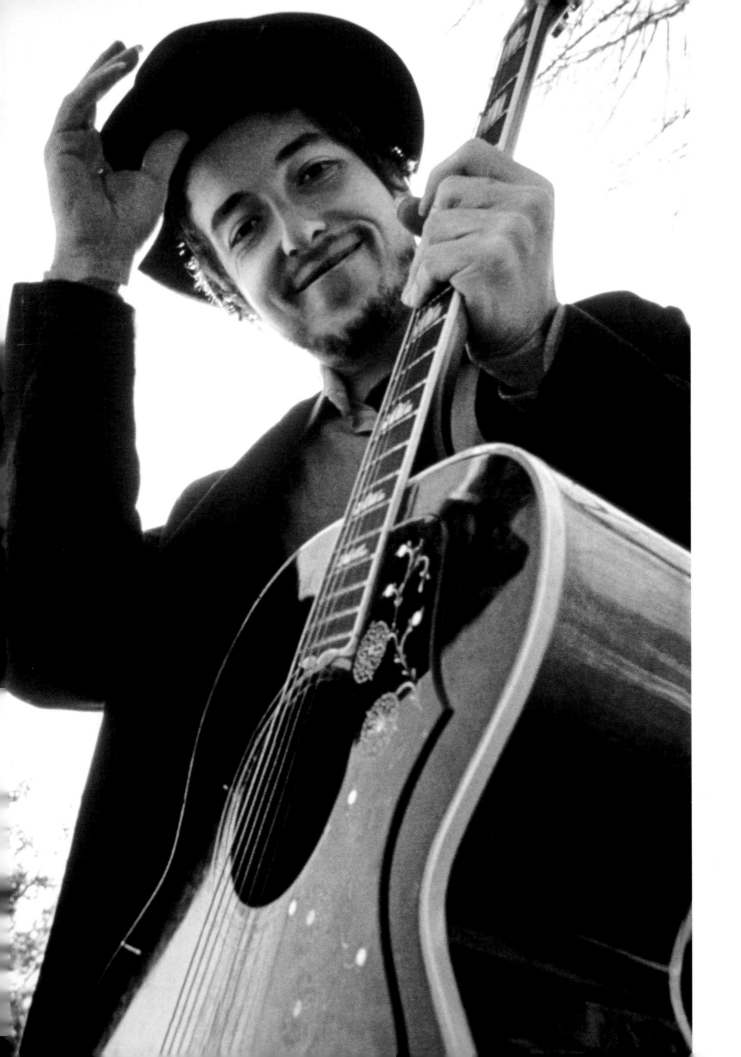

May 24th, 1941, Duluth, Minnesota, United States

Bob Dylan

He was a modern troubadour, a poet and gifted musician, a singer for the "other" America: "Resembling a cross between a choir boy and a beatnik," as Robert Shelton wrote 1961, Bob Dylan has received many awards and accolades, including, in 2016, the Nobel Prize for Literature.

Robert Allen Zimmermann was still a teenager when, in 1961, he left Minnesota for Greenwich Village, Manhattan, a neighborhood teeming with talent. In his head was Beat literature, blues classics, the records and stories of Woody Guthrie and Pete Seeger, but also the music of Joan Baez, who would guide him artistically. He felt like he was beginning a new chapter in life, and so he chose another identity: in 1962 he became Bob Dylan, a name destined to leave its mark in the great adventure of American music. Dylan immediately appeared to be different: his unusual voice, with its seemingly graceless timbre, flew in the face of every rule of professional singing.

His artistic ability quickly became obvious: he was only 22 when he recorded *Blowin' in the Wind*. And yet he was destined to divide opinion, because of his behavior, shy and straight-laced for some, aloof for others – and still more because of the simple structure of his ballads. They were poetry in motion that captured with surgical precision the changes, aspirations, and protests of a group of young people who intended, like him, to change the world. He was a diviner in search of different values: ethics, dreams, and slogans that boldly opposed the establishment, war, power, and consumerism. He was the biographer and poet of the other America. His cry was a severe one.

For Bob Dylan, 1968 was a year of transition. He had just written a courageous experimental novel, *Tarantula*, and released the album *John Wesley Harding*. In January, in his only live appearance until he toured in 1974, he took part in a concert in memory of Woody Guthrie. The photograph, taken in Byrdcliff, New York, would be used on the cover of *Nashville Skyline*, the album released in April, 1969.

Bob Dylan

It was heard when he first emerged with an acoustic guitar, and then again, in 1965, when he exploded in an electric rock reversal, which divided his audience and critics. Going against convention remained a constant for Dylan, from the ever-differing concerts of his *Never Ending Tour*, to the intense collateral activities he engaged in: writing, acting, painting. He surprised people, kept even his friends guessing. The decision not to be present to receive the controversial Nobel Prize for Literature in 2016 (the first one awarded to a musician) was surprising. Dylan chose to receive his prize three months later, to coincide with a concert given by him in the Swedish capital. His was a fair choice, if it were not for the way it was expressed, which seemed disdainful to many.

In 1962, Dylan had just arrived in New York and was part of the Greenwich Village scene, well described in *Inside Llewyn Davis* (2013), the Coen brothers film. His first album came out in the spring and interested only a few enthusiasts. The songs show his links with tradition and his American roots: among them are *Man of Constant Sorrow, House of The Rising Sun,* and *Freight Train Blues.*

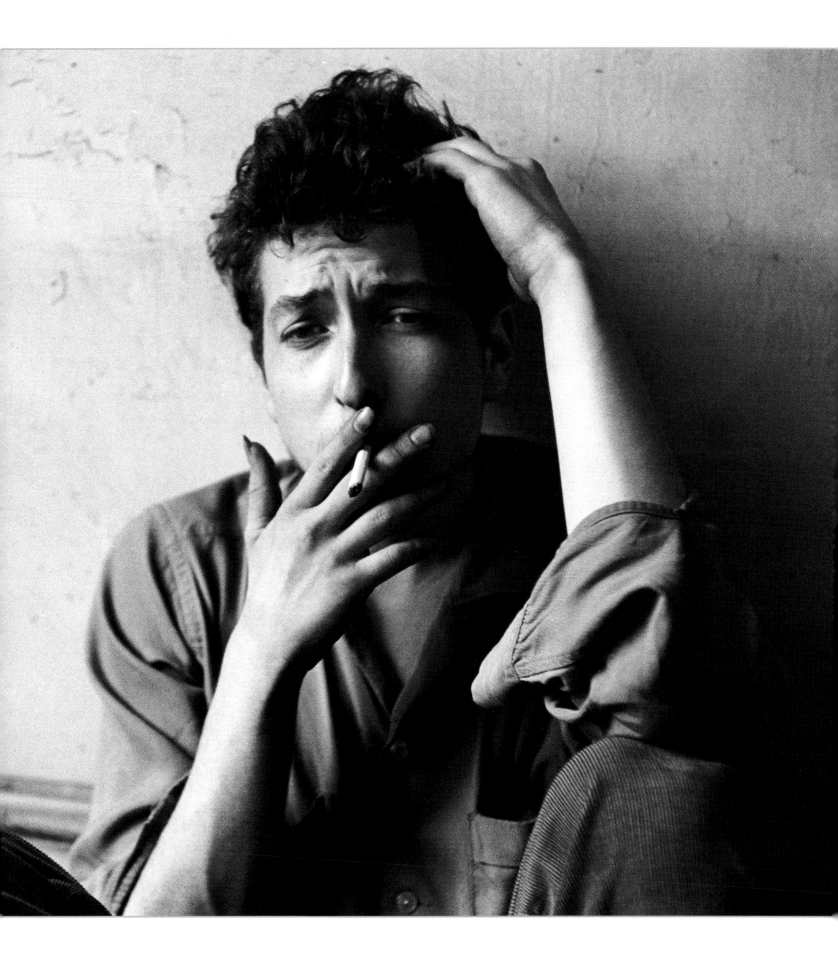

Stephen Hawking

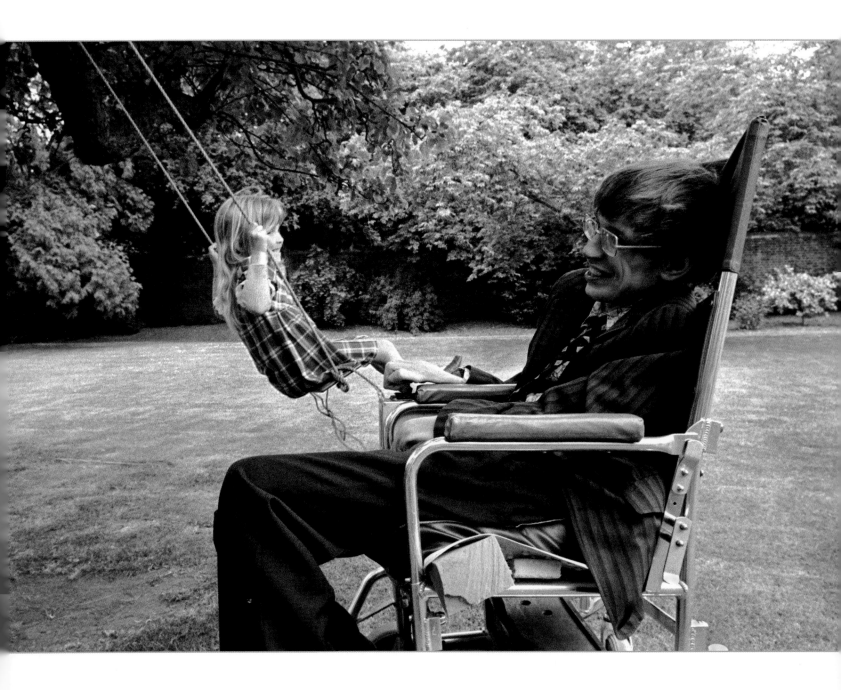

Lucy Hawking, carefree on a swing, steals a glance at her father, Stephen, in a wheelchair. It is 1977: the scientist, who already has important discoveries on black holes to his credit, enjoys a moment of relaxation in his Cambridge garden. Lucy is almost seven years old, and a future as a journalist and novelist awaits her. In addition to novels, she will also publish popularizing science books with her father.

Stephen Hawking is a mathematician, cosmologist, astrophysicist, author of bestsellers, heir to the tradition of Newton and Einstein. He is an iconic scientist, for his fundamental discoveries on black holes, for his ability to popularize science, and for demonstrating that the mind is stronger than the body.

Oxford, 1942. Stephen Hawking's adventure began in the British city famous for its university, which was spared wartime bombing. For years, there was no indication of this young man's brilliant destiny. Even the choice to study physics was not so much a vocation as an intermediate solution between his own preferences (Mathematics) and those of his father, who wanted his son to be a doctor. Stephen hid his extremely high IQ (160) under a raft of mediocre grades; but his classmates intuited the genius that the teachers could not recognize, and they nicknamed him "Einstein," jokingly but also a little seriously. Hawking founded his theories precisely on his studies of Einstein. What fascinated him were those regions of space-time called black holes. Hawking studied them by bridging two apparently different fields, quantum mechanics and general relativity. Thus he formulated, between 1965 and 1970, the theories that would make him famous, from "imaginary time" to Hawking radiation, the thermic radiation emitted from the black hole which leads to a reduction in its mass. His career took off: the Oxonian Hawking was appointed to the Lucasian Chair (of Mathematics) at the University of Cambridge, formerly held by Newton. In parallel to his success, however, his health declined. At 21, he was diagnosed with amyotrophic lateral sclerosis, a degenerative disease that according to the doctors would lead to his death in only a few years. Hawking survived, but the progressive paralysis confined him to a wheelchair, and in 1985 he underwent a tracheotomy, after which, in order to speak, he had to use voice synthesizer. The image of his body imprisoned by the disease adds a fascinating dimension to how, in enormously successful books, he describes far-distant worlds and galaxies. And his metallic voice, the Darth Vader of astrophysics, made such impression in the collective imagination that it appeared in two tracks by Pink Floyd, *Keep Talking* and *Talkin' Hawkin'*.

January 8th, 1942, Oxford, United Kingdom

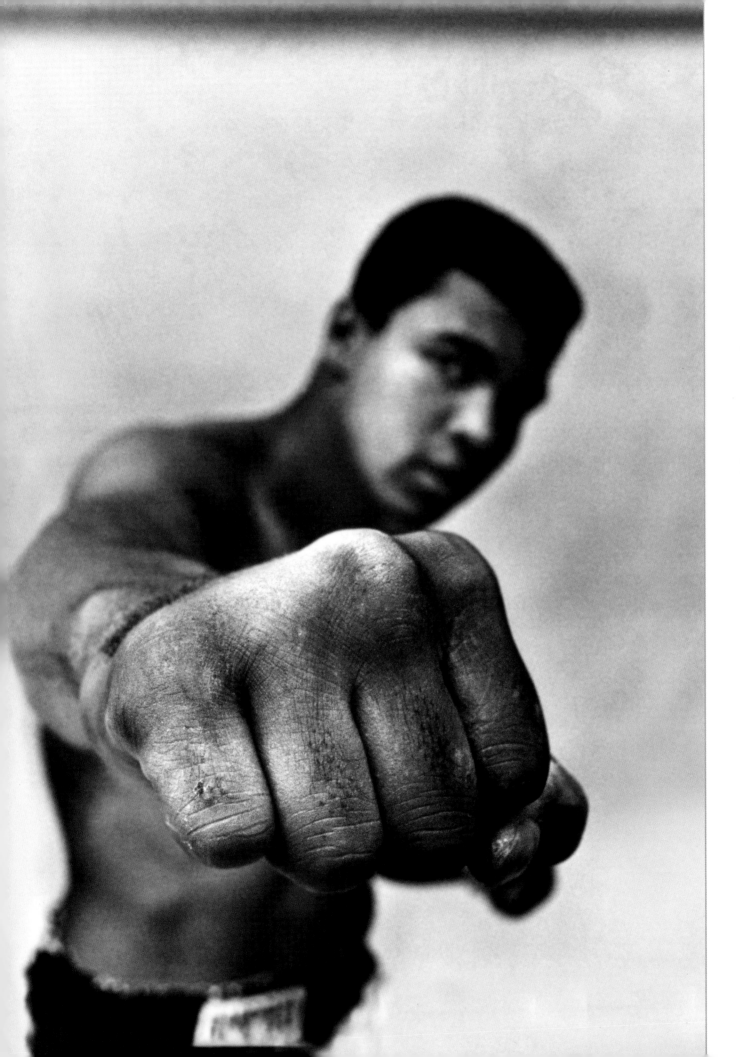

January 17th, 1942, Louisville, Kentucky, United States • June 3rd, 2016, Scottsdale, Arizona, United States

Muhammad Ali

"The Greatest." For his unforgettable matches, his struggle against racism, and his conversion to Islam, Muhammad Ali is remembered not as a great fighter, but the greatest.

Few boxers have set their stamp on the ring like Muhammad Ali. And outside the ring, few men have fought with the same tenacity for their ideas.

Ali revolutionized boxing forever, transforming the match into a perfect dance and a psychological challenge. His famous phrase, "Float like a butterfly, sting like a bee," encapsulates the technical characteristics of his style, but also the spirit: a butterfly and a bee cannot be imprisoned. But his successes in the ring – an Olympic gold medal, the heavyweights' belt won several times – tell only half the story of his greatness. The other half, the one belonging to the man, was shown to the world in 1967, when with the words "No Viet Cong ever called me nigger" Ali announced his objection to military service. The news created a sensation: unexpectedly, the problem of Vietnam and that of racism in the United States became intertwined. It was the talk of the town, in bars and on the street, in all those places where sports always take precedence over politics. Because it was not just any activist who had spoken out, but the World Heavyweight Champion, a universal idol.

Ali was arrested for draft evasion and banned from boxing until 1970. But he did not cease his courageous struggle. It was the same courage that led him, as a child, to chase after a thief who had stolen his bicycle. He was also a child when a white shopkeeper refused to give him a glass of water because of the color of his skin, showing him in the most painful way that, for blacks, rights existed only on paper. Thus he converted to Islam and changed his name, abandoning Cassius Clay, which he considered a leftover from slavery.

Muhammad Ali, World Heavyweight Champion, shows a challenging right fist during gym training in Chicago, the city where he lives. He is 24 years old. In 1966 he defended his title no less than five times. Up to 1966, he has won all 27 professional bouts: this is due to the power of his punch but also, above all, to his speed in the ring.

After his disqualification, Ali returned to the ring and in 1974 won back the world heavyweight title, becoming a universal hero. And also a timeless one: over twenty years later, at the Atlanta Olympic Games, the whole world was moved to see him proceed solemnly with the torch in his hands, trembling because of Parkinson's disease – but more courageous than ever.

200-201 Muhammad Ali during a break in training at the 5th Street Gym in Miami. It is 1971: he has returned to the ring after his suspension for draft evasion. Ali has suffered the first defeat in his career, by Joe Frazier. But the champion doesn't give up and continues to prepare under Angelo Dundee, who has trained him since 1960, when he went professional after his Olympic title.

202-203 Muhammad Ali, in shorts and boxing gloves, in the office next to the Chicago gym where he trains. The walls are covered with photos of past boxers. There's also a newspaper clipping with a portrait of President John F. Kennedy. It is 1966. Ali leapt to fame two years before when, against all expectations, he defeated the World Heavyweight Champion, Sonny Liston.

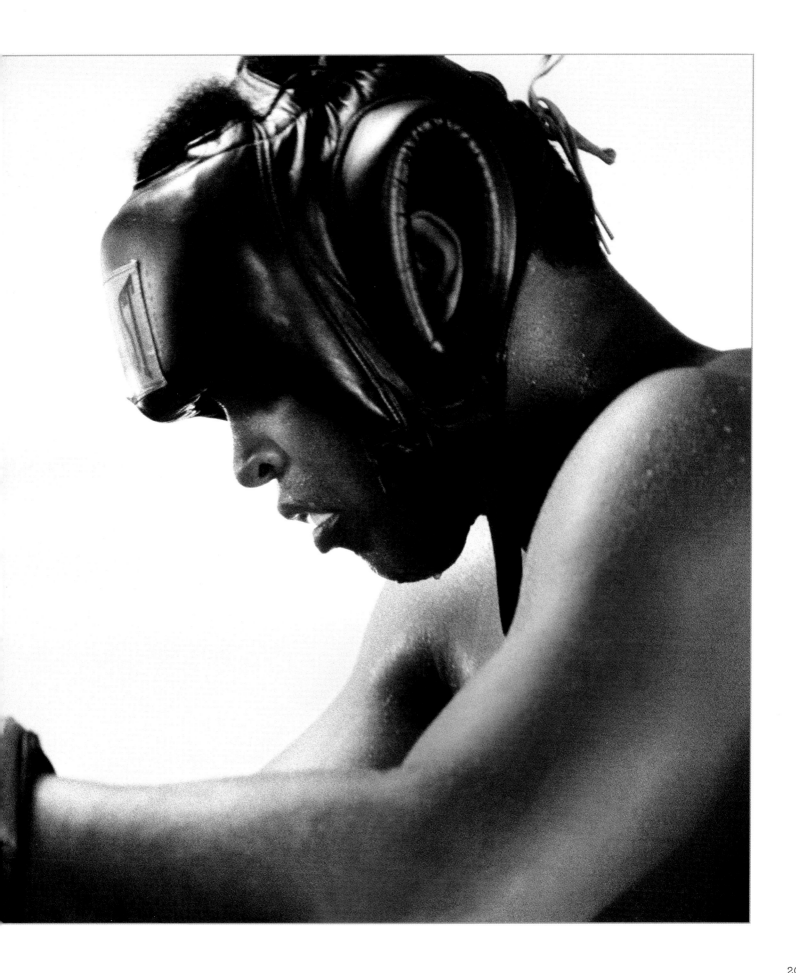

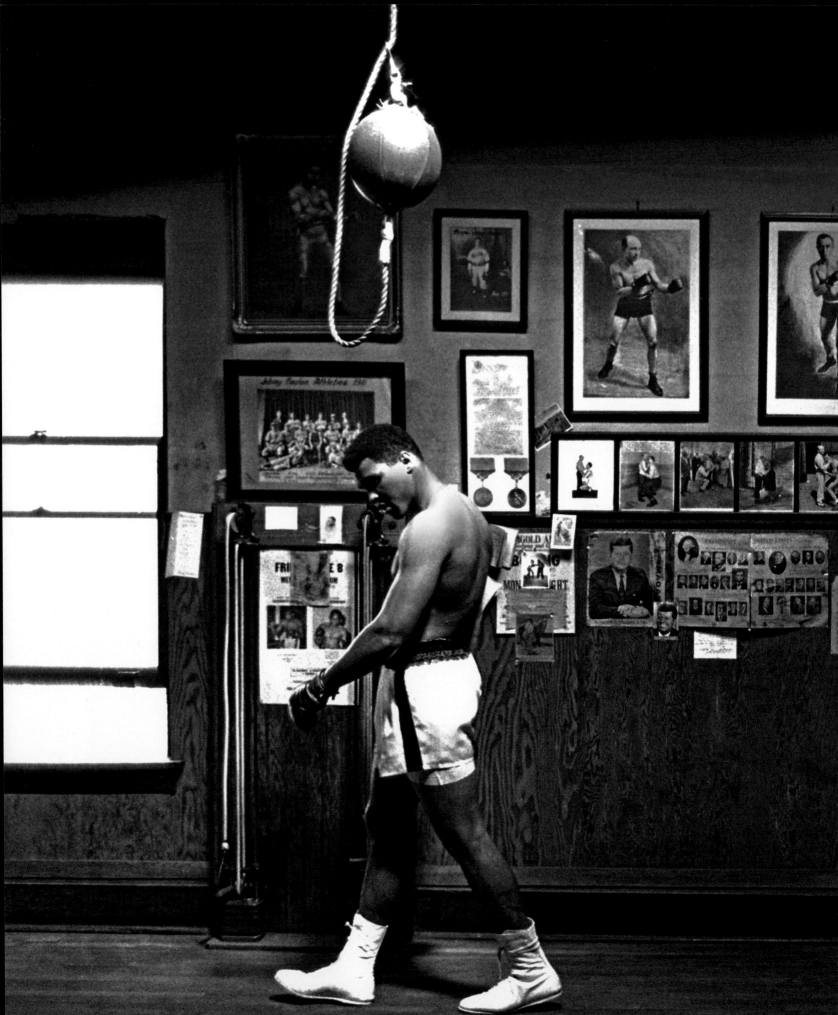

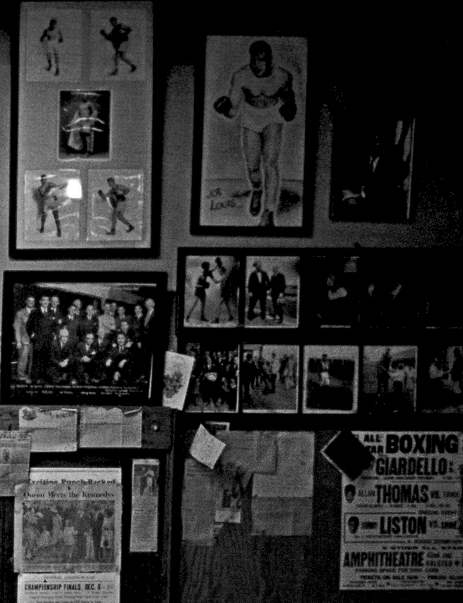

Lech Wałęsa

Leader of the first free Polish labor union, symbol of anti-Communism in the Eastern bloc, President of Democratic Poland, a critical voice for the opposition: for 50 years Wałęsa was a central figure in Polish politics, with victories, defeats, and (perhaps) a few questionable stalemates.

A hero in the revolution that led to the birth of the first non-Communist government in the Soviet bloc, Lech Wałęsa was also a key figure in the negotiations preceding the fall of the Berlin wall and the disintegration of the Soviet Union itself. His role in these events is documented. However, if what some of his political opponents maintain is true, it would be necessary to correct this portrait: Wałęsa has been accused of being an informer (codename Bolek) for Soviet secret services in the early 1970s.

People began to talk about Wałęsa, a humble Catholic electrician, in 1970 when, after an illegal strike (which ended up with the killing of at least 40 people by the police), he was arrested for "anti-socialist behavior" and sentenced to a year in prison. A decade of struggles followed which culminated, in August 1980, with the occupation of the Gdańsk shipyards. After a month of negotiations, the Communist government authorized the foundation of free trade unions: Solidarność was formed, with Wałęsa as president. A year later, having embraced another Pole, John Paul II, in the Vatican, Solidarność had 9 million members. Wałęsa's unmistakable moustache became a universal symbol of anti-Communism. Wałęsa and Solidarność organized strikes and expressed dissent while always following principles of nonviolence: in 1983, this was recognized by the Nobel Peace Prize.

Wałęsa aimed to dismantle the single party monopoly; in 1990, he achieved this objective and was elected President of the Republic. The head of the chancery was Jarosław Kaczyński, who was dismissed 11 months later. Thus began a rivalry destined to affect Polish politics for 25 years. In 2000, Wałęsa was defeated in the presidential election, retired from politics, and devoted himself to his grandchildren (he had eight children). But he lost no opportunity to criticize the conservative and Eurosceptic policies of Kaczyński, who today is among the most powerful men in Poland.

Lech Wałęsa chairs a meeting of the National Committee of Solidarność in Gdańsk in December, 1980. The labor union was founded on September 17th, and officially registered only two months later, but already many people have signed up: in little more than a year, more than a quarter of the Polish population will join Solidarność. Of people old enough to work in Poland, more than a third of them will join the union.

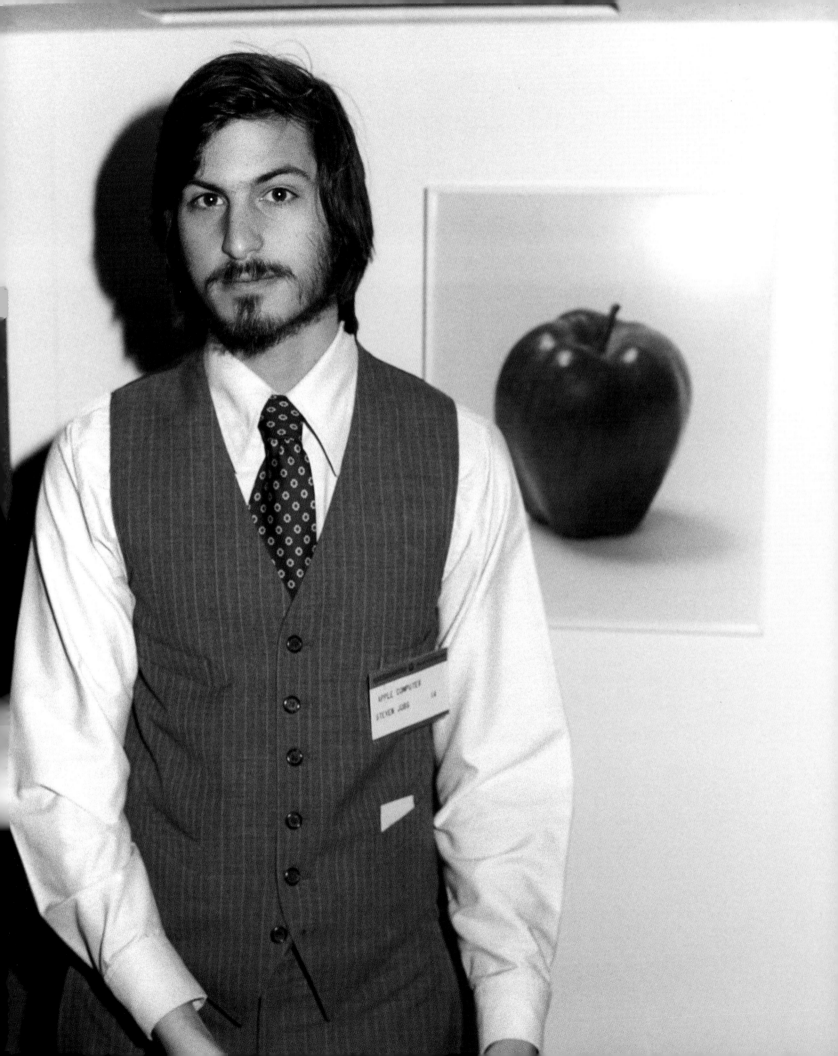

Steve Jobs

February 24th, 1955, San Francisco, California, United States • October 5th, 2011, Palo Alto, California, United States

Jobs was a visionary leader. Always anticipating what his customers wanted, he was a great communicator who brought passion and humanity to the technical world of computer graphics and functionality.

"It just works." You would hear that often from Steve Jobs during the launch of Apple products. Every presentation was a performance and Jobs, both guru and CEO, communicated enthusiasm and conviction for everything his company offered. Elegant and simple in appearance, practical and functional in application, Apple products modified the habits and improved the lives of its customers: thus the company he launched as a young man became the leader in technological production, the trailblazer for great innovations like the Apple II and iPad well before the competition. What made him proudest, before his death from cancer at 56, was having combined in Apple's products technology with art, giving science the depth and breadth of humanity. Steve Jobs never did it for money, or not only for money. His actions and fervid intelligence were driven by a passion for invention and innovation. But his passion often emerged without restrictions, in all of its power: scathing in judgments and explicit in praise, he was unrestrained even in making the most important decisions. He began in what has become the legendary garage of his foster parents, in Los Altos, California, with his friend Steve Wozniak, both of them passionate about electronics. He was interested in Zen Buddhism and lived, at the time, on fruit and vegetables and the occasional LSD tab. As Apple Computer, Inc., developed, he chose the best people to work with, delegating tasks with complete confidence in success. He resigned as chairman of the company in 1985, but re-appointed 11 years later, when the company was facing bankruptcy. From there, he took it to the top. "The people who are crazy enough to think they can change the world are the ones who do," we heard in a commercial for the 1997 advertising campaign *Think Different*. It was not a slogan but a distillation of Apple philosophy, delivered with a montage of great figures – from Einstein to Lennon to Picasso: geniuses of the past who influenced their eras as much as Steve Jobs has transformed ours.

Immaculately dressed, on April 16th, 1977, Steve Jobs attends the West Coast Computer Fair in San Francisco. He is presenting the Apple II, the machine that will pave the way for the home use of personal computers. Jobs is 22 years old, and the Apple Computer Co. – with its now universal logo of a bitten apple with six horizontal stripes of different colors – was founded only a few months before.

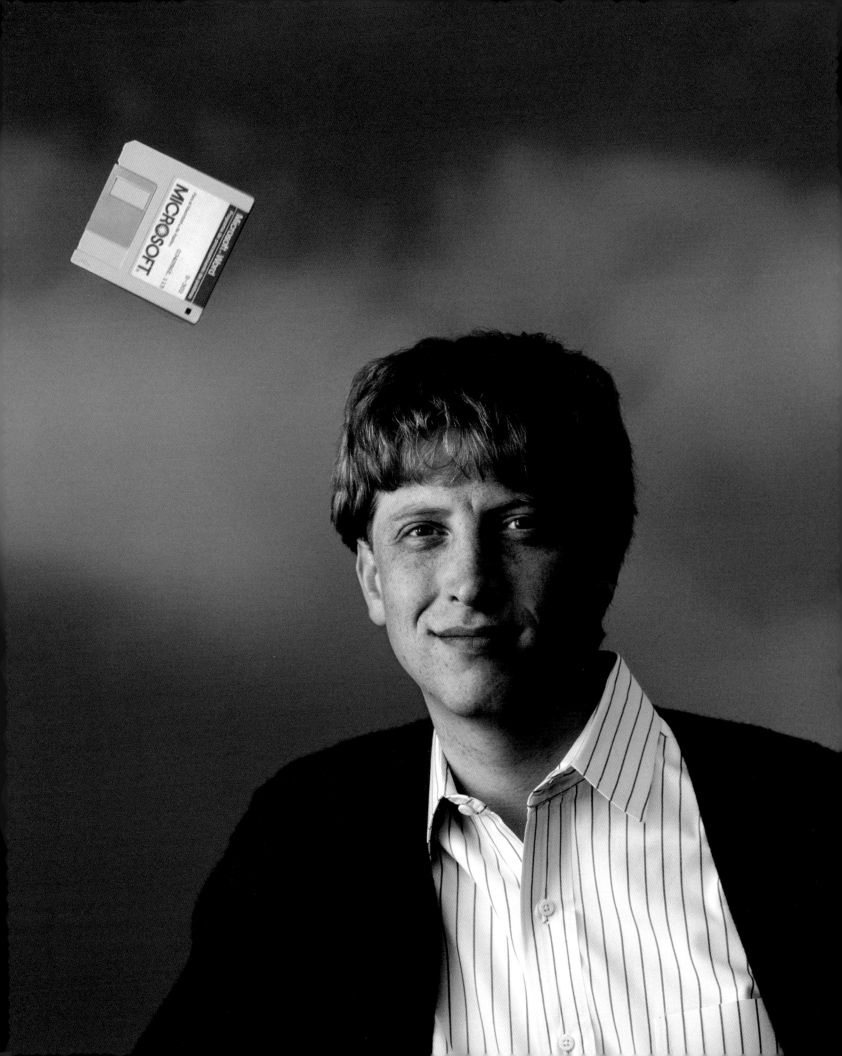

Bill Gates

Was he a computer science genius, or a clever entrepreneur? Probably both. But Bill Gates, the founder of Microsoft, prefers to describe himself simply as an "innovator" or "creative capitalist."

Bill Gates was only 13 when he hacked his first computer. The machine was as big as a closet and made available to his school for only a few hours each week. It was a brilliant stunt and it earned him his first IT consultancy. In a few years, his achievements took him to the Olympus of young IT talents: he wrote a program to monitor Seattle traffic and, already with the Microsoft brand, he built the programming language for the Altair 8800, one of first personal computers, which at the time was called a *microcomputer*. In the second half of the 1970s, Gates set aside writing codes: the MS-DOS operating system, which in the early 1980s he successfully used to sweep away the competition, was the work of his colleague, Tim Paterson. Gates purchased it and, rather than selling it, marketed only the license to use it: the idea was attractive for hardware producers. (For his part, Paterson would always resent Gates's tactics.) Around this time, Gates – not hesitant to be "inspired" by his enemy-friend Steve Jobs – realized the importance of the icon interface. Thus the Windows operating system was created, and it spread like wildfire. To Windows licenses, Microsoft linked programs such as Office, the suite of software that includes Word and Excel; it was a marketing strategy that revolutionized how people thought of computers. In 1990, Microsoft was verging on a monopoly, and attracted the attention of antitrust watchdogs: this, the first of several conflicts with authorities, however, did not prevent the company from going full steam ahead. In 2008, there was a twist: Gates resigned from Microsoft to dedicate himself to humanitarian work, and constructed a financial theory, "creative capitalism," which combined philanthropy and business. In order to spread technological and social progress to poor countries, he has argued, it is necessary to make sure that entrepreneurs' interests address the needs of the poor. The idea has been received with skepticism. Presently, however, the Bill & Melinda Gates Foundation, which is active in medical research and education, is the largest humanitarian foundation in the world.

October 28th, 1955, Seattle, Washington, United States

February, 1986. Bill Gates on the occasion of the opening of the Microsoft Campus, the new headquarters of the company in Redmond, Washington, northeast of Seattle. These are special days for him: in March, Microsoft is quoted on the Stock Exchange. The stock, initially offered at 21 dollars, is worth 28 by the end of the day. At the end of the year, Gates, who's 31, will become a billionaire.

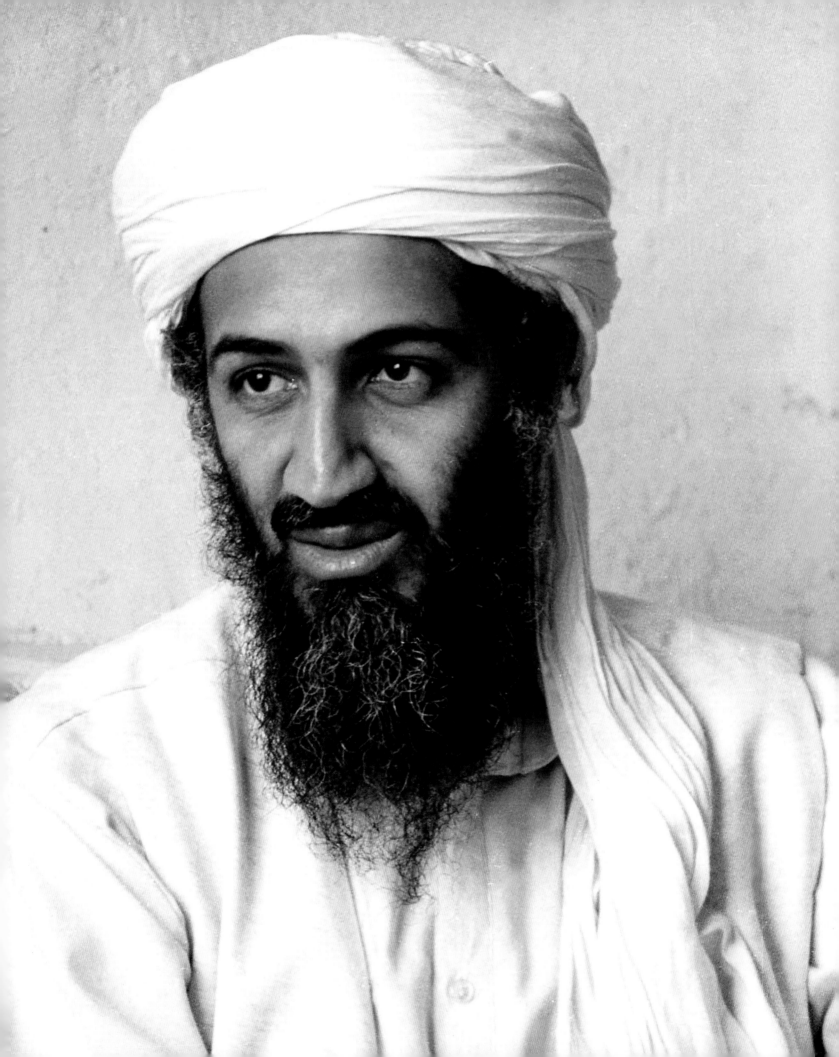

Osama bin Laden

March 10th, 1957, Riyadh, Saudi Arabia • May 2nd, 2011, Abbottabad, Pakistan

A symbol of terror, he strategized a form of global warfare founded on bloody and spectacular terrorist attacks, and on an ever more intense use of media propaganda.

Osama bin Muhammad bin Awad bin Laden, better known as Osama bin Laden, left behind him stacks of videos. Shot in Afghan and Pakistani caves, and all starring the same blurry and ranting figure, these were his means of communicating with the world. Invariably, an essential prop, there was an AK-47 at his side. ISIS would soon surpass him, making more omnipresent and spectacular the propaganda of terror and making its strategy more extreme: frightening the enemy by sudden attacks in his home territory. But at the beginning of the period of terrorist attacks, in the 1990s, the sharp profile of the man stood out: he lived and died veiled in mystery. He was able to move in the shadows and to strike places both populated and of great symbolic value. The Twin Towers of New York were the symbol of a nation, a culture, an empire. For this reason, on September 11th, 2001, they were destroyed by two commercial passenger aircraft hijacked by members of al-Qaeda, bin Laden's terrorist network. It is not easy to construct the stages of Osama's life. He was a descendant of a super-rich family of Saudi construction entrepreneurs, the Ladens. They were close to the al-Saud monarchy, and they loved the high life and extravagance. The reasons for the evolution, or involution, of his political and religious thought are obscure. A crucial event was his participation in the Afghan resistance of the Soviet invasion (1979-89), alongside the *mujahideen,* who were supported by the United States. Those "fighters for freedom," as the Western press described them, grew up with a religious ideology derived from Wahhabism, or Saudi Islam, the source of the most extreme Islamic fundamentalism. In the Afghan situation, a late act in the Cold War, bin Laden may have been a link between the CIA and the anti-Soviet rebels. It was only later, when the rate of globalization increased dramatically due to the spread of Internet, that bin Laden was transformed into the prophet of the hardest, most violent religious and political fundamentalism.

Osama bin Laden in a portrait from the 1990s. After criticizing the Saudi monarchy for their support of the US in the Gulf War, bin Laden was forced into exile in Sudan in 1992. In 1996 he had to leave and took refuge in Afghanistan. In those years, he organized the first al-Qaeda terrorist attacks, which culminated in attacks on the US embassies in Kenya and Tanzania in August, 1998.

He invented a new "web" model of terrorism with, in 1988, al-Qaeda, the "base": an international network, his group was like a franchising operation of terror to which individuals and other groups could easily affiliate. Al-Qaeda offered a globally recognized brand. In the collective imagination, that brand would acquire the characteristics of the face of the "sheikh of terror" and would be reinforced by the myth that he could not be caught. As early as 1998, bin Laden was included by the FBI in the list of most wanted terrorists, and yet he succeeded in inflicting the most painful damage on the United States since the attack on Pearl Harbor. In 2001, a record price of 25 million dollars was placed on his head, but that did not prevent Afghanistan, Pakistan, and Yemen from transforming into the perimeter of a political and military action against NATO forces. It took ten more years for bin Laden to be identified and killed in Pakistan by US special forces, in a raid which raised many questions. He was buried at sea from an aircraft carrier. Almost all the members of the Navy SEALs team responsible for bin Laden's capture disappeared the following year, during a high-risk mission in Afghanistan. Today, only two witnesses of bin Laden's death remain.

After the attacks of September 11th, 2001, the Al Jazeera television network showed various videos originating from bin Laden. This frame is from a video shot between November and December. The terrorist seems tired. (According to some analysts, he was injured). But he continued to threaten the US and justify the Twin Towers attack as a response to Israeli and US policies in the Middle East.

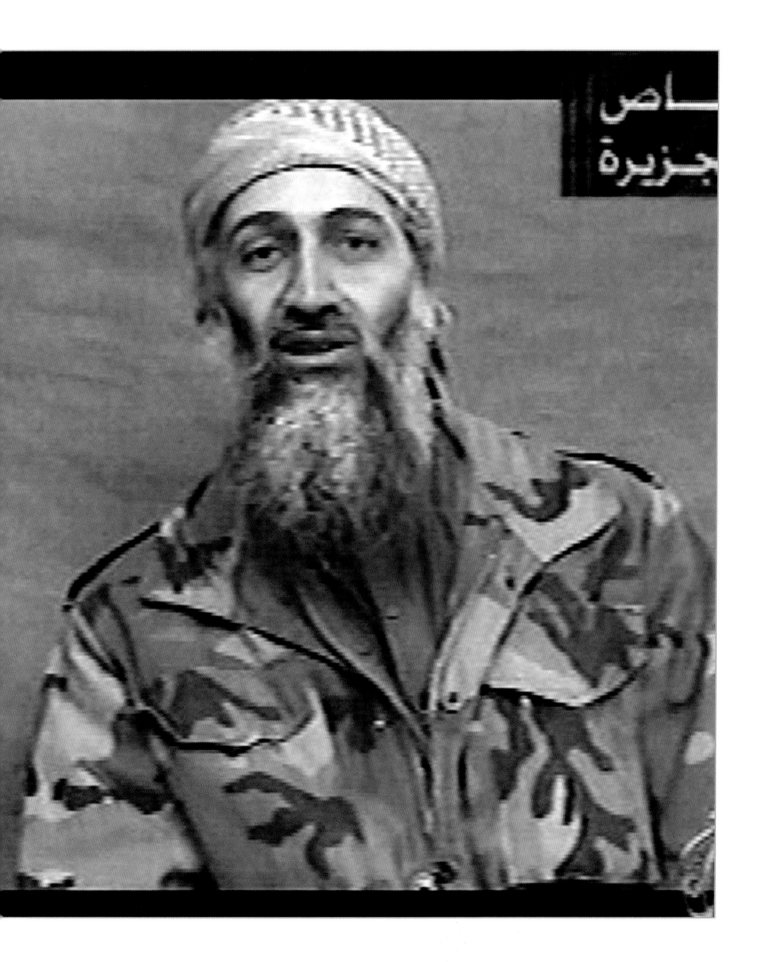

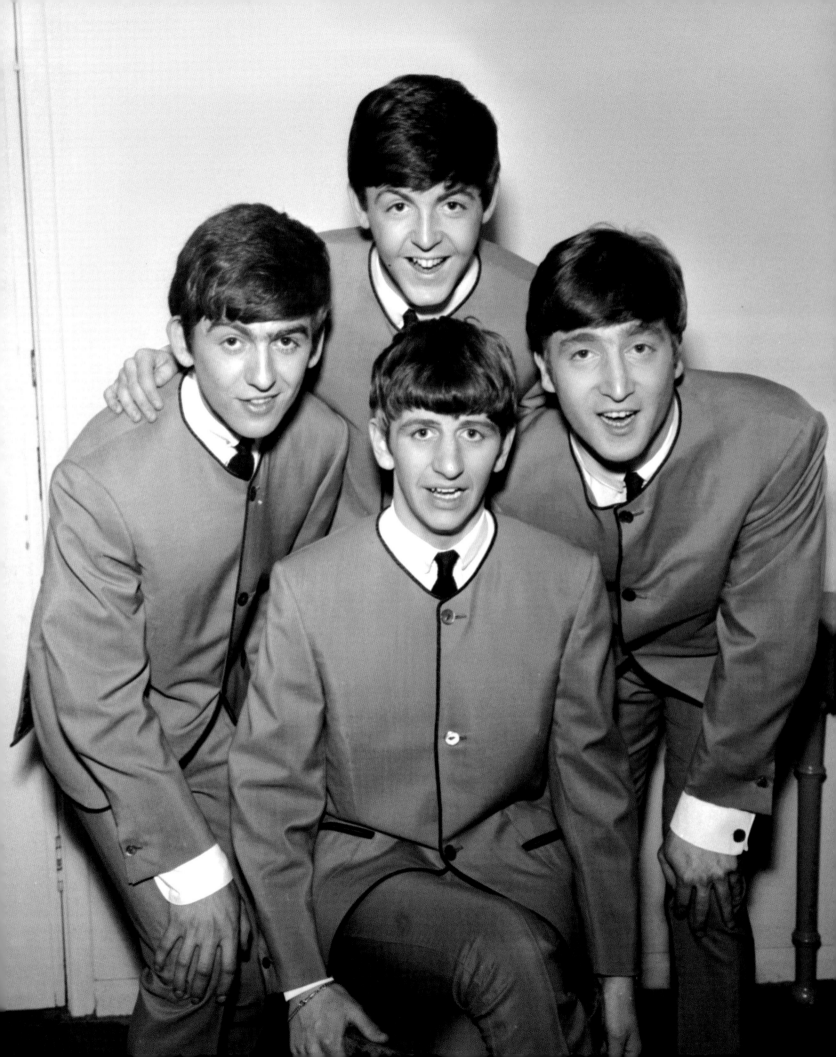

The Beatles

Titans in the history of music and pop culture, The Beatles were adored by crowds more than anyone before them. And Beatlemania goes on: almost 50 years after their last appearance in public, they continue to thrill millions of people, and their hits are played on the radio and in performances throughout the world.

Timothy Leary, early in the 1970s, famously wrote: "The Beatles are mutants. Prototypes of evolutionary agents sent by God, endowed with a mysterious power to create a new human species, a young race of laughing freemen." At the time, Mr. Leary might have been under the influence of one of those psychedelic substances he'd made himself the prophet of. But objectively, in fact, it was difficult to say something rational about the Beatles phenomenon. What was the secret of the superhuman success of the four boys from Liverpool? They were just twenty years old, and not content with reaching the top of world charts, they had become the personification of the dreams of a generation. Scenes of mass hysteria formed the backdrop of every concert, of every public appearance. Even Queen Elizabeth accepted their success by awarding them the Most Excellent Order of the British Empire in 1965. It is said that the Beatles took two LSD tablets to Buckingham Palace, with the idea of dropping them into the Queen's tea: they did not follow through with the plan. If we wanted to tell their story today, perhaps four words would be enough.

Empathy. Right from the start, playing in the dark and dilapidated Cavern Club in Liverpool, their union was visibly spontaneous, faithful to music. They were funny, close-knit, hungry for life. Unexpectedly, they caused a stir. Audiences, delighted to participate in the breaking of schemes and conventions, loved them. In 1962 the band settled down to its four members. John Lennon and Paul McCartney, both leaders and both very talented, did voice, guitar and bass guitar. George Harrison was the quietest: his romantic air would drive girls everywhere crazy. Ringo Starr, on the drums, and almost a caricature of likability, was a late but decisive choice for the chemistry of the group.

A unique style multiplied by four. In 1963, when their popularity exploded, the Beatles adopted a more sophisticated look: a similar hairstyle, the same outfit. In this photo they wear smoky gray Pierre Cardin suits, with collarless jackets (black piping). Clockwise from the left: George Harrison, Paul McCartney, John Lennon, Ringo Starr.

Liverpool, United Kingdom, 1960-1970

Style. The Beatles were irreverent but not vulgar. Their look was attractive and fashionable. In dress, they were elegant minimalists, with sober jackets and skinny pants, their hair thick on their foreheads. At the same time, it is impossible to forget their ironic satin military uniforms, their Oriental-style coats, and later, the fake furs, long hair and long beards.

Universality. From the United States to Japan, the music of the Fabulous Four spoke a universal language. They composed and wrote their lyrics by hand, in a continuous flow of novelty. After the first single, they were instantly famous: in a few weeks they dominated the top of the charts. *Please Please Me* stayed in the top ten for 62 weeks.

In the Abbey Road studio the Beatles examine the script of *A Hard Day's Night* (1964), their first feature film, directed by Richard Lester. We owe the idea of the group's film debut to the record producer Noel Rogers. The initial budget of 200,000 pounds will go mostly toward keeping onlookers at a distance; the figure will be doubled halfway through shooting.

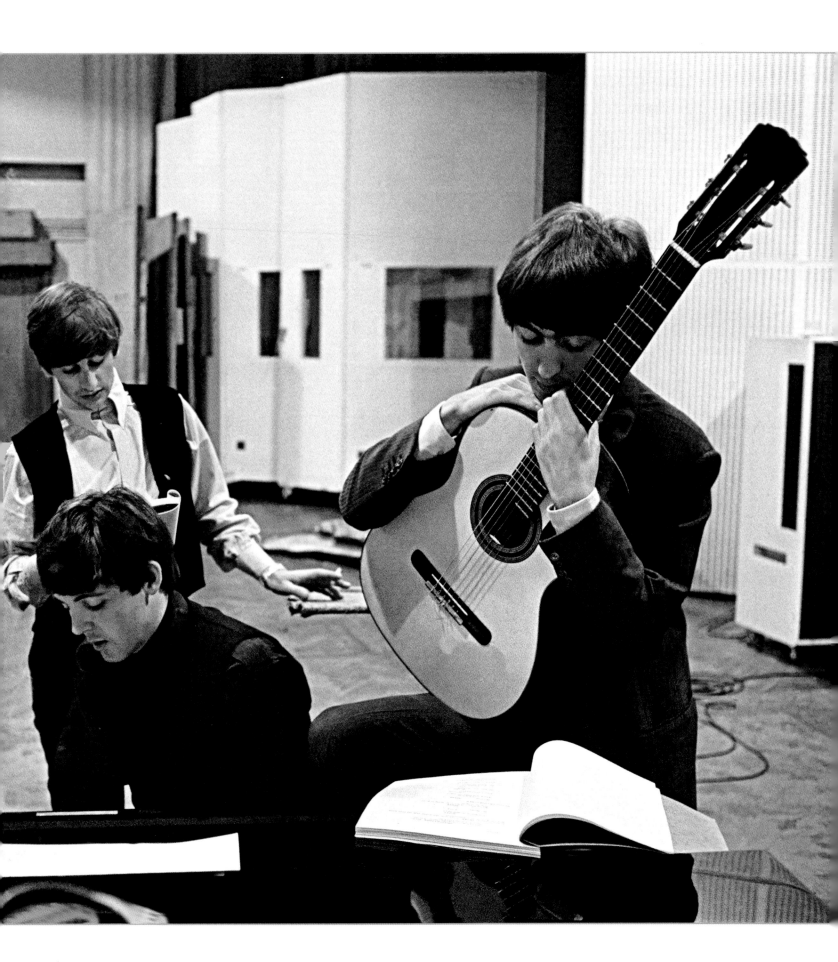

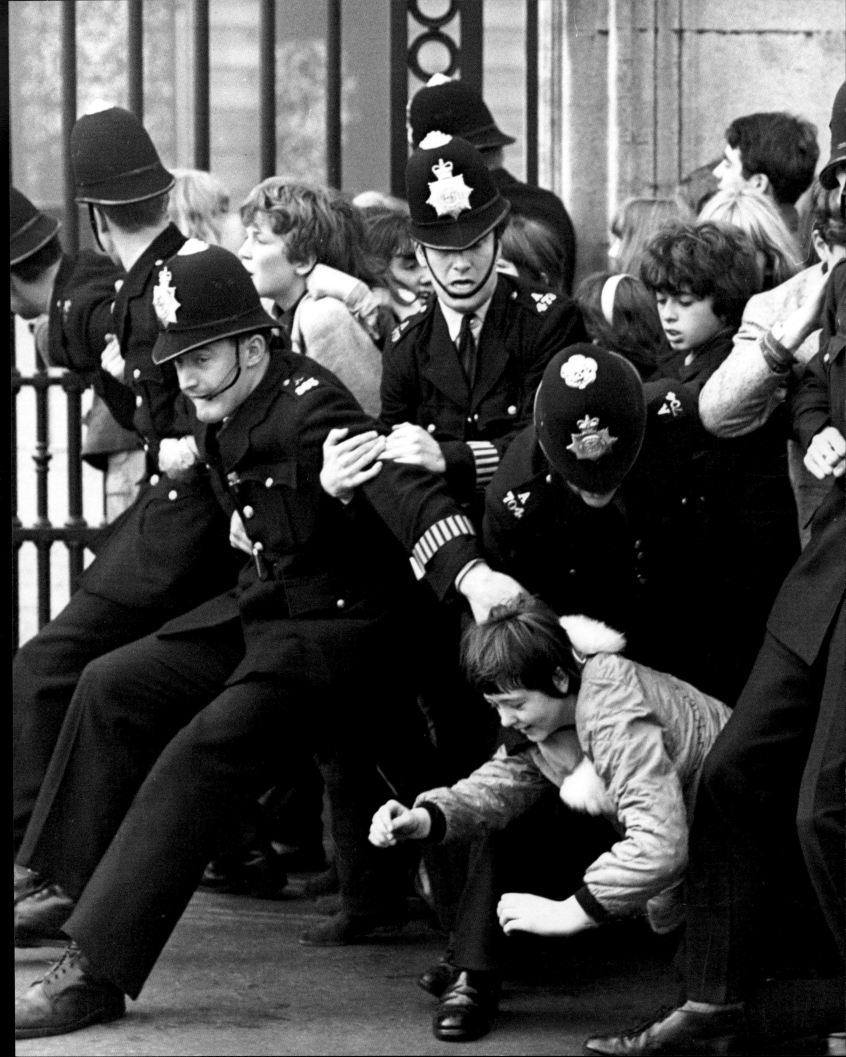

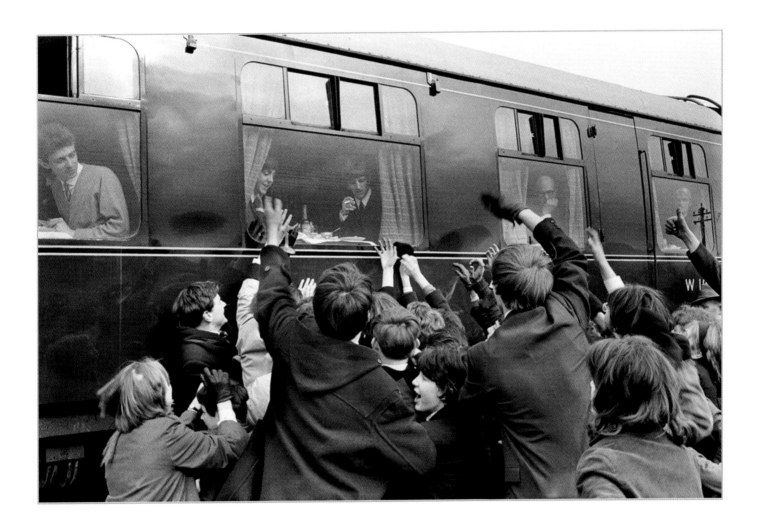

Evolution. The Beatles were capable of evolution in music and lyrics. The exciting, upbeat, danceable numbers of the early stage became more poetic in time. The horizons of the lyrics broadened to the outside world, to memory, to difficult relationships, to the contradictions of the era. They ended in a more experimental, psychedelic and politically involved period. Theirs was an ultra-prolific production concentrated in only eight years: *Let It Be*, the last album, came out in 1970. The end of the group freed the Fab Four to follow individual careers. That dream was tragically destroyed in 1980 with the murder of John Lennon, the soul of the group who carried them definitively into the realm of myth.

218 Outside the gates of Buckingham Palace on October 26th, 1965, the police struggle to hold off hysterical fans waiting for the Fab Four to arrive in John Lennon's Rolls Royce. The Beatles are to be elected Members of the British Empire. The reason: they are the best British "export product" of the era.

219 Ecstatic fans watch the Beatles' train passing during shooting of *A Hard Day's Night*. The film, an Oscar candidate for the best original screenplay and musical adaptation, was included in *Time*'s 100 most important films for its portrayal of the anti-conformist, spontaneous, and authentic tone of the era. For its 50th anniversary, a restored version was released in movie theaters.

Mark Zuckerberg

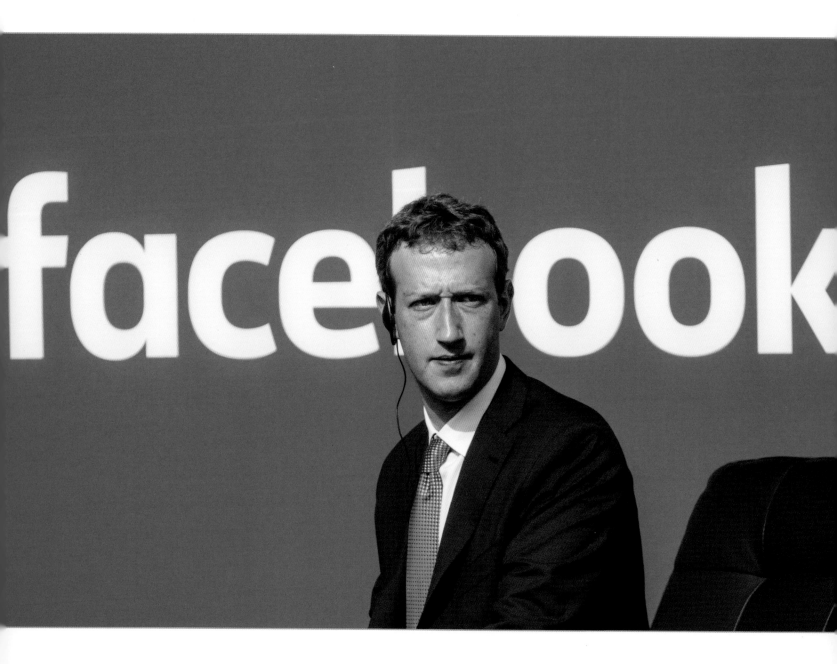

On September 27th, 2015, Mark Zuckerberg welcomed the Indian Prime Minister Narendra Damodardas Modi to the Facebook headquarters in Menlo Park, California. The Facebook community suggested more than 40,000 questions for Zuckerberg to ask his eminent guest. The debate touched on the future of India, the value of social media, and the importance of family.

May 14th, 1984, White Plains, New York, United States

Prophet of the social network era, Mark Zuckerberg, businessman 2.0, has opened the border between the real and the virtual. His success has only one name, Facebook, which, he states, "was not originally created to be a company. It was built to accomplish a social mission – to make the world more open and connected."

"Reflecting on a year of new challenges, opportunities and hope for a better future." Just a few words accompanied the 12 photos he shared to jump into 2017, a trivial but perfect post by Mark Zuckerberg, the founder of Facebook. We know his beginnings as a student prodigy, his passion for Homeric poetry, his good-guy look, his vast collection of gray sweatshirts and T-shirts, his selfies with his dog Beast. And we know the anecdotes about the birth of the billion-dollar social network, which he constructed as a teenager in a dormitory at Harvard; and about the resounding rejections he gave to the IT giants who would have done anything to get their hands on his creature. We know less about the other young and brilliant individuals who contributed to the invention of Facebook, some of whom would later sue Zuckerberg and obtain millions. (All is fair in love and war and business.) Because in the meantime Zuckerberg has grown up, become a man and the father of a little girl, as his 84 million Facebook contacts know: they can watch him changing her diapers. He is one of the most influential people in the world. He is a billionaire without seeming to be one: before his company was listed on the Stock Exchange, he felt it important to communicate that "we don't build services to make money; we make money to build better services." In 2010, TIME magazine crowned him Person of the Year, because Facebook opened the way to the era of mass social networks. He revolutionized the internet and the daily life of millions of subscribers: ordinary people, celebrities, companies, professionals gossiping, opining, and advertising. He has expanded our understanding of reality, the consequences of which we are still struggling to comprehend. There are certainly positive and negative aspects to this, as there always are when society adopts a new and highly powerful instrument. But this concern, more than a question for Zuckerberg's biographers, is one sociologists, legislators and media experts are examining and will continue to examine for a long time.

The Authors

Gianni Morelli. The author of novels, short stories, essays, educational books, and screenplays, he has worked in research institutes and written books on travel and geography. One of the founders of the ClupGuides, he has directed this series for more than twenty years. He has edited various publications for White Star, including *Masters of the Swindle* (2016, with Chiara Schiavano). He is the editor-in-chief at Iceigeo in Milan.

Roberto Mottadelli. A 20th-century art historian, he has collaborated with the Department of Film Studies at the Università degli Studi in Milan, and written for various national publications. For White Star, he is the author of *Signature Dishes from Around the World* (2011, with Paolo Paci) and editor of *The 100 Photographs that Changed the World* (2016, with Margherita Giacosa and Gianni Morelli).

Photo Credits

Page 10 Library of Congress/Corbis/VCG/Getty Images
Pages 12-13 Bettmann/Getty Images
Page 14 Time Life Pictures/Mansell/The LIFE Picture Collection/Getty Images
Page 16 Bettmann/Getty Images
Pages 18-19 GeorgeRinhart/Corbis/Getty Images
Page 20 Will/ullstein bild/Getty Images
Pages 22-23 Association Freres Lumiere/Roger Viollet/Getty Images
Page 24 AFP/AFP/Getty Images
Pages 26-27 SSPL/Getty Images
Page 28 SSPL/Getty Images
Page 30 NY Daily News Archive/Getty Images
Page 31 SSPL/Getty Images
Page 32 Ben Schnall/The LIFE Images Collection/Getty Images
Page 34 Bettmann/Getty Images
Page 36 Dinodia Photos/Getty Images
Pages 38-39 Margaret Bourke-White/The LIFE Picture Collection/Getty Images
Page 40 Laski Diffusion/East News/Getty Images
Pages 42-43 Sovfoto/UIG/Getty Images
Page 44 Time Life Pictures/Mansell/The LIFE Picture Collection/Getty Images
Page 46 Bettmann/Getty Images
Page 48 Mondadori Portfolio/Getty Images
Page 49 Photo 12/UIG/Getty Images
Page 50 Library of Congress/Corbis/VCG/Getty Images
Page 51 Time Life Pictures/US Army Signal Corps/The LIFE Picture Collection/Getty Images
Page 52 ullstein bild/ullstein bild/Getty Images
Pages 54-55 Fine Art Images/Heritage Images/Getty Images
Page 56 ARTHUR SASSE/AFP/Getty Images
Page 58 Robert DOISNEAU/GAMMA-RAPHO
Page 60 Herbert List/Magnum Photos/Contrasto
Page 61 Gjon Mili/The LIFE Picture Collection/Getty Images
Page 62 Robert Capa © International Center of Photography/Magnum Photos/Contrasto
Page 63 Robert Capa © International Center of Photography/Magnum Photos/Contrasto
Page 64 FPG/Hulton Archive/Getty Images
Page 66 Keystone/Getty Images
Page 67 Bettmann/Getty Images
Page 68 Keystone-France/Gamma-Keystone/Getty Images
Page 70 Lipnitzki/Roger Violet/Getty Images
Page 72 Lipnitzki/Roger Violet/Getty Images
Page 73 Lipnitzki/Roger Violet/Getty Images
Page 74 Hulton Archive/Getty Images
Page 76 Frank Scherschel/The LIFE Picture Collection/Getty Images
Page 77 Cornell Capa © International Center of Photography/Magnum Photos/Contrasto
Page 78 David Rubinger/CORBIS/Corbis/Getty Images
Page 79 Hulton Archive/Getty Images
Page 80 Keystone-France/Gamma-Keystone/Getty Images
Page 82 Michel Sima/RDA/Getty Images
Page 83 Rene Burri/Magnum Photos/Contrasto
Page 84 Heinrich Hoffmann/Getty Images
Page 86 Keystone-France/Gamma-Keystone/Getty Images
Page 87 Bettmann//Getty Images
Page 88 Universal HistoryArchive/UIG/Getty Images
Page 89 Roger Viollet/Getty Images
Page 90 Serge DE SAZO/Gamma-Rapho/Getty Images
Page 92 Major Horton/IWM/Getty Images
Page 93 Hulton Archive/Getty Images
Page 94-95 Nicolas Tikhomiroff/Magnum Photos/Contrasto
Page 96 Lyu Houmin/VCG/Getty Images
Page 98 Collection J.A. Fox/Magnum Photos/Contrasto
Page 99 Collection J.A. Fox/Magnum Photos/Contrasto
Pages 100-101 Universal History Archive/UIG/Getty Images
Page 102 J.R. Eyerman/The LIFE Picture Collection/Getty Images
Page 104 Hulton Archive/Getty Images

WHITE STAR PUBLISHERS

WS White Star Publishers® is a registered trademark
property of White Star s.r.l.

© 2017 White Star s.r.l.
Piazzale Luigi Cadorna, 6 - 20123 Milan, Italy
www.whitestar.it

Translation: Jonathan West - Editing: Max Rankenburg (Iceigeo, Milan)

ISBN 978-88-544-1174-6
1 2 3 4 5 6 21 20 19 18 17

Printed in Italy